WHAT WE BRING TO THE PRACTICE OF MEDICINE

LITERATURE AND MEDICINE

What We Bring to the Practice of Medicine

Perspectives from Women Physicians

Edited by

KIMBERLY GREENE-LIEBOWITZ

and

DANA CORRIEL

THE KENT STATE UNIVERSITY PRESS

Kent, Ohio

© 2023 by The Kent State University Press, Kent, Ohio 44242
All rights reserved
ISBN 978-1-60635-449-0
Published in the United States of America

Cataloging information for this title is available at the Library of Congress.

To Mom and Dad,
Two beautiful souls without whom I wouldn't be the person I am today.
Love,
Dana

To Gary, Hannah & Max,
Who tolerated late nights and missed dinners, mostly without complaint.
Love,
Kim

And thank you to all the women who so generously shared their stories for this
compilation: we could not have done this without you!

Contents

SURPRISE

SADNESS AND GRIEF

BALANCING ACT: PHYSICIAN PARENTS

INSPIRATIONAL STORIES

Introduction

KIMBERLY GREENE-LIEBOWITZ

What We Bring to the Practice of Medicine is a collection of essays intended to entertain and inspire readers and to motivate some to seek careers in medicine. These writings illustrate what we've learned from our experiences and what we bring to the practice of medicine, and add to the body of literature from other female physician writers, which dates back nearly two thousand years. Whether due to human nature or something more mutable, many of the overarching concerns of female physicians have not changed over time: clinical practice, the physician-patient relationship, career advancement, domestic responsibilities, work-life balance, bias and harassment, and barriers to success. Of course, the details have evolved. For example, *burnout,* a significant issue, wasn't even a term applied to professionals until 1974, and even then, it was used more generally for "caring professionals," not just physicians.[1]

Consider domestic responsibilities, which are noticeably gendered. Women, including physicians, are responsible for a disproportionate share of childcare, elder care, and miscellaneous housework.[2] This gap widened during the COVID-19 pandemic; as a result, female physicians reduced their work hours, research, and pursuit of leadership opportunities.[3] These commitments—and the desire for one's own family—have been long known to affect women's professional choices, including their areas of specialization and their decisions to work part- or full-time.[4] In the long term, these choices can lead to lower reimbursement, fewer opportunities for advancement, and a sense of divided loyalties. Regardless of a practitioner's specialty, her family planning can be hampered by a career in medicine. Female physicians have higher rates of infertility, miscarriage, and preterm delivery than women in the general population.[5] Further, fertility decreases around age thirty-two—which is, for most women, right when training concludes and medical careers are launched. Shift work, including nights, and physically demanding work are known to have negative effects on pregnancy in nonphysicians as well.[6]

Conversely, these same issues—family, work-life balance, career selection—lead to continual growth. Caring for elderly parents and adult children is rewarding, as is parenting, which is "joyful and meaningful" and stimulates personal growth.[7]

Many female physicians write about this interplay, demonstrating that clinical practice enriches their personal lives and personal experiences inform their patient care. This leads to rich and rewarding interactions with patients and improved family relationships.

Most nonfiction from female physicians touches on multiple issues, though a good discussion of the personal-professional dynamic can be found in Suzanne Koven's memoir, *Letter to a Young Female Physician: Thoughts on Life and Work*, published to critical acclaim in 2021. She reflects on her four decades in medicine, including the decision to work part-time to balance work and personal responsibilities, the impact her medical experience had on her interactions with her aging parents, and her own experience with imposter syndrome.[8] In a similar vein, Judy Melinek's career choice reflects a need to better balance work and life. Originally a general surgery resident, she switched to pathology, and took a position at the New York City Office of the Chief Medical Examiner. Her 2014 memoir, *Working Stiff: Two Years, 262 Bodies, and the Making of a Medical Examiner* chronicles her time at the medical examiner's office, and her experiences working in the 9/11 morgue tents. Melinek describes the experience as "[freeing us] from our six o'clock news phobias . . . nearly every unexpected fatality was either the result of something dangerously mundane, or of something predictably hazardous."[9]

In this collection, a number of authors explore similar issues. Rohini Harvey and Sasha Shillcutt detail the balancing act of parenting in "Forty Is Greater Than Twelve" and "The Transition from Doctor to Mom"; Rebecca Andrews and Jasmine Marcelin are parents first in "Chrysalis" and "Sometimes Doctor Mom Is Just Mom"; and Katharine Miao struggles to care for aging parents remotely in "Pandemic."

The barriers to professional success feature prominently in the writings of many female physicians. In many ways, women enjoy unprecedented access to medical careers: there are no longer rules preventing them from obtaining medical degrees or licenses or membership in professional societies, and the number of female physicians has exploded in recent years. Nevertheless, bias, discrimination, and inadequate mentorship combined with subpar work-life balance lead to fewer female department chairs, lower lifetime earnings, and lower levels of academic achievement.[10] Women's career choices do affect outcomes, but that doesn't explain the whole picture. For example, during the COVID-19 pandemic, women's academic journal submissions decreased, likely due to increased responsibilities at work and at home.[11] Sometimes gender discrimination is codified, as in the rules requiring women to use vacation in lieu of being granted maternity leave, and at times it is more insidious, as in a story Michele Harper included in *The Beauty in Breaking*, published in 2020. When she was denied a promotion, it wasn't clear whether gender, race, or both played a role. Her supervisor spoke

with her. "'Michele,' he said. 'You know every time I try to make a change at this institution, I just can't. I'm always blocked. You didn't get the position. I'm sorry to say it. You're qualified. I just can't ever seem to get a black person or woman promoted here. That's why they always leave! I'm so sorry, Michele. They've decided that even though you were the only applicant, and a super-qualified one at that, they're just going to leave the position open.'"[12]

Female physicians have a long history of providing care to women, children, and the underprivileged. For centuries, these were the only patients for whom they cared, and this has spawned literature about clinical and social issues pertaining to these populations. Rachel Pearson, who worked with indigent patients during her medical training, shines a light on poverty and how the US health care system fails marginalized patients in *No Apparent Distress: A Doctor's Coming of Age on the Front Lines of American Medicine,* published in 2017.[13] Through a slightly different lens, Sheryl Recinos's *Hindsight: Coming of Age on the Streets of Hollywood,* published in 2018, documents her experience growing up homeless in Los Angeles. Recinos, who has since become a family physician, is particularly interested in homeless teens and underserved populations.[14] She has moved her concerns a step beyond patient care and recently set up a scholarship program for college students who have experienced homelessness.[15]

The physician as patient or patient advocate is a common theme in books written by physician-authors. They provide an intimate look at medical care and the clinical experience and illustrate things from "the other side." Rana Awdish's 2017 book, *In Shock: My Journey from Death to Recovery and the Redemptive Power of Hope,* is a good example. Awdish was a young intensivist, pregnant with her first child, when she became critically ill. Her memoir documents how she learned to tolerate being a patient in need of critical care and how it opened her eyes to the flaws and opportunities for improvement in medical care.[16] Another example of physician-as-patient is Uzma Yunus, whose blog about her experience with breast cancer spawned a book, *Left Boob Gone Rogue: My Life with Breast Cancer,* published shortly before her death at age forty-six.[17]

Like these authors, our achievement on this stage is preceded by a long history of female healers who wrote about medicine and their experiences. These healers were sometimes called physicians but were also herbalists, wise women, midwives, vetulae, surgeons, apothecaries . . . and witches. They long predate the nineteenth-century physician pioneers who are usually considered the first women in medicine. To what extent does history influence us, affecting our role as physicians, parents, daughters, friends and lovers—and to what extent is this reflected in our writing?

The professionalization of medicine began in 1140, when King Roger of Sicily decreed that the practice of medicine required a qualifying exam and licensure.

Subsequently, Holy Roman Emperor Frederick II established standards for training in the thirteenth century, mandating study at the University of Salerno and a license to practice medicine. Gradually, the word *physician* came to mean "skilled healer." As professionalization spread north, women began to be excluded from formal medical training and were often not permitted to join guilds that would allow practice of medicine. Universities, church leaders, and trained physicians discredited female healers by labeling them charlatans, quacks, or witches.[18]

The stories of these earlier healers and their writings have been obscured by centuries of both deliberate and accidental obfuscation: for instance, copy errors in manuscripts, merged documents leading to incorrect assumptions about authors, and scholarship errors.[19] Identifying female healers in the historical record can be difficult: women were defined by their professions in the written records of the Middle Ages much less often than men, and this trend continued into early modern times.[20] Finally, the work of women throughout history is subject to scrutiny men's work has not been.[21]

The history of women in medicine begins in the ancient world, including Sumeria, Babylonia, Egypt, Greece, Rome and China. Surgical tools were found in the tomb of the Sumerian Queen Shuba of Ur (3500 B.C.E.); Egyptian records document the enrollment of women in a medical school in Heliopolis in Egypt (1500 B.C.E.); and in the fifth century B.C.E., Herodotus wrote of Egyptian women performing surgical procedures with "stone knives" and splinting broken bones. There are multiple references to female midwives, surgeons and anatomists in Jewish texts.[22] Roman Empire–era funerary inscriptions from Greece, Rome, Spain, and North Africa commemorate female physicians and their medical achievements; and medical recipes and remedies attributed to women appear in books written by male authors from this same period.[23] Though limited data is available, professional achievements and family ties are celebrated.

However, history has a way of both obscuring and fabricating facts, especially about women. Consider Peseshet and Merit Ptah: during a 1929–30 exploration of Giza, a false door with hieroglyphics dedicated to Peseshet (2600 B.C.E.)—"Overseer of the Healer Women"—was discovered in the tomb of Akhethetep, an Old Kingdom courtier. It is assumed she was a physician, but no available documentation supports that conclusion.[24]

A few years later, in 1938, Kate Campbell Hurd-Mead reported, in her history of women in medicine, that an image of a female physician named Merit Ptah (2700 B.C.E.) had been found in a tomb in the Valley of the Kings.[25] This was accepted as truth until 2019, when Jakub Kwiecinski proved the story apocryphal. Merit Ptah is not on the lists of ancient Egyptian healers, and there are no Old Kingdom tombs in the Valley of the Kings. Kwiecinski suspected that Hurd-Mead confused

Merit Ptah and Peseshet and he believed the story demonstrated the importance of role models for "women entering science and medicine."[26]

We know today that role models provide guidance and affect the numbers of women in leadership positions.[27] In this collection, Torie Comeaux Plowden shares in "Serendipity" how her role model, a female gynecologic surgeon, influenced her career choice. "Filing Cabinet," by "S.P.," shares the story of a cancer patient who, when seeing a young psychiatrist for the first time, reveals childhood sexual abuse. She says she'd rather die than get better. S.P.'s role model serves as educator, demonstrating a unique approach to care and helping to salvage the interaction. In both of these cases, the physicians knew their role models personally, as most physicians do; we no longer rely on ancient role models. Nevertheless, there are lessons to be learned from the long procession of female healers.

Consider two Greek gynecologists from the first millennium: Metrodora and Aspasia. Metrodora authored *On Diseases and Cures of Women,* the oldest surviving medical manuscript written at least in part by a woman. Little is known of Metrodora beyond her writings; even her name may be a pseudonym.[28] She may have lived in the second or the seventh century C.E., and it is not certain whether she was a physician. There is only one extant copy of her work, which dates to the late tenth or early eleventh century. Gemma Storti notes: "Even though the identity of Metrodora will probably never be revealed, it is nevertheless possible that the name refers to a female individual—be it the author of this collection's chapters . . . , the compiler, or a female physician who collected remedies deemed worth preserving."[29]

Aspasia was a fourth-century Greek midwife and gynecologist who pioneered and wrote about a number of surgical techniques. Her writings have not survived, but they are referenced in the sixteenth volume of *Tetrabiblon,* by Aetius of Amida, a sixth-century C.E. physician. From Aetius, we know Aspasia wrote about management of uterine hemorrhoids, varicocoeles, uterine cancer, abortion, and clitoridectomies, which were common at the time. Some of her methods are still in use today. However, because her name was common, some questioned the veracity of her existence, and her name has been largely lost to history.[30]

Metrodora and Aspasia not only practiced but wrote about women's health, exemplifying the historical principle that "women's health is women's business."[31] Today women freely choose any specialty, but many still focus on women's health. In this collection, authors describe successes in this field that are a blend of clinical decision-making, patient engagement, support from family and nursing, and good communication. For example, during the complicated delivery KrisEmily McCrory writes about in "The Perfect Birth," a birth plan is discarded. The patient has requested an unplanned epidural; the baby is difficult to monitor and then in

distress; and both an episiotomy and a vacuum-assisted delivery are necessary. Yet it is still a "perfect birth." In "A Life Saved," Andrea Eisenberg looks at the complex issues around fetal sex selection. There is a struggle to resolve differences between physician and patient beliefs, and we see how biases can adversely affect decisions. Finally, bias is a key theme of Avni Desai's "No Small Feat," in which a young woman of extremely short stature presents in labor to a clinic. Assumptions by the community, the clinic, and even the physician are barriers to safety and care. In these latter two essays, the clinical outcome is predicated as much on communication as on clinical skill.

Women's health—obstetrics, gynecology, and other care of women—was also the focus of female physicians in the Byzantine Empire (330–1453 C.E.). Most women and girls had little access to formal education, but the educated were permitted to practice medicine.[32] The Byzantines, credited with establishing the first hospitals, staffed them with both male and female physicians.[33] There are no writings by female physicians surviving from the Byzantine Empire specifically, but Salerno—once a part of the Byzantine Empire—eventually gave rise to the first center of formal medical education, a number of women *medicas* (healers or physicians) and one of the few known women physician writers of the medieval era.

Salerno, just past the southern end of the Amalfi coast, was situated at the intersection of Roman and Byzantine Christianity. The city was proximal to a Jewish community dating to the second century C.E. and to the Islamic communities of Sicily and North Africa. By the tenth century, this amalgamation of cultures had given rise to a center of medical education independent of church control and therefore available to women, Jews and Muslims. Salerno was the most important Western European center of medical learning during the eleventh and twelfth centuries, and it was in this setting, likely during the early decades of the twelfth century, that Trota (or Trocta or Trotta) de Salerno was active.[34]

Little definitive information is known about Trota, like her predecessors, although much has been hypothesized. We know that Trota was a healer, possibly a physician, in twelfth-century Salerno. At that time, there were a number of other women named "Trota" or "Trocta" in the city, and there were a number of women healers, but only one Trota who was also a healer.[35] She authored at least two texts: *De curis mulierum* (*DCM,* translated as Treatments for Women) and *Practica* (Book of Practical Medicine—a collection of treatments and cures).[36] The *Trotula,* a collection of three treatises, including *DCM,* was the predominant women's health reference during the thirteenth through fifteenth centuries.[37] There is evidence that she was in contact with other Salernitan physicians, such as Copho, who is quoted multiple times in her work.[38]

Perhaps more interesting, and more relevant to this collection, is why her history is so confusing. Monica Green, in her extensive research about Trota, attributes

the confusion to four factors: medieval misogyny, Renaissance editorial changes, Italian nationalism, and nineteenth- and twentieth-century feminism.[39] Scribes appropriately attributed the manuscript to a female author named "Trotula" or "Trota" until 1544. At that time, the *Trotula* texts were merged to create a single narrative and all post-third-century names were suppressed. Now called *De passionibus mulierum* (The Diseases of Women), there was no evidence it was a medieval manuscript, and it was included in a collection of works by ancient physicians. Subsequently, in 1566, an editor changed the author's name from *Trotula* to the masculine *Eros* and altered language in the book that indicated the author was female. As a result, the *Trotula* appeared to have been authored by a man.[40]

Antonio Mazza's 1681 history of Salerno resurrected Trota, falsely claiming she was one of the first female university professors. Salvatore De Renzi fabricated a family and a physician spouse for her in his 1852 *Collectio Salernitana*. In between, linguist C. G. Gruner revisited the *Trotula* and in 1773, determined that its author was an anonymous medieval man.[41]

With the emergence of modern feminism in the nineteenth century, Trota attracted attention once again. Women in were eager to accept what Mazza and De Renzi had written, and they attributed authorship of the entire *Trotula* to her, but historians did not agree. Debates and editorial changes continued until this mystery was partially unraveled by historian John Benton in 1985 and more fully by Monica Green two decades later.[42]

This story seems long and complicated because it is—and because at the root of these changes are sociopolitical trends that affect women physicians today. Bias, pride, feminism, willingness to change—these themes show up repeatedly in the essays in this collection and in other works of female physician authors. Several essays in this collection directly acknowledge bias. Jazbeen Ahmad describes an encounter through the eyes of another in "The Every Patient": "You are not sure what to make of me. I am young, I am female, I have a nose ring, and I am brown; I have no accent where most are expecting one." In "Leverage," Photine Liakos is asked how she, a girl, could be capable of doing a "man's" work. Elizabeth Preston-Hsu addresses a more insidious form of bias in her residency program in "Pink Panties": lack of maternity leave and limited scheduling flexibility for new parents, male or female. Preston-Hsu reports that the policies engendered further prejudice against her among peer physicians: "My motives for being in medicine were questioned." At a broader cultural level, bias against female physicians continues.

It is also interesting that at least one iteration of Trota's story assigned her a spouse and children. Through most of history, women, even professional women, were largely defined by their families, and in the medieval period, women were often subsumed into the family businesses, leaving little evidence of their individual identities. Today, women are much more likely to have independent identities and

be defined as more than "so-and-so's mother" or "so-and-so's spouse," but family continues to play a critical role in the lives of female physicians, as multiple contributors to this collection note. This goes beyond domestic responsibilities. Monica Kaira's "Doctor Mothers" is a good example. Kalra juxtaposes her experience parenting with inpatient pediatric care, comparing the nurturing her child receives with that given to an abandoned and chronically ill child in the hospital. Each of her roles is influenced by the other and yet distinct.

Personal anecdotes slipped into the writing of some medieval medical authors. For example, Trota relayed a case history about a patient with "wind in the womb."[43] Louise Bourgeois, a prominent sixteenth-century midwife, shared multiple case histories in her writings and devoted space to providing advice to her daughter, Antoinette, who hoped to be a midwife as well.[44] However, most early female medical writers focused on the practicalities of medical care, providing empirical guidance, describing surgical techniques, curative recipes, therapeutic instructions, and diagnostic guidance. Hildegarde of Bingen, the only other known female physician-author from the medieval period, took this approach in her medical and scientific writings.[45]

Hildegarde, born in 1098, was the tenth child in a family of wealthy landowners. Promised to the Church by her parents, she entered the Benedictine convent in Disibodenberg at the age of eight.[46] In 1136 she become its prioress; and then, in 1147, she took eighteen nuns from her convent to Rupertsberg, opposite Bingen, to form a new convent. She remained there as Abbess until September 17, 1179, when she died, at the age of eighty-one, in her sleep. In 2012, she was canonized a Catholic saint.[47]

Hildegarde was a mystic, a healer, a composer, and an artist who created her own language. She published three books about visionary theology (*Scivias, Liber Vitae Meritorum,* and *Liber Divinorum Operum Simplicis Hominis*), wrote fifty-eight sermons, composed a sacred musical drama titled *Ordo Virtutum* and at least sixty-nine other musical compositions, recorded her unique language in *Lingua Ignota* and *Litterae Ignotae*, wrote multiple letters, and authored two texts on medicine and science: *Physica* and *Causae et Curae.*[48]

Hildegarde wrote *Physica,* also known as *Liber Simplicis Medicinae* and *Subtilitates Diversarum Naturarum Creaturarum,* between 1151 and 1159.[49] The book covers natural remedies in nine categories: plants, elements, trees, stones, fish, birds, animals, reptiles and metals.[50] *Causae et Curae,* also known as *Liber Compositae Medicinae,* is a five-volume treatise on medieval medical practice.

These books provide evidence of her medical acumen, but Hildegarde cultivated the image of an uneducated holy woman whose learning and visions were of divine origin.[51] This is not true. First, although Hildegard would not have attended a formal medical school, monasteries were centers of medical education

and care.[52] She would have had access to texts and practical learning and used that knowledge to care for the sisters as well as the laypeople who were connected with the monastery.[53] Second, her writings show that she was familiar with German folk medicine as well as contemporary twelfth-century science and medicine.[54]

When Hildegard was canonized, the pope described her as someone who "cared for the spiritual and material well-being of her sisters."[55] Attention to spiritual and material well-being of patients goes beyond clinical care, as shown in Julia Michie Bruckner's "If You Like Piña Coladas." Bruckner provides a young girl frequently admitted to the hospital with complications from sickle cell disease with the opportunity to dream of an escape from her difficult life. Likewise, in "A Good Death," Teja Dyamenahalli can't save the life of a very young boy, but she can support his family and bear witness as they come to grips with their loss.

In spite of differences in their medical education and knowledge, both Hilde-garde and Trota were known as physicians in their own times and by their own communities. Note that *physician* had a more fluid definition in the medieval era than now. A physician treated diseases, administered medications, and was at the top of the medical hierarchy; surgeons, apothecaries, and barber-surgeons were lesser practitioners and did not undergo the same training. University learning, in most places available only to men by the thirteenth century, conferred cachet and was required for licensure, which was usually granted by a Church authority. However, women who wanted to practice medicine had alternate pathways.

In fourteenth-century Venice, women were not licensed but were permitted to practice "per grazia."[56] It was not uncommon for the daughters and wives of physicians to practice medicine: in many places, after an apprenticeship, they were examined and licensed. However, there were limits to what they could do. For example, women in Valencia, Bologna and Naples were only permitted to treat women and children.[57] Nevertheless, the professionalization of medicine signaled a sort of death knell for women, who were not to gain access to university-based medical education—except in Italy—or receive full recognition as physicians again until the nineteenth century.[58]

Today, women are not denied access to universities, but they still face barriers. In "Why Do You Want to Be a Doctor?"—her contribution to this collection—Maria Maldonado explores both self-imposed and external challenges. Derailed by the death of her father when she was nine, she was thirty when she finally finished college and was admitted to medical school. She wanted to be a doctor because "I wanted people to know that people who looked like me could."

Throughout the medieval and Renaissance eras, increasingly divisive language was used to devalue and discredit women healers. At least part of this was related to territoriality: healers and physicians were competing for a small pool of patients. In a 1325 Parisian petition, nonphysician healers were referred to as "persons ignorant

of the medical art, old women particularly, and even more to be detested, soothsay-ers." Prevailing views gave credence to the attacks on women healers. Prominent writers postulated that women were physically, mentally, and morally weaker than men, and the Church held that women were inferior and thus needed to be kept under male authority. Jewish women were seen as even lower than Christian women: "If Christian women were evil, Jewish women were barely human."[59]

Such stereotypes are clearly untrue, yet it was hundreds of years before their ef-fects lessened, and they still have repercussions. In "How I Found My Voice," Karen Yeter writes of how her competence was questioned due to her size and the pitch of her voice. Of course, intellectual ability has no relation to physical features. Many sorts of bias persist, but bias is no longer codified, and the medical community recognizes the benefit of diversity among physicians. Surveys of medical students have shown that diversity and inclusiveness helped them achieve educational and clinical goals, particularly in preparing them to meet the needs of diverse popula-tions.[60] In this collection, Audrey Nath's "Learning to Listen" demonstrates how cultural competence can improve a patient encounter. From a slightly different angle, shared religious and cultural backgrounds facilitate relationships in Kimberly Greene-Liebowitz's "Sometimes, I Help People Die" and Photine Liakos's "Good Friday." In the first, a shared Jewish heritage enables a physician to help a family begin dealing with the end of life; and in the second, a Greek Orthodox background and a hefty dose of compassion connect doctor and patient.

This broader perspective on diversity was not something that would have been understood by our medieval counterparts, for whom bias—particularly misogyny—was a persistent issue, and not one they could overcome. It is therefore no great surprise that although a small number of unlicensed female physicians continued to practice after the fourteenth century, they were fewer in number than prior to professionalization. They played an important role in providing care to the poor, as physicians' fees were prohibitive for many. Gendered policies were ultimately successful in shifting women into other medical fields, particularly midwifery, and providing charitable home-based medical care.[61] In the conclu-sion to *Making Women's Medicine Masculine*, Monica Green writes that "the late medieval/Renaissance erasure of female medical authority seems to have been quite effective: early modern women knew nothing of any female traditions of medical practice beyond midwifery and the domestic medicine they themselves practised in their homes."[62]

A limited number of medical writings by European women survive from the late medieval era, Renaissance and Enlightenment. These women were not university-trained physicians, but they made important contributions to the sci-entific literature. Oliva Sabuco de Nantes Barrera (b. 1562) introduced the concept of psychosomatic illness, the brain as a "control center," and airborne diseases in

Nueva Filosofia. In England, Hannah Wolley (b. 1622) authored seven books; her *Gentlewoman's Companion* included medical guidance for a female audience. Mary Trye, also a seventeenth-century Englishwoman, was medical practitioner whose treatise promoted "chemical cures" and condemned Galen's theories, taught in the universities.[63] In Germany, Justine Siegemund, an expert on difficult births, published the first female-authored obstetrical text in German in 1690.[64] However, these women were the exception.

Regardless of the state of licensure, women—particularly wealthy women—continued to practice "domestic" or "household" medicine. It was seen as part of their charitable and "motherly" duties, and they usually provided care free of charge to friends and neighbors.[65] A number of English and French recipe ("receipt") books written by these women survive, most dating to the first half of the seventeenth century. These manuals were eventually supplanted by books authored by university-educated male physicians—that is, professionals.[66] Given the quality of medical care supplied by university-trained physicians at the time, these untrained women might have had equal or better success ameliorating symptoms.

Female physicians sometimes play an analogous role today, as several examples in this collection illustrate. In "For Better," Heather Gooden visits an elderly couple at home, more to offer support and check in than to provide medical care, and in "Choosing to Die," Suzy Feigofsky tells a story of home-based end-of-life care. One wonders if there is some expectation that women still play the role of domestic healer, as seen in "Attempted Murder," in which the physician caring for Jennifer Caputo-Seidler's diabetic boyfriend automatically assumes she is responsible for the insulin error that brought him to the emergency room. Did he assume she was the caregiver because she was a medical student or because she was a woman? And are such presumptions about "domestic care" ever valid?

There is a sinister note to the period from approximately 1350 to 1650, when the "witch craze" peaked, resulting in the executions of 250,000–500,000 people.[67] At least 85 percent of the persecution's victims were women, including a number of midwives and irregular healers. Midwives "surpassed all others in wickedness" and were responsible for contraception, abortion, infanticide, and sacrifice of children to the devil.[68] Women who used herbs to heal or who healed "without having studied" were "witches and should die."[69] Licensed physicians were called on to aid the inquisitors. Torture was advised, as was the execution by burning.[70] Although nearly half the cases heard by the Parlement de Paris pertained to healers, Monica Green postulates that the "midwives-as-witches" theory isn't entirely accurate, as there isn't adequate evidence that midwives were regularly accused of witchcraft.[71] Nevertheless, the *Malleus Maleficarum* (1486), the premier witch-hunter's guidebook, singles out midwives and repeatedly refers to healing, health, and cures.[72]

At least some of those accused of witchcraft were punished for the uncertainty of medical treatments and outcomes but these mysteries are intrinsic feature of medicine. They might have been more common in the past but they persist today. Take the mysterious ingestion in Rachel Kowalsky's "Halloween Blood." The puzzle is never fully solved, but the outcome is nevertheless satisfactory. It is interesting to speculate how the situation might have played out in the Late Middle Ages in Europe. Most likely, the child would have seen a domestic or unlicensed healer and the Halloween blood easily could have triggered accusations of witchcraft.

By the end of the eighteenth century, the respected independent female healer was a thing of the past. Midwives were either subservient to male gynecologists or considered little better than hacks. It was nearly a hundred years before a woman would try to become a physician again. She remained hidden from the public eye until 1865, when James Barry, an 1812 graduate of the medical school at University of Edinburgh, died. A startling discovery was made when his body was laid out: He was "a perfect female."[73] Handwriting analysis and surviving letters have shown that Barry was likely born Margaret Ann Bulkley in 1789. The real James Barry was Margaret's uncle, who died in 1806. In November 1809, she assumed his identity and after completing her medical training, had a forty-year career in the British army.[74]

Barry retired in 1859, the same year American-trained Elizabeth Blackwell (1821–1910) became the first female physician to have her name added to the newly created British medical register. During the same period, women sometimes adopted male personas for personal or professional reasons and even Blackwell was advised to adopt "masculine attire" to complete her training.[75]

James Barry was in the military nearly a century before female physicians were welcomed into the British Medical Corps (1942) and into the US Army and Navy Medical Corps (1943).[76] It is likely that Barry, who handled casualties of the Crimean War, saw injuries similar to the ones described by Torie Comeau Plowden in her essay in this collection titled "Selfless Service"—young men who had lost limbs or been disfigured or left with other, less visible scars. Witnessing such battle wounds changes physicians; Plowden says, "I still think of the young men I saw that day . . . a team helped them thwart death and rebuild meaningful and productive lives . . . that was one of the most profound moments of my medical training."[77]

Elizabeth Blackwell was not only the first woman on the British medical register, but the first in the modern era to earn a degree from an allopathic medical school. She applied to multiple schools before gaining admission to Geneva Medical College in 1847—where she was admitted as a "joke." Harassed by fellow students and denied entrance to certain lectures, she still graduated at the top of her class in 1849. However, Blackwell was more than just a physician: she was a prolific

author whose works ranged from tracts about child rearing, medical herbs, and sociology to her autobiography about opening the medical profession to women. She is symbolic of nineteenth-century feminism.[78]

With few options open to women, medical colleges for them began to open in the United States by the middle of the nineteenth century. Considered "irregular," they did not offer education on par with that available to male students. Among these were the New England Female Medical College in 1848, followed by the Female Medical College of Pennsylvania in 1850. Most medical schools simply refused to admit women; even Geneva Medical College changed its rules to exclude women after Elizabeth Blackwell graduated. For those women not willing to settle for less, the road was hard. For example, Emily Blackwell, Elizabeth's sister, was asked to leave Rush Medical College after a year, and had to switch to Western Reserve College in Cleveland to finish her education.[79] Even when women obtained the coveted medical degree, American hospitals and dispensaries were reluctant to hire them. It became clear to Emily and Elizabeth that the best way to provide opportunities for women was to found their own institutions, so in 1857, the Blackwell sisters plus Marie Zakrzewska, Elizabeth's protégée, founded the New York Infirmary for Women and Children.[80] When the Blackwell sisters founded the Women's Medical College of the New York Infirmary in 1868, there was, at last, a traditional medical school where women in America could receive a medical education equivalent to that available to any man. The school stayed open until 1899, when Cornell began to admit women.[81]

Meanwhile, in England, Elizabeth Garrett (1836–1917) was also trying to become a physician. No medical school would admit her, so she cobbled together an education via individual courses, training in Paris, and supportive mentors. In 1865, to take the medical licensing exam, Garrett took advantage of a loophole at the Society of Apothecaries, which was later closed, denying entry to other women.[82]

Just a few years later, Sophia Jex-Blake (1840–1912) spearheaded the enrollment of the first seven women in the medical school at University of Edinburgh (1869). Like Blackwell, these seven were subject to harassment and denied access to classes, in a situation that culminated with the 1870 Surgeon's Hall riot. The University of Edinburgh school of medicine declined to award the women diplomas, forcing them to finish their training elsewhere. It would be 1877 before Jex-Blake finally earned her medical degree from the University of Berne. In the meantime, like the Blackwells, Jex-Blake realized that the path to equal education was in the creation of a quality medical education program for women. In 1874, she, Garrett, and the Blackwell sisters founded the London School of Medicine for Women.[83] In 1875, Great Britain passed the Enabling Act, which allowed British universities to grant medical licenses to women—although it said nothing about admitting them in the first place.[84]

Since the mid-nineteenth century, plenty of things have changed in medical education. Women today enjoy unprecedented access to high-quality education and training. They only leave their homes to train if they wish, but they may do so in a variety of places. For example, Katie Wiskar attended medical school in Vancouver, but her contribution to this book, "Up North," tells of her experiences with rural medicine during a rotation in a small town in northern Canada.

Jex-Blake and Blackwell were advocates for women in medicine as well as for their patients. Female physicians today continue to follow this model. Voicing one's opinion can engender problems, but it can also benefit patients, as it does in the essay "Put a Bow on It." Photine Liakos's intervention enabled a young girl to have something special after a foot amputation: a striped cast. Little things can make a big difference.

Given all these advances, it is disappointing that female medical students and residents still experience harassment from male peers. A 2019 study reported that 65 percent of US female surgical residents had experienced gender discrimination and 19.9 percent sexual harassment.[85] Less common is physical mistreatment, as reported in Kimberly Greene-Liebowitz's essay "First to Report," which tells of an older male intern who used his size, gender, and professional rank to abuse a medical student. Clearly, this is never acceptable.

Research published in 2022 shows that patients and visitors are most likely to mistreat physicians, and they are much more likely to mistreat female than male physicians. This includes verbal mistreatment, physical intimidation, sexist remarks and unwanted sexual advances.[86] This is never OK, and the ways we deal with these inappropriate encounters is important. In her essay "The Twist of a Patient Apology," Dana Corriel reflects not just on a patient's unkind words but also on her reaction to them. Ultimately, the patient apologizes, presenting an opportunity to rebuild a relationship. Since mistreatment is associated with increased stress and harassment with burnout, capitalizing on opportunities to salvage bad situations is beneficial.[87]

In spite of these ongoing issues, women have made incredible gains in the field of medicine. It has not been a steady path, but it is worth it to point out some of the milestones along the way. In 1864, the first Black female physician, Rebecca Lee Crumpler, graduated from the New England Female Medical School; in 1867, the second, Rebecca J. Cole, graduated from the Women's Medical College in Pennsylvania (WMCP).[88] In 1866, Ann Preston became the first female medical school dean in the United States.[89] In 1875, the first woman was licensed to practice medicine in Canada, Jennie Kidd Trout. In 1889, the first Native American female physician, Susan LaFlesche Picotte, graduated from WMCP; ten years later, the second, Lillie Rosa Minoka-Hill, graduated from the same school.[90] The Sorbonne began admitting women in 1866, Irish universities welcomed women beginning

in the 1880s, and Johns Hopkins began to accept women in 1893.[91] Finally, by the end of the nineteenth century, Mary Putnam Jacobi had disproven the prevailing theory that women were weak and emotionally unstable during menstruation (and thus unsuited to the field of medicine) with her 1876 essay, "The Question of Rest for Women during Menstruation."[92]

These physicians were strong advocates who used their voices to better the opportunities for other women seeking careers in medicine, for women and children in need; and for the care of patients in general. On both sides of the Atlantic, they started schools and hospitals and began to make inroads into the medical profession. In this collection, advocacy, especially for communities with very limited resources, is best exemplified by Heather Hammerstedt's "Precious." Hammerstedt's work in Uganda led to an improvement in the quality of emergency care such that once-fatal malaria cases are less likely to kill.

In 1900, there were seven thousand female physicians in the United States (5.5 percent of the nation's total).[93] Then, in 1910, the Flexner report was released. Intended to raise the standards in American medical schools, the report condemned schools that did not conform to the Johns Hopkins model of education (four years of medical school after four years of undergraduate study, lab work, and expanded clinical training). As a result, six of eight Black medical schools and the majority of women's ("irregular") medical schools closed.[94] Thus, in 1949 women still only comprised 5.5 percent of medical students, and in 1972 only 7 percent of practicing physicians in the United States were women.[95] However, in 1972, Title IX—which prohibits sex discrimination at educational institutions receiving federal money—passed. By 1981, 24.9 percent of US medical school graduates were women.[96] Numbers continued to rise, and in 2019, for the first time, the number of female medical students in the United States surpassed the number of male medical students.[97]

In the present day, female physicians and physician-authors have the luxury of exploring subjects and themes our predecessors could not have considered, such as leadership equity, physician-patient relationships, work-life balance, empathy and emotion, bias and harassment, and job satisfaction. Given what we know, it seems unlikely that they would have considered the last three issues at all—there was simply less of a focus on the individual in the past than there is today. However, today these topics receive equal billing. *Empathy,* in particular, is interesting because the term only came into use in the last century; prior to that, the closest analogous word was *sympathy.*[98] Late-nineteenth-century physicians derided sympathy for not being scientific and masculine.[99]

Today, we understand that logic and science are not divorced from empathy, which is valued in both men and women. In "Game On" in this collection, Annette Ansong demonstrates both compassion and clinical competence while

identifying and managing an infant's life-threatening cardiac malformation. In Dawn Harris Sherling's "The Secret Keeper," a different kind of skill is needed. A patient's grief—and her stunning confession—can only be managed with professionalism, privacy, and empathy. Shikha Jain shares her experience balancing clinical care, self-care, and empathy while caring for cancer patients, especially those with terminal diagnoses. Her essay "What Do You Do, Mommy?" relates how she finds the joy in her patients' final achievements—a reconciliation with a sibling, a bucket list, a marathon—and mourns in their losses as well. This delicate balance of caring for the body and the soul differentiates an adequate physician from an excellent one.

The physician-patient interaction is directly related to the dual issues of clinical competence and compassion. No relationship will be good in the absence of knowledge and the ability to apply it, but "sentimentality" is critical to making good connections. In *What Doctors Feel* (2013), Danielle Ofri says, "It is critical to be aware of the potent influence of emotion on our 'rational' decision making. Remaining cognizant of our emotions . . . will offer the patient the most solid and trusting setting."[100] Emotion can enrich a physician-patient relationship, leading perhaps to more thoughtful care and greater engagement. This is demonstrated in "Grandma's Dead," in which Rebecca Andrews explores the deep rapport developed during a multiyear relationship with a patient and her family. Emotion can impede success, as in "My Doctor-Patient Conflict." In this example, Sharon Ben-Or is the patient, and her physician colleague's inability to deal with his own frustration and discomfort hampers her ability to move on. "I didn't understand the emotional toll my situation had taken on him and how hard it had been for him. I realized that he protected himself with a cloak of optimism," she says when they finally have a frank discussion, realizing that she is not the only one who was dissatisfied.

Humor evokes a range of emotion. In *What Doctors Feel,* Danielle Ofri remarks that gallows humor and slang are derogatory at times, and that part of the learning process for students is to find out what sorts of humor are acceptable and what are not.[101] When done well, humor can be beneficial: studies in the UK and Canada have found that cancer patients appreciate humor.[102] In contrast, an Israeli study found that humor in primary care settings was variably received.[103] Understanding that humor can be risky, the essays by Jessi Gold and Jill Grimes—"There's No Laughing in Medicine" and "TMB Disease"—demonstrate perfectly that there are, in fact, good times to laugh with patients. In the first, the ever-awkward rectal exam is the source of entertainment and in the second, it is the patient who introduces humor, poking fun at his increasing age.

These topics and others can only be explored because of the vast changes that have occurred over the past two millennia in scientific knowledge, social views, culture, and religion as well as in the role of women in medicine, and female

physician authors as well. Female physicians are no longer rare, limited to caring for women and children, excluded from education and training, or demonized. It is difficult to imagine a situation in which a female physician's writings would be ascribed to a man or her name would simply be erased. It is possible, of course. The past 170 years are, after all, less than 10 percent of the time covered in this introduction. Just a blip.

Still, I choose to believe we have made incredible advances. Yes, women in medicine are still facing issues: among these are underrepresentation in leadership roles, burnout, and more prominent barriers for women of color and underrepresented minorities. Subtle misogyny in the rules around vacation, breastfeeding, tenure, and family leave makes it difficult for women to remain in demanding medical fields, though not impossible. The COVID-19 pandemic has introduced challenges we could not have anticipated, in the form of greater difficulty with work-life balance, higher rates of burnout, decreased job satisfaction, and significant challenges due to decreasing trust in public health institutions. Nevertheless, we hope that you will see these essays in the context of all the people who came before us and will come to understand what we know: medicine is a difficult path, and its reality may not match up with the vision. Yes, there are barriers. However, it is an incredibly rewarding career. It is an honor and privilege to participate in our patients' lives. We see the beautiful and the terrible. We celebrate and mourn with our patients and shepherd them through the gamut of emotions. Medicine is beautiful and sad and funny and courageous and enriching. Read on and join us on this journey.

NOTES

1. Rajvinder Samra, "Brief History of Burnout," *British Medical Journal* 363 (2018): 52–68.

2. Jolly Shruti et al., "Gender Differences in Time Spent on Parenting and Domestic Responsibilities by High-Achieving Young Physician-Researchers," *Annals of Internal Medicine* 160 (2014): 344–53; Eveline Hitti et al , "Domestic Tethers. Gender Differences in Career Paths and Domestic Responsibilities of Top-Research Medical School Graduates," *PLOS One* 17, no. 4 (Apr. 2022): e0267288, doi: 10.1371/journal.pone.0267288; Kim Parker et al., "Family Support in Graying Societies: How Americans, Germans and Italians Are Coping with An Aging Population." Pew Research Center, May 21, 2015, https://www.pewresearch.org/social-trends/2015/05/21/family-support-in-graying-societies/; Eduardo Porter, "Why Aren't More Women Working? They're Caring for Their Parents," *New York Times*, Aug. 19, 2019.

3. Sachiyo Nishida et al. "Dilemma of Physician-Mothers Faced with an Increased Home Burden and Clinical Duties in the Hospital during the COVID-19 Pandemic," *PLOS One* 16, no. 6 (June 2021): e0253646, doi: 10.1371/journal.pone.0253646; Adebisi Alli et al., "Advancing Women to Leadership Positions through Individual Actions and Institutional Reform," *Pediatrics 148, supplement 2, (Sept. 2021)*: e2021051440D, doi: 10.1542/peds.2021-051440D

4. Adebisi Alli et al., "Advancing Women to Leadership Positions"; Laura Jefferson, Karen Bloor, and Alan Maynard, "Women in Medicine: Historical Perspectives and Recent Trends," *British Medical Bulletin* 114 (2015): 5–15.

5. Natalie Clark Stentz et al., "Fertility and Childbearing among American Female Physicians," *Journal of Women's Health* 25, no. 10 (Oct. 2016): 1059–65.

6. Ellen Mozurkewich et al., "Working Conditions and Adverse Pregnancy Outcome: A Meta-Analysis." *Obstetrics and Gynecology* 95, no. 4 (Apr. 2000): 623–35; Linda Stocker et al., "Influence of Shift Work on Early Reproductive Outcomes: A Systematic Review and Meta-Analysis," *Obstetrics and Gynecology* 124, no. 1 (July 2014): 99–110.

7. Kim Parker et al., "Family Support in Graying Societies"; Kei Nomaguchi and Melissa A. Milkie, "Parenthood and Well-Being: A Decade in Review," *Journal of Marriage and Family* 82, no. 1 (2020):198–223.

8. Suzanne Koven, *Letter to a Young Female Physician: Thoughts on Life and Work* (New York: W. W. Norton, 2021).

9. Judy Melinek and T. J. Mitchell, *Working Stiff: Two Years, 262 Bodies, and the Making of a Medical Examiner* (New York: Scribner, 2014).

10. Ashley C. Wietsma, "Barriers to Success for Female Physicians in Academic Medicine," *Journal of Community Hospital Internal Medical Perspectives* 4, no. 3 (July 2014): doi: 10.3402/jchimp.v4.24665; Kimber P. Richter et al., "Women Physicians and Promotion in Academic Medicine," *New England Journal of Medicine* 383, no. 22 (Nov. 2020): 2148–57; Christopher M. Whaley, et al., "Female Physicians Earn an Estimated $2 Million Less Than Male Physicians Over a Simulated 40-Year Career," *Health Affairs* 40, no. 12 (Dec. 2021): 1856–64.

11. Katherine M. Wright et al., "COVID-19 and Gender Differences in Family Medicine Scholarship," *Annals of Family Medicine* 20, no. 1 (Jan. 2022): 32–34.

12. Michele Harper, *The Beauty in Breaking: A Memoir* (New York: Riverhead, 2020), 109.

13. Rachel Pearson, *No Apparent Distress: A Doctor's Coming of Age on the Front Lines of American Medicine* (New York: W. W. Norton, 2017).

14. Sheryl Recinos, *Hindsight: Coming of Age on the Streets of Hollywood* (N.p.: Sheryl Recinos, 2018).

15. Sheryl Recinos, "The Impact Scholarship," *Sheryl Recinos MD* (blog), Sept. 14, 2014, https://sherylrecinosmd.com/f/the-impact-scholarship.

16. Rana Awdish, *In Shock: My Journey from Death to Recovery and the Redemptive Power of Hope* (New York: St. Martin's, 2017).

17. Uzma Yunus, *Left Boob Gone Rogue: My Life with Breast Cancer* (N.p.: n.d.: 2018); Uzma Yunus, *Left Boob Gone Rogue* (blog), accessed Aug. 11, 2022, https://uzmamd.com.

18. William L Minkowski, "Women Healers of the Middle Ages: Selected Aspects of Their History," *American Journal of Public Health* 82, no. 2 (Feb. 1992): 288–95; Leigh Whaley, *Women and the Practice of Medical Care in Early Modern Europe, 1400–1800* (London: Palgrave Macmillan, 2011); John F. Benton, "*Trotula, Women's Problems, and the Professionalization of Medicine in the Middle Ages,*" *Bulletin of the History of Medicine* 59 (1985): 30–53; Monica H. Green, "Who/What Is 'Trotula?'" *Academia*, Jan. 6, 2020, https://www.academia.edu/41537366/WHO_WHAT_IS_TROTULA_2020; James J. Walsh, "The Earliest Modern Law for the Regulation of Medicine," *Bulletin of the New York Academy of Medicine* 11, no. 8 (1935): 521–27.

19. Gemma Storti, "Metrodora's Work on the Diseases of Women and Their Cures," *Estudios bizantinos* 6 (2018): 89–110; Jakub Kwiecinski, "Merit Ptah, 'the First Woman Physician': Crafting of a Feminist History with an Ancient Egyptian Setting." *Journal of the History of Medicine and Allied Sciences* 75, no. 1 (Jan. 2020): 83–106; Cassie Freund, "Meet Merit-Ptah, the ancient Egyptian Doctor Who Didn't Exist: Though Created by Accident, Her Story Fit Neatly with Burgeoning 20th Century Feminism," *Massive Science*, Aug. 4, 2020, https://massivesci.com/articles/merit-ptah-egypt-physician-doctor/.

20. Mary Fissell, "Introduction: Women, Health, and Healing in Early Modern Europe," *Bulletin of the History of Medicine* 82, no. 1 (2008): 1–17; Monica H. Green, "Documenting Medieval Women's Medical Practice." In *Practical Medicine from Salerno to the Black Death*, ed. Luis Garcia-Ballester et al. (Cambridge: Cambridge University Press, 1994), 322–52.

21. Holt Parker, "Galen and the Girls: Sources for Women Medical Writers Revisited," *Classical Quarterly* 62, no. 1 (2012): 359–86.

22. Janis A. Pastena, "Women in Surgery: An Ancient Tradition," *Archives of Surgery* 128, no. 6 (June 1993): 622–26.The Jewish texts referred to include the Torah (Old Testament), Talmud (primary Rabbinic text; source of Jewish law) and Niddah laws (Jewish family purity laws). This is, of course, not proof that women held these positions.

23. Parker, "Galen and the Girls"; Rebecca Flemming, "Women, Writing, and Medicine in the Classical World," *Classical Quarterly* 57, no. 1 (2007): 257–79.

24. "Peseshet (in G 8942)," *Digital Giza: The Giza Project at Harvard University,* 2022, http:// giza.fas.harvard.edu/ancientpeople/346/full/.

25. Hurd-Mead was an 1888 graduate of the Women's Medical College of Pennsylvania, an obstetrician-gynecologist, the onetime president of the American Medical Women's Association, and author of a 1938 history of women in medicine: *A History of Women in Medicine: From the Earliest of Times to the Beginning of the Nineteenth Century* (Haddam, CT: Haddam Press, 1938); Benton, *"Trotula, Women's Problems"*; Kate Campbell Hurd-Mead, "Changing the Face of Medicine," National Library of Medicine website, last updated June 3, 2015, https://cfmedicine. nlm.nih.gov/physicians/biography_159.html.

26. Kwiecinski, "Merit Ptah, the First Woman Physician."

27. Wietsma, "Barriers to Success for Female Physicians"

28. *Metra* is the Greek word for uterus.

29. Storti, "Metrodora's Work on the Diseases of Women"; Gregory Tsoucalas and Markos N. Sgantzos, "Aspasia and Cleopatra Metrodora: Two Majestic Female Physician-Surgeons in the Early Byzantine Era," *Journal of Universal Surgery* 4, no. 3 (Jan. 2016): doi: 10.21767/2254-6758.100055.

30. Flemming, "Women, Writing and Medicine"; Tsoucalas and Sgantzos, "Aspasia and Cleopatra Metrodora"; John Scarborough, "Theodora, Aetius of Amida, and Procopius: Some Possible Connections," *Greek, Roman and Byzantine Studies* 53, no. 4 (2013): 742–62; Gregory Tsoucalas, Antonis A. Kousoulis, and George Androutsos, "Innovative Surgical Techniques of Aspasia, the Early Greek Gynecologist," *Surgical Innovation* 19, no. 3 (2012): 337–38.

31. Flemming, "Women, Writing and Medicine."

32. Ioannis D. Gkegkes et al. "Women Physicians in Byzantium," *World Journal of Surgery* 41 (2017): 892–95.

33. Whaley, *Women and the Practice of Medical Care.*

34. Lola Ferre, "The Multi-Cultural Origins of the Salernitan Medical School: A Historiographical Debate," *Journal of Mediterranean Studies* 27 (2018): 1–18; Samuele Rocca, "In The Shadow of The Patriarch: The Organization of The Jewish Communities In Roman Italy In Late Antiquity," *La Rassegna Mensile Di Israel* 83, nos. 2–3 (2017): 93–118; Edward Theodore Withington, "Medical History from the Earliest Times" *Hospital* 13, no. 325 (Dec. 1892): 179–80; Albert S. Lyons and R. Joseph Petrucelli, *Medicine: An Illustrated History* (New York: Harry N. Abrams, 1978), 319–21; Monica H. Green, "Who/What Is 'Trotula'?"

35. In the twelfth and thirteenth centuries, these women were called *Mulieres Salernitane.*

36. Benton, *"Trotula, Women's Problems"*; Green, "Who/What Is 'Trotula?'"; Monica H. Green, "In Search of an 'Authentic' Women's Medicine: The Strange Fates of Trota of Salerno and Hildegard of Bingen," *Dynamis* 19 (1999): 25–54.

37. Louise Bourgeois (1563–1636), royal midwife to Marie de Medici, second wife of King Henry IV of France, first published *Observations diverses sur la sterilité, perte de fruict, fœcondité, accouchements, et maladies des femmes et enfants nouveaux naiz* (Diverse Observations on Sterility,

Miscarriage, Fertility, Childbirth, and Diseases of Women and Newborn Children) in 1609, followed by additional volumes in 1617 and 1626. Her work, which comprises three volumes providing case histories, obstetric guidance, and recipes for treatments, ultimately supplanted the *Trotula*. Alison Lingo and Stephanie O'Hara published an English translation as *Diverse Observations on Sterility, Miscarriage, Fertility, Childbirth, and Diseases of Women and Newborn Children. Discussed in Detail and Successfully Practiced by L. Bourgeois, called Boursier, Midwife to the Queen. A Work Useful and Necessary for All* (Toronto, ON: Iter Press, 2017); Alison Lingo and Stephanie O'Hara, "Louise Bourgeois (1563–1636): Transforming the Landscape of Medicine and Midwifery," *Women's Studies* 49, no. 3 (2020): 220–26; Whaley *Women and the Practice of Medical Care.*

38. Copho authored his own *Practica*, but it has not survived. Benton, "*Trotula, Women's Problems*." *Anatomia Porci* (Pig Anatomy), written in the twelfth century (ca. 1100–1150) is attributed to him; pig anatomy was considered analogous to human anatomy, and pigs were dissected in lieu of human cadavers. This tradition dates back at least to Galen in the second century. See Le Roy Crummer, "Copho's 'Anatomia Porci,'" *Annals of Medical History* 9, no. 2 (June 1927): 180–82. Dissection of human cadavers appears to have begun in Bologna by the end of the thirteenth century. Raffi Gurunluoglu et al., "The History and Illustration of Anatomy in the Middle Ages," *Journal of Medical Biography* 21 (2013): 219–29; Green, "In Search of an 'Authentic' Women's Medicine."

39. Green, "Who/What Is 'Trotula?'"

40. Benton, "*Trotula, Women's Problems*"; Green, "In Search of an 'Authentic' Women's Medicine." Hans Kaspar Wolf, the 1566 Trotula editor, changed the author from "Trotula" to "Eros" on the advice of Hadrianus Junius, a Dutch physician, who claimed *Trotula* was a corruption of *Eroiulia*, which was a corruption of *Eros*.

41. Green, "In Search of an 'Authentic' Women's Medicine." There is no evidence Trota was a member of a prominent family or married to a physician, and she could not have taught at *La Schola Salernitana* because it did not exist in the early twelfth century.

42. For further information, see Monica Green's writings about Trota: Green, "In Search of an 'Authentic' Women's Medicine"; Monica H. Green, "Reconstructing the Oeuvre of Trota of Salerno," in: *La Scuola medica Salernitana: Gli autori e i testi,* ed. Danielle Jacquard and Agostino Paravicini Bagliani (Florence, Italy: Sismel/Edizioni del Galluzzo, 2007), 183–233.

43. Green, M. "Reconstructing the Oeuvre of Trota of Salerno," 187.

44. Lingo and O'Hara, "Louise Bourgeois (1563–1636)."

45. Trota and Hildegard are usually considered the only female physician authors of the medieval era, but this is not accurate. See Monica H. Green " Bodies, Gender, Health, Disease: Recent Work on Medieval Women's Medicine," *Studies in Medieval and Renaissance History: Sexuality and Culture in Medieval and Renaissance Europe,* 3rd ser., vol. 2 (2005): 1–4. De Renzi cited four other women physicians in his history of Salerno who wrote medical treatises: Abella of Salerno, Rebecca Guarna, Mercuriade, and Costanza Calenda. Further scholarship is needed on these women, whose works are not extant. Other evidence of medical writing is provided by Matthaeus Platearius (d. 1161), who cited at least fourteen recipes from women in his medical text, *Circa Instans.* See Whaley, *Women and the Practice of Medical Care;* and Green, "Documenting Medieval Women's Medical Practice."

46. There is some confusion as to the exact date and type of entry she made into religious life. See Emily Sutherland, "Hildegard of Bingen: Entry into Disibodenberg," *Parergon* 27, no. 1 (Jan. 2010): 53–66.

47. Victoria Sweet, "Hildegard of Bingen and the Greening of Medieval Medicine." *Bulletin of the History of Medicine* 73, no. 3 (1999): 381–403; Pope Benedict XVI, "Apostolic Letter: Proclaiming Saint Hildegard of Bingen, Professed Nun of the Order of Saint Benedict, a Doctor of the Universal Church," The Holy See website, Oct. 7, 2012, https://www.vatican.va/content/benedict-xvi/en/apost_letters/documents/hf_ben-xvi_apl_20121007_ildegarda-bingen.html.

48. Green, "Bodies, Gender, Health, Disease"; Sweet, "Hildegard of Bingen and the Greening of Medieval Medicine"; Pope Benedict XVI, "Apostolic Letter"; Gertrude M. Engbring. "Saint Hildegard, Twelfth Century Physician," *Bulletin of the History of Medicine* 8, no. 6 (1940): 770–84.

49. In the medieval era, books titles were not always clear and set by the author; scribes sometimes merged documents to create a novel book, as seen with the *Trotula;* and finally, scribes sometimes renamed works. Engbring, "Saint Hildegard, Twelfth Century Physician"; Sweet, "Hildegard of Bingen and the Greening of Medieval Medicine."

50. Green, "In Search of an 'Authentic' Women's Medicine"; Engbring, "Saint Hildegard, Twelfth Century Physician"; Sweet, "Hildegard of Bingen and the Greening of Medieval Medicine."

51. Green, "In Search of an 'Authentic' Women's Medicine."

52. Prior to 1163, canonical law forbade the study and practice of law or medicine for "avaricious" reasons; and after the Council of Tours in 1163, monks and "canon regulars" were forbidden to leave their orders to study medicine or law. See Darrel W. Amundsen, "Medieval Canon Law on Medical and Surgical Practice by the Clergy," *Bulletin of the History of Medicine* 52, no. 1 (Spring 1978): 22–44.

53. Engbring, "Saint Hildegard, Twelfth Century Physician."

54. Green, "In Search of an 'Authentic' Women's Medicine"; Charles Singer, "The Visions of Hildegard of Bingen," 1928, republished in *Yale Journal of Biology and Medicine* 78, no. 1 (Jan. 2005): 57–82.

55. Pope Benedict XVI, "Apostolic Letter."

56. Green, "Documenting Medieval Women's Medical Practice."

57. Laws regulating the practice of medicine were passed in Valencia in 1329. See Whaley, *Women and the Practice of Medical Care.*

58. The medical system in Bologna was distinctly male, but there are women healers documented in other parts of Italy, especially Naples and Padua, through the eighteenth century. See Whaley, *Women and the Practice of Medical Care.*

59. Whaley, *Women and the Practice of Medical Care.*

60. Jasmeet Dhaliwal et al., "Student Perspectives on the Diversity Climate at a U. S. Medical School: The Need for a Broader Definition of Diversity," *BMC Research Notes* 6, no. 154 (Apr. 2013): doi: 10.1186/1756-0500-6-154; Somnath Saha et al., Student Body Racial and Ethnic Composition and Diversity-Related Outcomes in US Medical Schools *Journal of the American Medical Association* 300, no. 10 (2008): 1135–45.

61. As noted elsewhere, women were also surgeons, barber-surgeons, apothecaries, et cetera. They are responsible for the development of midwifery as a specialty; birth was historically considered the domain of women, and they retained control over it until the "man-midwife" (i.e., male OB/GYN) came into being in the seventeenth and eighteenth centuries. This was a major shift; before then, tradition and taboos had kept men out of the birthing room. At midwifery's peak, schools and licensure helped to maintain standards and ensure literacy of urban midwives. See Whaley, *Women and the Practice of Medical Care;* and Monica H. Green, *Making Women's Medicine Masculine: The Rise of Male Authority in Pre-Modern Gynaecology* (New York: Oxford University Press, 2008).

62. Green, *Making Women's Medicine Masculine,* 291.

63. According to Whaley, she was a "practitioner of physick" rather than a university-trained physician. Whaley, *Women and the Practice of Medical Care.*

64. Green, *Making Women's Medicine Masculine.*

65. Whaley, *Women and the Practice of Medical Care.*

66. Whaley, *Women and the Practice of Medical Care.*

67. This was a period of great upheaval: declining influence of the Church, shift from feudalism to urbanization and from a trade-based to a wage-based economy, and expansion of women's

roles outside the home. The Black Death (1348–57) killed 40–60 percent of the European population, further shifting social mores. Women sought work outside the home, a rise in the age of financial independence led to an increase in the age at first marriage, and prostitution and premarital sex increased, resulting in out-of-wedlock births and a rise in infanticide. Sanctioned by Pope John XXII in 1326, the Dominicans led the charge against witches. See Nachman Ben Yehuda, "The European Witch Craze of the 14th to 17th Centuries: A Sociologist's Perspective," *American Journal of Sociology* 86, no. 1 (1980): 1–31.

68. Barbara Ehrenreich and Deirdre English, *Witches, Midwives, and Nurses: A History of Women Healers* (New York: Feminist Press, 1973); Ben Yehuda, "European Witch Craze"; Heinrich Kramer and James Sprenger, *Malleus Maleficarium*, trans. Rev. Montague Summers (Great Britain: John Rodker, 1928).

69. Whaley, *Women and the Practice of Medical Care*; Ehrenreich and English, *Witches, Midwives, and Nurses*; Kramer and Sprenger, *Malleus Maleficarium*.

70. Ben Yehuda, "European Witch Craze."

71. Green, "Bodies, Gender, Health, Disease."

72. Kramer and Sprenger, *Malleus Maleficarium*.

73. Brian Hurwitz and Ruth Richardson, "Inspector General James Barry MD: Putting the Woman in Her Place," *British Medical Journal* 298, no. 6669 (1989): 299–305.

74. Hercules Michael du Preez, "Dr. James Barry: The Early Years Revealed," *South African Medical Journal* 98, no. 1 (Jan. 2008): 52–58.

75. Historical records generally do not clarify whether the decision to live as the opposite gender was related to gender, sexuality, opportunity, or some combination of the three. Data suggests that Barry wished to have a career that would have been denied to a woman. However, in other cases, records suggest an individual preferred to live as a man or wanted to marry a woman, both of which are seen with Joseph Lobdell, born Lucy Ann Lobdell (1829). See "A Mountain Romance. Strange Life of Unhappy Women; A Singular Family History—The Female Huntress of Long Eddy—Strange Love of Two Women—An Accomplished Boston Girl a Voluntary Outcast—An Unfortunate Daughter." *New York Times*, Apr. 7, 1877; Hurwitz and Richardson, "Inspector General James Barry MD."

76. Mercedes Graf, "With High Hopes: Women Contract Surgeons in World War I," *Minerva: Quarterly Report on Women and the Military* 20, no. 2 (Summer 2002): 16–28.

77. Hurwitz and Richardson, "Inspector General James Barry MD."

78. Graf, "With High Hopes."

79. Western Reserve was one of the few schools willing to admit women. Its first female graduate was Nancy Talbot Clark. See Graf, "With High Hopes."

80. Zakrsewska went on to found the New England Hospital for Women and Children in 1862. See Dhaliwal et al., "Student Perspectives on the Diversity Climate at a U. S. Medical School."

81. Olivia Campbell, *Women in White Coats: How the First Women Doctors Changed the World of Medicine* (New York: Park Row Books, 2021).

82. The Society of Apothecaries could examine and license people in medicine. See Campbell, *Women in White Coats*.

83. Garrett was the first dean of this medical school. She also published extensively on clinical matters and women in medicine and was the first British woman appointed to a medical post at a non-female institution. Jex-Blake founded the Edinburgh Hospital and Dispensary for Women and Children in 1885, founded a short-lived medical school for women in Edinburgh, and was a vocal advocate for women's education, a prolific author. Campbell, *Women in White Coats*.

84. Campbell, *Women in White Coats*; Jefferson, Bloor, and Maynard, "Women in Medicine."

85. Yue-Yung Hu et al., "Discrimination, Abuse, Harassment, and Burnout in Surgical Residency Training," *New England Journal of Medicine* 381, no. 18 (Oct. 2019): 1741–52.

86. Liselotte N. Dyrbye et al., "Physicians' Experiences with Mistreatment and Discrimination by Patients, Families, and Visitors and Association with Burnout," *Journal of the American Medical Association Network Open* 5, no. 5 (2022): e2213080, doi:10.1001/jamanetworkopen.2022.13080; Susannah G. Rowe et al., "Mistreatment Experiences, Protective Workplace Systems, and Occupational Distress in Physicians," *Journal of American Medical Association Network Open* 5, no. 5 (2022): e2210768, doi:10.1001/jamanetworkopen.2022.10768.

87. Dyrbye et al., "Physicians' Experiences with Mistreatment and Discrimination"; Rowe, et al., "Mistreatment Experiences, Protective Workplace Systems, and Occupational Distress in Physicians."

88. "Honoring Black Americans' Contributions to Medicine," American Academy of Family Physicians website, Feb 5, 2021, https://www.aafp.org/news/inside-aafp/20210205bhmtimeline.html; Alissa Falcone "Remembering the Pioneering Legacy from One of Drexel's Legacy Medical Colleges." *Drexel News*, Mar. 27, 2017, https://drexel.edu/news/archive/2017/march/women-physicians.

89. Campbell, *Women in White Coats.*

90. Falcone, "Remembering the Pioneering Legacy."

91. Campbell, *Women in White Coats;* Laura Kelly, "Fascinating Scalpel—Wielders and Fair Dissectors": Women's Experience of Irish Medical Education, c. 1880s–1920s," *Medical History* 54 (2010): 495–516; Pastena, "Women in Surgery."

92. Kate Lister, "The Victorian Period: Menstrual Madness in the Nineteenth Century," in *"And Then the Monsters Come Out": Madness, Language, and Power,* ed. Fiona Ann Papps (Oxford: Interdisciplinary Press, 2014), 75–86; Chrissie Perella, "Mary Putnam Jacobi: Still Famous after 150 Years," *Legacy Center Blog,* Drexel University Legacy Center Archives and Special Collections, College of Medicine website, Nov 2013, https://drexel.edu/legacy-center/blog/overview/2013/november/mary-putnam-jacobi-still-famous-after-150-years/.

93. "History of Women in Medicine," Office for Diversity and Inclusion, Heersink School of Medicine, University of Alabama at Birmingham, accessed May 15, 2022. https://www.uab.edu/medicine/diversity/initiatives/women/history.

94. Ehrenreich and English, *Witches, Midwives, and Nurses.*

95. Ehrenreich and English, *Witches, Midwives, and Nurses.*

96. "History of Women in Medicine"; "Figure 12. Percentage of US Medical School Graduated By Sex, Academic Years 1980–1981 through 2018–2019," in "Diversity in Medicine: Facts and Figures 2019," Data and Reports, Association of American Medical Colleges, accessed May 15, 2022, https://www.aamc.org/data-reports/workforce/interactive-data/figure-12-percentage-us-medical-school-graduates-sex-academic-years-1980–1981-through-2018–2019.

97. "The Majority of U. S. Medical Students are Women, New Data Show," press releases, Association of American Medical Colleges, Dec. 9, 2019, https://www.aamc.org/news-insights/press-releases/majority-us-medical-students-are-women-new-data-show.

98. *Empathy* was first used in 1908, as a translation for the German word *Einfühlung,* which literally means "feeling-in." The definition of the word has since continuously evolved. See Susan Lanzoni, "A Short History of Empathy," *Atlantic,* Oct. 15, 2015, https://www.theatlantic.com/health/archive/2015/10/a-short-history-of-empathy/409912/.

99. Arleen Tuchman, "'Once in a Republic Can It Be Proved That Science Has No Sex': Marie Elizabeth Zakrzewska (1829–1902) and the Multiple Meanings of Science in the Nineteenth-Century United States," *Journal of Women's History* 11 (1999): 121–42.

100. Danielle Ofri, *What Doctors Feel: How Emotions Affect the Practice of Medicine* (Boston: Beacon, 2013), 74–78.

101. Ofri, *What Doctors Feel.*

102. May McCreaddie and Sheila Payne, "Humour in Health-Care Interactions: A Risk Worth Taking," *Health Expectations* 17, no. 3 (June 2014): 332–44; Rajiv Samant et al., "The Importance

of Humour in Oncology: A Survey of Patients Undergoing Radiotherapy," *Current Oncology* 27, no. 4 (Aug. 2020): e350–e353, doi: 10.3747/co.27.5875.

103. Martine Granek-Catarivas et al., "Use of Humour in Primary Care: Different Perceptions among Patients and Physicians." *Postgraduate Medical Journal* 81, no. 952 (Feb. 2005): 126–30.

Overcoming the Odds

Why Do You Want to Be a Doctor?

MARIA MALDONADO

When I was nine, I found my father dead in bed. My mother had told me to wake him, because he'd be late for work. I walked into their bedroom and saw him lying face down, his face burrowed in the pillow with a green, thick liquid marring the white pillowcase. He was a snorer, but that morning he was silent. I poked him but got no response.

"Dad. Dad! Mom, I can't wake him," I called to my mother.

"What are you talking about?" she asked from the kitchen.

She walked up the narrow dark hallway toward the bedroom, yelling, "Victor, wake up!"

She entered the room, made the short diagonal path to their queen-sized bed, and caught him in her arms, tugged at him over and over. Here's what I remember.

I remember that our neighbor and Mom's best friend, Winnie, who lived on the floor above ours, came to our apartment and scooped my sister, brother, and me up and brought us to her own home. She fed us Life cereal at her kitchen table—the irony of which was not lost on me, despite my age.

I remember the policemen who charged into our apartment. They carried him out on a stretcher. I didn't see him again until the wake, where there was an open casket and my mother sank to her knees as she entered the viewing room in the funeral home, screaming.

But most of all, I remember the grief that cloaked my mother through my adolescence and left me on my own to become a tree that grew wild, never pruned, so its branches grew uneven, misshapen, and arced in any way they could to capture light and water.

Why do you want to be a doctor? Every budding physician knows to be ready for this question during medical school interviews. And there are universal, pat answers: *I want to help people* or *I want to couple my love of science and humanity to make a significant contribution.* While these are true for most of us, we know that the most authentic reasons are as varied as the people who enter the field of medicine.

I'm now twenty years into my career as a primary care physician and medical educator, and I continue to reflect on why I went into medicine. I think my desire

to become a doctor was originally grounded in my father's death, because of an inane thought that becoming a physician would corral and control the unexpected. And it was also because I had something to prove.

But it could have gone another way.

To explain, I need to bring you back to City College's 1982 graduation ceremony. I was in a cap and gown and at a ceremony I had no rights to. I was twenty-one years old. I knew my family would wonder why my name wasn't listed in the program. I would tell them that it was just how things were at public institutions—there were so many students, you couldn't expect them to get everything right.

But I was lying. My name wasn't missing because of an administrative oversight. I hadn't met the qualifications for graduation and had no business marching in the procession.

It was hot. Sunny. The graduation took place on the college's south campus—today it no longer exists. I felt muted. In the years to come, I would tell no one of this deception.

It wasn't supposed to go this way. I knew I was smart. I should have been able to manage college. But being smart is not enough. You need to put in the work, you need support, and you need to be able to ask for help. At the age of sixteen when I entered college, I lacked direction and felt like I was on my own.

The family lore I grew up with was that my father was a genius. I was told he could perform calculus in his brain. He grew up in Harlem and went to Rice High School, a Catholic school. He was not only gifted but also gregarious and kind. He'd give his last dollar to anyone who needed it. He met my mother at the Wollman's skating rink in Central Park. Though it appeared they'd be an unlikely match—she was the daughter of two Orthodox Jewish parents who emigrated from Poland and Russia, and he was the son of a devout Catholic woman who had moved to New York from Puerto Rico at thirty years old—they were drawn to each other. He loved my mother's disdain for authority, and my mother was drawn to intelligent men. He was over six feet tall, lanky, and had a closely cropped afro and umber skin. When he met my mother, he placed his hand, which looked like it might have been made for playing the piano, on my mother's knee. She immediately told him to take his hand off her and who did he think he was! But in time she would let his hands roam. She became pregnant with me the first time they made love. They married. By the time they had three children, we were living in El Barrio in Manhattan on Ninety-Eighth Street and Lexington, in the housing projects that were cropping up all over the city in the 1960s.

My father's patience was legendary. He taught me math with a book of matches. He'd take the thin strips of cardboard with red tips and teach me simple addition and subtraction by hiding them behind his back and then he'd make them reappear. He made abstract concepts concrete.

In retrospect, I think on some level my father knew he would die at a young age.

In the middle of explaining how to decipher an article in the *New York Times* for a current events assignment, he suddenly kneeled in front of me, fixed my eyes with his.

He said, "No matter what happens, Maria, remember this. I will always love you. I will always be there for you."

"Yeah, Dad. Okay," I said. I laughed.

After he died, I'd remember what he said, especially when I felt lonely.

My father had graduated at the top of his high school class and won a full scholarship to Iona College. But he had to drop out of school and go work for the post office to support us. When my aunt's husband graduated from the engineering school at City College, my father celebrated with him, but everyone couldn't help thinking that my father should have been sharing the experience. The family regret was palpable—you could wrap your arms around it.

I would change that. I felt responsible for fulfilling my father's college dream. I wanted to be the first in my family to graduate. But because of the persistent and overwhelming grief engendered by my father's sudden death, my mother could not guide or support me. I stumbled through high school and ended up at City College by default. I rarely went to class. In the five years I spent there, I completed only two years of credits. When I look back, I realize that I was depressed. I couldn't ask for help, and I was too embarrassed to admit to anyone that I was failing in school. I resolved the problem by pretending to graduate. Carrying it off was easier than I thought. I procured a cap and gown—the office responsible for giving them out didn't check a list to see if I had a legitimate right to the rites of graduation. The photos from that day feature a young woman with a smile that doesn't reach her brown eyes, wearing a black gown zippered up halfway to reveal a striped spaghetti-strap dress and a cap placed haphazardly on her mass of brown curls.

Three years later, I was working as a special events planner at a major newspaper corporation in its advertising division. I had met my husband, who worked a block away from me at an investment firm. And I had decided to go back to college after I realized that I did not want to be planning parties for the rest of my life. When my husband and I went through a rough patch, I went to therapy. My work there led to a major transformation in my personal life and in my career choice. When I learned to tell the truth about college to those who mattered to me, I felt the beginning of the release from shame.

During a counseling session, my therapist asked about my career plans. I told him I thought I might become a psychologist—I was pursuing a BA in psychology. And he asked the question that changed my life.

"Why don't you go to medical school?"

"I could do that? I could go to medical school?" I responded.

"Sure, you'd only need to take a couple of classes as prerequisites for medical school—maybe twelve. Why not?" he asked.

Why not? Because I thought that "other people" went to medical school. There were no doctors in my family. I didn't know any physicians. But when my therapist gave me permission to consider this possibility, something shimmered inside me and took root.

I realized I had wanted to go to medical school ever since I was nineteen years old, when my mother was hospitalized for endocarditis, an infection of one of her heart valves. She was hospitalized for weeks at Mount Sinai Hospital. When the doctors assembled outside her room during their rounds and discussed her case in hushed tones, I'd strain to hear and decipher their cryptic language. I wanted to be part of their conversation, but none of them looked like me—a Latino woman who wore an afro, like her father. How could someone like me go to medical school? Plus, at that time, I was not a strong student.

After that therapy session, I decided to act like medical school was an option. I registered for the prerequisite science courses and treated each as a challenge, to see if I had what it took to succeed. I got a job in City College's Department of Pharmacology so it would be easier for me to take the classes. I volunteered at an emergency department, made frequent appointments with the premed advisor, and read *Scientific American* regularly so I could nail the English part of the MCAT. There was something mystical about the process, and things fell into place as if I was finally on the path spiritually chosen for me. I accomplished a near straight-A average, and my new grades countered those on my prior transcript. I became a serious candidate for medical school and beat down the part of me that railed at my audacity.

I applied to several medical schools and received invitations to interview at most of them. I will never forget the day I received my acceptance letter from my dream school.

In the meantime, I finally had enough credits to graduate from City College. I had a legitimate graduation day in June to line up with matriculation to medical school that August. I didn't go to that college graduation. It didn't seem right, because I had marched nine years earlier. Numbers are funny. I couldn't help thinking about the coincidence between those nine years and the fact that I had been nine years old when my father died. Now, I was thirty—a year older than my father had been when he died. And I felt reborn, on a brink of a brand-new life.

I was at work the day of my authentic graduation, and I could hear the music and hum of the huge graduating class in the streets. I closed my eyes and let the pomp and circumstance shine on and through me. I secretly congratulated myself and reveled in the knowledge that I had finally earned the right to my college graduation. I had taken and been granted a second chance.

Why did you want to become a doctor? I wanted to help people. I wanted to know that every day I'm doing something unequivocally positive. At this stage of my career, I know I can't corral death, but I know I can help my patients cope with the unthinkable. And also? I wanted people to know that people who looked like me could, and I wanted the dream that was deferred for my father.

Leverage

PHOTINE LIAKOS

I close the chart and stack it up with the others. Clinic is finally over for the day. I check my watch. I might actually make it home in time for dinner. For once.

Or not.

My pager goes off just as I leave the clinic building. The emergency room phone number stares up at me.

Well, damn.

I'm not on call, but that doesn't mean anything. I go back into the clinic build-ing to make the phone call. I wait on hold, watching the minutes tick by.

"Hey." It's my fellow ortho resident and best friend, Alex.

"What's up?"

"Are you still here?" Alex asks me.

"Unfortunately, yes. What's up?"

"I've been down here trying to reduce this hip. I swear it won't go in."

"Sedated them enough?"

"Yeah."

My chances of getting home in time for dinner are looking bleaker and bleaker.

"I wouldn't have called you, but I've had Ray and Ben down here already."

"They couldn't get it in?" This is not sounding good at all.

"No. I had them try, and then I tried again. Can you come try? Please?"

"Maybe it needs to go to the OR?"

Worth asking. I know the answer before Alex even responds.

"You know what Dave will say."

I know what Dave will say.

Dave is one of our chief residents. He'll say to try again. It's what he always says. It's so irritating. I know going to the OR means a general anesthetic for the patient, that it's better to get it done with just mild sedation, and then the patient can go home.

But sometimes your best isn't good enough, and the OR is the only option. I guess I'm his last resort before calling Dave.

"Fine. I'll be over."

I head to the emergency room. It's a Friday afternoon, and it's already a frenzy of activity. Level 1 trauma centers are never a good place to be on a Friday night.

I skirt past the stretchers in the halls and head down to room 13—the ortho room. Yeah, that's not a funny coincidence either—grim humor on someone's part.

I find Alex with Ben and Ray. They all look dejected, and Alex in particular has that frustrated look I know well.

"No luck?" I ask, as I join them.

He shakes his head. "Nope."

"I don't know why you called her, Alex," Ray says, frowning at me. "It's not like she'll be able to get it in if we haven't. You should have just called Dave."

"Shut up, Ray," Ben and Alex say at the same time.

Ray shrugs. "It's just a waste of time."

Ray is annoying. He's always smug and downplays everyone else's skills. He's not a very good diagnostician, and he's not that great procedurally, either. Knocking everyone else down just makes him feel better about himself, but it's incredibly frustrating.

Not in small part because it's usually directed at me.

I'm the only woman in the program, which makes me an easy target for his obnoxious comments. He does it to the others too but definitely not as often or in as cutting a manner as he does to me.

I ignore him and fire off questions. How much sedation has the patient had? How long has the hip been out? What was the original mechanism? How many attempts have they made?

I get my answers.

"One try, and then we've got to call Dave, Alex. We can't keep doing this all night. If I can't get it in, we've got to go to the OR."

Ray snorts. "As if you'll get it in. I told you—we've already tried. More than once."

I continue to ignore him. I look at the X-rays. I check for a pulse in the patient's foot. Strong and steady.

Phil, the nurse, gives me a dubious look. "You're not quite dressed for this."

I'm not. I'm rarely ever out of scrubs. But I'm on the chairman's service right now—hand surgery. He's particular about attire on clinic days. No scrubs. So, I'm in a dress and nice shoes. Definitely not the right attire for climbing onto a stretcher and trying to reduce a hip.

Whatever. This needs to be done, and I won't get home if I keep delaying.

"I'll be fine, Phil."

Orthopedics has a lot of very precise, technically complex, delicate procedures. This is not one of them. Hip reductions are about as basic and primitive as you'd

imagine. Sedate the patient, and then pull like hell in the right direction while someone else provides countertraction. You're trying to fatigue the patient's muscles and maneuver the dislocated joint back into place.

It's calculated and depends on vectors and angles and forces, but it's very physical. There needs to be a balance of patient muscle relaxation, positioning, and the strength to overpower the patient's muscles. At its most basic, it's a whole lot of pulling and persistence.

I ask Phil to get some more of the sedative. I get Ben and Alex positioned to provide countertraction.

I scramble up on the stretcher after Phil gives the patient the additional medication dose. The stretcher mattress is soft, and I'm wobbling in my inappropriate shoes. I've got a foot on either side of the patient's legs, right at the edges of the stretcher. Kevin, the EMT working tonight, puts out a hand to steady me.

He then moves to stand behind me. I'm going to be pulling, and I'm near the end of the stretcher as it is. It's a bit of precarious positioning, but that's how it goes for these.

"I'm right behind you," he says to me. "I'll catch you if you get off-balance."

"Don't look up her skirt while you're hanging out there, Kevin," Phil says.

This is typical ER banter. You get used to it.

"Kevin, so help me," I say. I know he's teasing, but I have to say it.

He nods. "Yeah, yeah. I wouldn't dare. I know you can kick my ass."

Kevin has seen me reduce some difficult fractures. He's the one who usually ends up assisting me—he's a night-shift guy, and I swear he works all the time. He's one of the good guys, but I make a ridiculous sight right now, up on this stretcher, in a dress and low heels, trying to pop this guy's hip back.

"All right," I say. "Let's do this."

Ben and Alex press down on the patient's pelvis from either side of the stretcher. Ray is leaning against the wall, arms crossed. Not helping. Typical.

I grab the patient's leg, bending the knee and flexing the hip gently. I can't get it all the way flexed because of the dislocation. The patient doesn't react; I've got adequate sedation. I lock my arms behind the patient's knee and pull up and back toward myself. Slow and steady. I let myself lean back a little to get more pull.

Now it's just a matter of endurance—my muscles versus the patient's. If I can pull long enough and consistently enough, I should be able to do this. It's patience, persistence, and power, but patience and persistence often matter more than pure force.

That's one of the common misconceptions about ortho. Sure, much of the discipline requires stamina and strength, but you also have to be smart about it. All your variables need to be accounted for, especially if you have a bit of a natural disadvantage.

Or an assumed one.

I'm strong. No question about it. But despite that, there's often an erroneous supposition that just because I'm a woman I won't have the capacity to do some of the more forceful parts of this specialty. It's not true, and it gets tiring having to prove that over and over.

Like now.

Ray is sure I'm going to fail at this, and that aggravates me. I can do this. I've done it before. As long as I can control all the variables, there's no physical or radiographic reason we shouldn't be able to get this hip back in.

I'm sweating now. I can feel beads of perspiration on my forehead and a trickle of sweat running down my back. I'm pulling at a constant rate, leaning back, using my own body weight to help me make the patient's muscles give.

Ben and Alex are bearing down on the patient's pelvis—I'm pulling so hard the patient's midsection is almost coming up off the bed. "Come on, guys. Countertraction. Don't tell me I'm pulling harder than you two can handle," I bark at them. It has the intended effect. They push down and stabilize the patient.

I can sense Kevin hovering in concern behind me. My left foot is almost off the stretcher so I wiggle it over a few inches. Phil's frowning at me. "You're gonna break something of your own if you fall from that height," he says.

"I'm *not* going to fall." I grind the words out. Sweat is dripping off my face, and my biceps are starting to quiver. Slow and steady. Slow and steady. I've got to keep pulling.

I lean back just a bit more, trying to keep my balance on the shifting sheets on this narrow stretcher, and then suddenly the patient's muscles give, the hip pops back in with an audible clunk, and Kevin proves his usefulness as I wobble at the sudden shift and he steadies me from behind.

"Got it," I say, as Phil shouts down the hall for the X-ray tech to come take a confirmatory shot.

I awkwardly climb down off the stretcher and wipe my forehead.

"I knew you'd get it." Alex knocks my shoulder with his.

Ray narrows his eyes at me. "Yeah, it's always easier when someone else has done all the hard work for you."

"Shut up, Ray." Ben has a short temper on good days, and today is obviously not a good day. "You didn't last half as long as she did, so you've got nothing to talk about." He thumps me on the back and heads out. Ray slinks out after him.

The X-ray confirms the reduction is anatomic. I help Alex get an abduction pillow in place, and Phil runs the IV fluid. The sedation is fairly short-acting, so the patient will start to wake up soon, although he'll be groggy for a bit.

I look at my watch. It's almost seven o'clock.

Nothing ever goes quickly on hospital time. Things always seem to take longer than you expect, although reductions like this feel like they take forever. Minutes

seem to stretch out interminably when you're using all your strength in a wait-ing game with muscle fatigue—a game of chicken between your stamina and the patient's muscle tone.

"Never seen you miss one," Kevin says to me. "Every time. I've been in this ER for years. You don't give up, but you play it smart. Get the sedation on board, make sure the position is good, and then you wait it out." He leans closer and his voice drops. "They didn't give it enough time."

It's seven thirty by the time I get to my car and start the drive home.

I got it done. Saved the patient a trip to the OR. Proved once again that I belong here, with the guys. That I can do anything they can do.

Sometimes it's not just knowing what to do but having the patience to persevere. For more than just the reductions.

Learning to Listen

AUDREY NATH

Ding, ding.

The tones were a repeated F♯, two octaves above middle C. The hospital speaker system made this sound to alert us of an incoming overhead message. While assisting in surgical cases during medical school, I listened for the beeps of the intercom; every time it came on, songs played in my mind in the key of F♯ major. At one point, I even went out and bought an album that contained one of these songs, since I had been thinking of it so often.

One day, I mentioned the beeps and songs in F♯ major to one of the anesthesiologists in the operating room. He responded with a blank stare. It was as if I was reporting findings from a distant planet.

I spent much of my time in medicine feeling like a stranger.

Medicine felt foreign to me because before I embarked on the path of courses and examinations in the pursuit of becoming a physician, my dreams had more to do with performing piano concertos and composing wind quintets than clinching a difficult diagnosis. After entering medical school, I often felt as though I was a musician lost in the hospital. In the operating room and the intensive care unit, my mind wandered, analyzing the chords that came out of the cacophony of beeping machines. At times, I wrote down some of the more interesting chords in little bits of staff paper that I sketched onto my patient lists. A ventilator alarm or a rhythmic cough transformed into notes splashed onto a page. This quick notation of the music around me appeared the only remnant of my former life.

During the long hours, months, and years of both pediatric and neurology residency training, I escaped the nagging feeling of being an outsider by instead focusing on the stories that I heard from families, many of which intrigued or haunted me well after the encounter was over—for example, the mother in San Antonio detailing how she and her very ill daughter had been smuggled across the Mexican border to obtain medical care. She told her husband, before leaving, "If it is meant to be, one day we will be reunited." Finally, instead of hearing interesting chords among the background noise of the hospital, I listened to something far more relevant to my work: my patients.

One night, it all seemed to come together.

I was called by the emergency department around 4:00 A.M. to see a teenaged patient who'd had a seizure at home. Normally, it would have been a routine neurology consultation; I would review his existing seizure medications, figure out what may have triggered the seizure, and adjust the medications if necessary. In this case, however, despite a history of multiple seizures and a diagnosis of epilepsy, the patient was not taking any seizure medication. His family had repeatedly refused therapy. The ER physician's parting words to me were "Good luck."

With that, I grabbed my trusty neurologist kit. It held the obligatory reflex hammer, ophthalmoscope, and various finger puppets that pediatric neurologists use when assessing visual fields in young children. I didn't have any particular strategy in mind for approaching this family. To be honest, at that point, I was mostly just trying to wake up.

When I entered the room, I found a sweet, teenaged Black boy sitting in a gown. He was shy, and he smiled at me. His mother was sitting in a chair across the room, staring straight ahead with her arms crossed. When I introduced myself, she did not look at me. It seemed we were already at odds.

She told me about his seizure but kept coming back to a refrain of "I know what you're going to say, Doc. You're going to start him on some meds. You're gonna take my baby away, and there's not a damned thing I can do about it."

The heart monitor beeped; an E to A perfect 4th interval permeated the air.

My initial response was to do what many doctors do in situations like this: I fell back on concrete issues. I explained that there are many different seizure medications, and we would try our best to find one with the fewest side effects. Most importantly, however, we needed to prevent these seizures because they could result in injury or even death.

She stared at the wall, fuming. My words only seemed to make her angrier. I felt lost.

There has to be something more to this, I thought. *What am I missing?*

I took a deep breath and delved a bit further: "What happened the last time he tried seizure medication? Did he have some trouble with his mood?"

His mother erupted into laughter. "Oh, 'Some trouble with mood?' Is that what we're calling it?"

I studied her face, trying to understand what had just happened. In the background, a baby cried, its wail punctuating my thoughts with its high-pitched glissando.

Then I got the real story. While taking the last seizure medication, her son had become violent, "like a monster." He was unrecognizable to her.

"He's much bigger than me, so it was dangerous," she said. "But I don't care about me. That's not the problem."

She looked me directly in the eye.

"You know what happens when a six-foot-tall Black kid goes out in the street, acting crazy? He'll get shot. That's the danger."

Suddenly, her fears became so clear and so obvious. The reason we didn't understand them before was because, quite frankly, no one had asked.

We discussed a few medications that could be appropriate for him, and I stressed to her that we would never keep him on a medication that caused an intolerable side effect; there were many options. After hearing this, her face relaxed, and she began telling me stories of all that he had accomplished despite his cognitive delays. Her face lit up when showing me pictures of him working with the homeless population near Mission Hill and receiving an award from the mayor of Boston. Somewhere in all of this, I handed over a prescription for seizure medication. When the emergency room physician came in to check on us, he seemed incredulous to see the patient's mother giving me a hug.

I had learned to listen for chords and intervals as a musician, but that night, I discovered the power of listening to a previously unheard voice. This truly remarkable woman's story may not have filled my papers with notes on a treble clef, but she had her own beautiful melody.

First to Report

KIMBERLY GREENE-LIEBOWITZ

It happened after midnight.

I was a fourth-year medical student, and I'd already had a few run-ins with the surgical intern. Tall, maybe six feet, and solid, he struggled to communicate effectively. By the time I started my surgical sub-internship, I had already heard stories about him: he was impatient and rude, especially to women, and he had difficulty getting along with others. Perhaps he was unpleasant because of his chronic sleep deprivation. Or maybe the surgical internship wasn't what he'd expected. I never knew. He was technically my superior, but he was on a different service and not in my chain of command, so my only encounters with him were in the call room, when he snarled at me; and during Grand Rounds, when he ignored me.

I didn't know if he was brilliant and gifted or idiotic. I don't even remember his name.

I did know one important thing, though: he thought that the bottom bunk in our coed, shared call room was not for me. After all, I was only a sub-intern—not an overworked, exhausted intern, like him. On more than one occasion, he woke me simply to insist that I vacate the lower bunk. I didn't know if he reserved that abuse just for me or if he treated everyone that way, and I was torn about whether I needed to heed his orders. He might not have been my supervisor, but we were in a teaching hospital, where hierarchy mattered.

And . . . I was a student. Everything was new and unfamiliar. It was 1999, and there was no #MeToo movement nor were there work hour limits. Libby Zion laws, enacted in New York to protect patients and limit the number of hours students and residents worked, did not apply to me. Hazing was part of the culture, and we took it for granted that on surgical rotations there would be a subset of people willing to abuse us for fun. Forget about mentioning gender: the worst of the hazers were other women. We didn't look out for each other. We looked for ways to destroy each other.

The night it happened, I was on the bottom bunk. It was where I wanted to be. I could reach the phone and the night table, and I didn't like the top bunk. Many

nights, the interns didn't make it into the call room to sleep at all, so even though I knew he could make me miserable, I had decided to take my chances.

I was asleep when he came in, turned on the overhead light, and began to yell.

I cannot remember the sequence of events. I must have gotten out of the bottom bunk—voluntarily or on his orders. As I climbed up to the top bunk, he yanked me down. I remember tumbling through the air, grabbing at the bed, and somehow landing on my feet, but he held me, fingers digging into my flesh. The facts are tangled with the memory of the metallic taste of fear. He was bigger than I was, stronger than I was, frightening with his poor communication and combative intonations. His grip was tight and painful. It was hateful, not sexual. I applied my fingers and then my nails, digging into the skin of his arm to effectuate my release. When I was free, I fled.

Afraid to return to the call room, with no idea what to do, I spent the night hiding in a darkened corner of a patient lounge, cold and blanketless, rubbing my arms where he'd grabbed and bruised me. The couches were hard plastic and vinyl, easily cleaned of bodily fluids but not very comfortable. Bright light from the nearby nurses' station and the rattling of medication carts kept me from sleep. Through some quirk of scheduling fate, I hadn't been on call with my team, and the hours crept by as I waited for the first of them to arrive.

My chief resident paged me before I had a chance to seek him out. "Where are you?"

I stumbled over the answer. Waiting for the team. Afraid to reveal the assault. Worried that I would be blamed because of where I'd chosen to sleep. I was afraid of what it meant for residency, for letters of recommendation, for future hazing.

I was summoned and allowed to tell my story to the senior residents and the attending. Then they told me *his* version.

He'd gone to the emergency room when I'd fled. My weapons, my nails, had drawn blood. He reported an assault. Got a tetanus shot and testing for infectious diseases: hepatitis B, hepatitis C, HIV. They'd treated his wounds and forbidden him to operate until they healed, or at least that's what I was told. No matter that he was eight inches taller than me and outweighed me by seventy pounds: I was the attacker, he'd said. That was the story the interns and residents repeated, and there were rumblings that some of them were out for blood, though I never knew how much of that was true.

The story rose up the chain of command: I was in trouble. Department chairs wanted to know what had happened. No medical student ombudsman or dean was contacted; in fact, I don't even know if one existed. My team members helped as much as they were able, and perhaps my attending ran interference for me, but it felt like I was marooned in a sea of enemies.

Balancing on a thin edge, I walked through the morning, pretending things were normal when we rounded on patients. With the paranoia of uncertainty, I was positive they were all looking at me, whispering behind my back. I choked on the fear, positive that I was doomed. Finished. Real or not, it felt that there was no room for error, of my own making or due to someone else's actions. Eventually, I was called before my attending. They would overlook this, he explained. But I was not to get in any more trouble, and I was to stay away from the intern in question.

Perhaps they thought my misbehavior could be trained out of me.

The weight of blame had fallen entirely upon my head, but I barely noticed. I was simply grateful that the department was willing overlook my failings, so I soldiered on and I said I was fine. One stupid intern and one assault wouldn't deter me.

Except the reality was much more nuanced.

I matched in a surgical subspecialty in that hospital. After months of struggling with the decision, I decided not to train there. Was I running away? Had I been deterred? I don't know, but on the day I gave notice, I shook off my shackles. I could walk away. I was freed to walk the untrodden paths ahead, and I didn't have to look back.

I took two non-clinical years, and then I matched again. That time, I finished my residency.

In the more than twenty years since this happened, the memory of these events has faded, although they still color my opinion of that hospital. I now understand the power dynamics and communication strategies that were at play that day. For a long time, I wished I knew then what I have learned since, and I wished I had handled things differently. I wished I had known how important it was to be first to report. Eventually, I realized it no longer mattered, and I stopped looking back.

I was not ready to tell this story until recently. It had to percolate and mature, and the anger needed to fade. I was once afraid of repercussions from the hospital. I am not afraid anymore.

I was *his* victim, but I am not *a* victim. It's an important distinction. Anyone can be a temporary victim, but it is what you do afterwards that determines whether it defines you.

It's All about Compassion

The Every Patient

JAZBEEN AHMAD

When I arrive in the emergency department, I know little about you except your name and what is bothering you most. At our first meeting, you adjust and readjust the ill-fitting hospital gown, your eyes reluctant to meet mine. I try to comfort you with a smile and a handshake, but your voice still quavers when you confirm who you are. I say my name slowly and pause to ensure you caught it and are comfortable repeating it. I suspect it is a name you have not heard before. You look me up and down, peering at my name tag. Like most, you are trying to figure me out. I am a stranger who is supposed to make you feel better, and you are not sure what to make of me. I am young, I am female, I have a nose ring, and I am brown; I have no accent where most are expecting one.

I ask about every detail of your life. It is my job, but I often feel like I am prying. It's not natural to ask you to divulge information to me, a stranger, that you don't even discuss with your best friend or family. Every time I go through this process, it feels invasive.

I ask many questions. Sometimes, it is the same one over and over, reframed just a little each time. Due to regular visits to your primary care physician, you are familiar with the interview process. It does not make the conversation easier, but at least you know what to expect. I let you talk until I believe you have told me what worries you most. By the end, your expression relaxes, and you allow yourself to sink into your pillows. Your daughter is at your bedside, and when you finish, she jumps in to tell me what she has noticed.

I tell you the mundane details of what to expect next: the floor you will go to, the tests that will be ordered, your expected length of stay. At the end of the interview, I bring forth a dark topic: your wishes in the event of a cardiac or respiratory arrest. This discussion is crucial, and I have it with every patient, but it is never easy. As soon as I broach the subject, your eyes widen and fill with tears. I am quick to reassure you and explain that we just need to know your wishes in the event of an emergency.

You tell me you have never thought about this before. Apprehensive, you look to your daughter. Neither of you is ready for you to go yet. As I begin to explain

the options, you look confused and anxious, brows drawn together. I imagine it is frightening for you to hear the grave reality of what cardiac resuscitation and endotracheal intubation entail, including but not limited to broken ribs, lung injury, and possible brain injury. After a moment of silence, you tell me, like many do, that you would want me to try to save you but that you never want to be on machines for a prolonged period of time. I look to your daughter to ensure she has heard this statement. I remind you that in the near future, a discussion needs to take place so that your daughter knows what to do in the event you are unable to make your own decisions. Your eyebrows shoot up, and it is clear that I am the first person to bring this to your attention.

I admit you to the hospital and start piecing together the puzzle. Your lab abnormalities and abnormal vitals begin to trend toward normal, and you tell me you feel better. You are eating, you are walking. Nevertheless, I revisit your complaints and do some imaging to explore these more thoroughly. The cough that just hasn't been going away, the new constipation that started a few months ago, the confusion that is gradually worsening and making you feel crazy, the headaches. As I search for answers, we get to know each other. You ask me about my story and ask to see pictures of my children. You show me pictures of your children and your grandchildren. You tell me about your life, the good and the bad. I meet your husband, your other daughters, your sons. I learn their names and shake their hands. We find common ground, and we share some laughs. Inside I fear the worst, but I don't let you see.

I find the source of your problems. It is cancer. I cry alone where no one can see me. When I am calm, I tell you what I have discovered. Tears stream down your face before I finish speaking. I feel helpless, offering you tissues to dry your tears. You ask me to speak with those you hold nearest to your heart. They ask what can be done and what the next step should be. I discuss the options with all of you, explaining that the therapy will be difficult and the overall survival benefits minimal. At best, you'll gain a few months. I tell you to take some time to think, to determine how you want to proceed. You discuss your thoughts with your family, your friends, your priest, rabbi, or imam, the hospital chaplain.

When I visit you again, you tell me you do not want pain. You have lived a good life, and you want to spend the time you have left with those you love. You tell me although you knew you would not live forever, it hurts to now know that your life is ending. It is a difficult discussion, and when we are done, I help you tell your family what you have decided. After you explain what you would like for your remaining time, you cry and they cry too. It is the beginning of their realization that soon, they will be without you.

It takes your family time to accept what you want; you wait, and I wait. They cannot imagine that you would not want to do everything possible to get a little

more time here in this world, with them. With time, they begin to understand and respect your wishes. When I tell you I wish there were more I could do, you take my hand and thank me for helping you realize what decision was best for you. Your family embraces me and thanks me for helping them come to terms with how you want to spend your remaining time. You go home with your family on hospice.

I think about you after you leave. To me, you are a mother, a father, someone's grandmother or grandfather. You are the every patient.

Grandma's Dead

REBECCA ANDREWS

"Grandma's dead." That is the entirety of the patient portal message glowing at me.

I am sitting in a conference across the country from home, taking refuge from the hot desert sun in the cool hotel air.

I am doing what I think I do "best": multitasking. To conquer my work, I scatter my neurons to the different areas that need my attention: the patient in front of me, the patient calling, my ever-burgeoning email box, my children texting the latest adolescent emergency. My eldest child has asked me when doctors will get twenty-seven hours in the day with which to do all these tasks. This tells me that my "best" is not nearly as good as I think: either I am less adept at my work or I am too distracted with administrative burdens when I should be present.

And this is one of many reasons I am looking at my patient portal messages during my conference.

The portal and I have a love-hate relationship. I enjoy reaching my patients directly in moments when a phone call is not possible, but I have received my fair share of messages that produce momentary panic: the "I am having chest pain" message sent three hours ago or the outrageously elevated blood pressure or blood sugar with no call to the office.

But I have been at this now for a decade, and my patients and I have trained each other. I've adjusted my approach to their needs, and they've learned what is too much of an emergency for electronic communication. We have grown together.

My patients use the portal to get what they want most: a direct connection to me. My medical assistant is seasoned as well. She works the traditional phone calls but agrees to leave the portal to me. This creates an extra sense of privacy and shared participation for my patients.

"Grandma" has been my patient since graduation from residency. I don't need to look at the chart to know the patient, her story, or her family.

I can no longer remember when she began calling me "Rebecca," dropping all measure of formality. We met when she was obese, smoking, and diabetic with uncontrolled blood pressure and blood sugar. That was before weight loss, bypass surgery, and dialysis. She was a slimmer woman—though perhaps not

healthier—when I saw her through her seventy-fifth birthday and her great-grandchild's NICU stay. She followed me from one job to the next, complaining about the hassle as she saw my medical students and residents and tolerating the switch to the ever-cumbersome bus system when my office was no longer walking distance from her home. This became progressively more difficult for her as she became less mobile, shifting from walking to wheelchair. We met on Tuesdays and Thursdays—days I don't normally see patients—to work around her dialysis schedule, and it was a family affair of dynamic proportions. Sometimes three or four younger women—Grandma's loved ones who were also my patients—would fill the room. There were fewer if she had recently reprimanded a granddaughter and left her sulking at home. Sometimes those same granddaughters tried to "hitchhike" onto her appointment with their own complaints.

Sitting in that conference room, I reread the message. It's blurry, and I realize I am crying. I was once told that displaying such emotion—crying with patients—can make them lose faith in your skill and experience. I have found this information to be incorrect; I have chosen to ignore this advice. Emotions display my humanity, create a bond, and remind the patient that I, too, have seen tragedy and pain. My patients and I have a silent agreement: my office is a safe space for *anyone* to share. This allows for deep, rich relationships built on trust, commonality, acceptance, and empathy. The line between patient and physician blur sometimes: a cup of coffee with a fellow physician patient, an elderly couple who meet me for lunch once a quarter, an aged socialite who requests our "social" office time, a priest who administers healing to my staff as we tend to his needs.

In the office, I can analyze symptoms to piece together the puzzle of a patient's diagnosis. Seated here, I try to process why my response is precipitous and visceral. But I know why: a patient is so much more than a listing of diagnoses, of vital signs measured and noted. Patients are wives and husbands, painters and teachers, runners, dog lovers: they are people. My patients should know they leave an indelible mark on my heart and soul.

Perhaps it is not surprising that my shoulders begin to shake. Quick and quiet, I rise, stifling a sob, looking for the exit. Bursting through the double doors, I type in the numbers I know by heart. The phone rings and I hear a granddaughter's voice. It takes me a moment to swallow back my grief and tears; it's time to doctor again. This patient needs my counsel.

I say, "I am so sorry to hear about Grandma."

Good Friday

PHOTINE LIAKOS

I was the only intern on the colorectal service when I met Maria.

Maria had frequent bowel obstructions. In the six weeks I was on service, she was admitted at least three times with an episode. She'd had a few surgeries already, and our goal was to manage her strictures and obstructions nonoperatively, so that meant that each time she was admitted, I had to place a Cantor tube in her. We both dreaded it.

A Cantor tube is long and thin, meant to go in the nose and down into the digestive tract to relieve obstructions. It looks like a simple tube except it has a small, sealed, mercury-filled rubber bag at the far end. When it works, it is a welcome substitute for invasive surgery.

I hated putting in Cantor tubes. First, I had to requisition the tube. Then get the mercury, which I aspirated from a vial and injected into the rubber bag with a needle and syringe. I had to be careful not to spill or drop any—it was, and is, a biohazard. Unfortunately, it had happened to me: A bead of mercury dripped off the syringe, forming a ball and rolling off to who knows where. The biohazard team had to come, the patient room had to be evacuated, and it was a huge mess until the drop of mercury got cleaned up.

The mercury risk wasn't even the worst part.

The worst part was getting the tube into the patient. A rubber bag full of mercury was not an ideal thing to stick up someone's nose, and patients hated them.

Theoretically, according to the manual, I should have been able to fold it up, lube it up, and slide it down. Theoretically.

However, the rubber bag of mercury was large. It didn't fold well. It didn't stay folded. Especially not when coated in lubricant. It was an agonizing process for the patient and pretty frustrating for me, the intern, as well. After I got it in, I had to monitor its progress with multiple X-rays to see if the mercury weight could push through the blockage.

I got to know Maria fairly well during those six weeks. Three Cantor-tube insertions created a bit of a bond. Her family owned a restaurant, so they weren't able to visit much during the days or evenings. Or weekends.

I was on call every other night, so I was in the hospital constantly. I ended up spending a fair amount of time with her—the extended time placing the tube, the numerous X-rays during the night checking placement, the frequent checks on her abdomen to see whether she was managing to decompress the obstruction.

I could tell she was frustrated by her condition and lonely during her hospital stays. I'd stop by to chat before I went to bed most of the nights I was on call. We shared a common heritage, so it was entertaining to share stories of our grandmothers, list our favorite foods, and compare notes on our parents' superstitious traditions.

The third time she was admitted was on Good Friday. It had become apparent to me that Maria was religious. Easter is a big deal in our culture—particularly the Friday night services and the Saturday midnight mass. The hospital happened to be right across the street from one of the largest churches in the city.

We went through the Cantor-tube saga that afternoon, and I kept checking on the X-rays. The floor wasn't particularly full that weekend. I noticed Maria's room was on the side of the hallway that faced the other medical center buildings, not the church.

She was much quieter than usual this admission. I found the charge nurse before I headed down for dinner.

"Hey, Rachel? Can we possibly move Maria across the hall?"

"Why? What's wrong with her room?" Rachel narrowed her eyes at me. "You didn't spill mercury again, did you?"

I groaned. "No, I didn't spill mercury. It's just that tonight's Good Friday and it's kind of a big deal to her. The rooms across the hall face the church, and I think it might make her feel better if she could see that tonight."

"Let me see what's open."

"Thanks, Rachel. If there's a room with a good view of the church, that would be great."

Rachel coordinated the swap, and a few hours later Maria was in her new room. I stopped by to check in on her and let her know things were moving along nicely.

"Thanks for changing my room."

"How'd you know it was me?"

"I suspected it was you, but Rachel confirmed it when I asked. Thanks. I've been away from home so much these past few months. I was really hoping I'd be home for Easter." Maria's gaze turned to the lighted church across the street.

"I know. I was hoping you'd get more than a week out of here." I looked out the window and down into the church parking lot. "Hey! They're getting ready to do the processional—you want to watch?"

Maria got out of bed and I maneuvered her IV pole by the large picture window. We both sat on the window seat and watched the procession circle the church. The faint sound of singing made its way to us, despite the thick glass windows.

When it was over, I helped her get back into bed. Time for another X-ray.

"I'll let you know how this X-ray looks. You feeling any better?" I asked, once she was situated and leaning against her pillows once more.

"A bit. I think your company and the room change are making me feel a whole lot better than the tube. Thank you for thinking of me."

"Any time. Much as I enjoy your company, I'd like to get you home by Sunday this time, so you can have Easter with your family."

"I'd like that too, but I'm not getting my hopes up."

She was right not to count on it. It was slow going with the Cantor tube, and she wasn't cleared to go home on Saturday.

I went to her room a few minutes before midnight. As I expected, Maria was awake, standing at the picture window, looking at the church, dark in that time before the midnight Easter vigil.

"You want some company?" I asked her.

"I'd love it."

I stood at the window, and as the clock struck midnight, the flickering lights of candles started glowing in the church windows, the light increasing as the flame was passed from row to row, person to person, along the entire interior of the church.

It wasn't long before people began to trickle out, their candles wavering in the darkness of an after-midnight city.

We watched in silence, until the church descended into darkness again, all the congregation members home with their families for the traditional midnight feast.

"The restaurant always hosts a midnight meal," Maria said.

"I'm sorry you're missing it."

"There's always next year. Hope I'm not here again."

"I hope so too. I hope you can go home tomorrow or Monday."

"Me too."

"I wanted to let you know I go off service tomorrow. I'm headed to the cardiac floor, so I won't be your intern anymore."

Maria frowned at me and reached out her hand.

I took it and she gave my hand a quick squeeze. "I want to thank you for everything you've done for me, all these times I've been here," she said. "I'm here a lot, but you made these last few times more bearable."

"Certainly not with my questionable Cantor-tube skills," I replied.

She grimaced. "You're no worse than some and better than most, honestly. But no, I'm grateful for the concern you've shown, but it's more than that. You've cared for me as a person, taking the time to talk to me, letting me vent about how much I hate this disease, how frustrating these admissions are, how much I miss my family when I'm here. You've made it personal, taking that kind of time and making sure I had a room that faced the church this weekend. It's made a bigger

difference than you know." She tilted her head and smiled. "Anyone can do the medical stuff. It takes a special person to do the personal side."

Six weeks later, I rotated onto the surgical floor again—this time as part of the orthopedic service. Rachel came to find me that first afternoon.

"Hey, Maria was here last week. I told her you were headed back but not on colorectal. She left this for you."

Rachel handed me a card. Inside was a thank-you note from Maria and a gift card for her family's restaurant.

"Thanks for making my time better. Enjoy a well-deserved night out with your husband on me."

I saw her a few times over the next few years, as her family restaurant became a favorite of ours—for special occasions like birthdays and anniversaries, when we splurged a little on our typically frugal budget.

Sometimes it's not the procedures or the practical aspects of care that stay with someone. It's the personal moments, the moments you get to be yourself and reach out on an individual level.

If You Like Piña Coladas

JULIA MICHIE BRUCKNER

"Feel that sun," she whispered, "hear those waves."

We laughed, lounging side by side, feet up on the humming radiator. The scuffed linoleum transformed—I could almost feel the sand in my toes.

A package of cheap piña colada lollipops left by one of the hospital volunteers prompted our imaginary tropical vacation. It was late, I was hungry, and Shante was circling the halls, the glistening bags of saline and morphine dangling from her IV pole, its wiry extensions conjuring a sun-kissed palm.

"Shante, want a lollipop?" I ventured, "Let's park it for a while."

She shuffled over, and we plopped into the wheelchairs kept in a huddle at the end of the ward.

"Man, this tastes good," she said after a lick. "But kinda like suntan lotion."

"I'm gonna pretend it's a real piña colada—frosty and strong," I countered, "and that we are in Jamaica."

"I'm game, Doc," she replied, adjusting her gown and leaning back. "Bring on the beach."

We sat a while, enjoying the peace of three in the morning. This was my favorite time of twenty-four-hour calls. It had a deep quiet, heavy and still. Most patients slept, the new admissions were tucked in, and the interns were hunkered down to finish charting. As the senior resident supervising the pediatrics ward, I'd usually head to the call room for a snooze. But when Shante was up and restless, I found myself staying awake too.

Shante was one of our regulars. Her severe sickle cell disease prompted hospitalization every month or so. The nurses groaned when the emergency department called to admit her, because she always stayed for weeks, weaning from her pain medications at her own pace. Our ward was her uneasy home, grudgingly accepted by both parties.

The first few days, she would slam the pain away with the strongest of opiates, sleeping most hours, waking groggy and grumpy. As the pain quelled, she emerged: first distant, with one-word answers and sly glances; then angry, throwing and

thrashing in a teenage tantrum. Her storm would soon calm, and glimpses of her humor and warmth began to peek through.

Her family never visited. Life was harder at home for Shante than in the hospital. Born on a Caribbean island, she was brought to the wintery slush of the urban northeast as a baby, before she could get her toes in the sand. When she was small and her disease made her tiny fingers and knobby knees swell, her mother would share her hospital bed. But as the admissions became more frequent and chronic pain transformed her, her mother wearied. After Shante told her she was gay, we never saw her mother.

We gave her updates by phone; she was kind but terse. She always picked Shante up punctually when it was time for discharge. But Shante never wanted to leave.

So she'd make rounds through the halls. Usually, I'd find her at the nurses' station, trying her latest jokes on the night crew, sneaking candy from the drawers when they got up to check vital signs or silence someone's beeping medication pump. Sometimes I'd find her in the room of a drug-exposed baby, his tweaks of withdrawal calmed by her contralto voice as she rocked him back and forth in her arms, her IV dangling.

I loved those nights. We were on her terms—no bed, no rounds, no admonitions, no treatments. Her surly scowl was transformed into a surreptitious smile.

I learned to seize those times, to meet her where she was, push my expectations of her a bit higher, forget about her disease until morning rounds.

We talked music, celebrities, fashion, ward gossip. She demonstrated the dance moves she wanted to show off at her brother's wedding, if her aching hips, eroded by recurrent pain, let her. She listed all the food she was going to cook up when she got home—jerk chicken, spicy beans and rice, plantains, fried pork, grilled shrimp.

Sometimes we'd watch *Project Runway* on her iPad. One night, we hatched a plan to write to Tim and Heidi, the program's hosts, suggesting they do a hospital-gown redesign challenge. Shante got a head start, scrounging markers and glitter paint from the playroom to embellish her own gown. Creating an asymmetric drape, she sashayed through her pain, turning the empty hall into her runway.

She ribbed me about my style—my baggy scrubs, boring T-shirts, and white coat with graying cuffs and collar. And my pagers—three always hung from my ID lanyard.

"Doc, you got more pagers than a 1995 drug dealer," she'd tease.

These were the moments I remembered when things got tougher.

The time between her hospitalizations became shorter. The pain began to curtail her nightly walks. Too frequently starved of blood flow, her hips corroded, bone scraping bone with each sashay, each step, even a shift in bed. We finally told her it was time for surgery—new hips for her upcoming birthday. We tried to help

her celebrate, conjuring visions of the painless runway walks and smooth dance moves her titanium hips could enable. Her enthusiasm was feeble; surgery—the anesthesia, the pain, the immobilization, the scars—terrified her.

I saw her after the orthopedic surgeons had done their work. She wore her frustration like a rough blanket, cowering under it in bed. The surgery didn't help as hoped. Recovery was complex, with acute chest syndrome, wound infections, and many more days bedbound and alone. She spent her brother's wedding in a wheelchair, watching others dance. She entered adulthood eroded.

As I started my last months of residency, Shante no longer graced the ward. Now too old and frustrating for pediatrics, she was admitted to internal medicine. I doubted they had glitter paint or lollipops there.

As a new resident, you believe you can somehow cure. But often we can't stop disease, though we can comfort the spirit. We can look beyond the anger and pain to listen, distract, imagine, and laugh. We can stay up to jokes over lollipop piña coladas on imaginary sand under a fluorescent hallway moon.

Put a Bow on It

PHOTINE LIAKOS

Danielle had been coming to the limb deformity clinic since she was an infant. She was born with fibular hemimelia—a condition also known as congenital absence of the fibula, which results in an abnormally short lower leg and significant foot and ankle deformities. Treatment can range from limb lengthening and ankle stabilization procedures to complex reconstructive surgeries and, in some cases, amputation of the deformed foot and ankle to allow for more functional gait with a prosthesis.

I met her one of the first times I worked in the clinic. Since none of the residents who had cared for her previously were on service, I became her doctor. She was thirteen, and plans were underway for a definitive procedure for her condition.

She was a self-possessed, vibrant girl, with a definite opinion about her care plan, and she was an active participant in the decision-making process. Danielle's severe foot deformities limited her ability to be active, despite the numerous reconstructive and stabilizing procedures that had been performed on her.

She and her mother had researched all the options and had met numerous times with the attending physician staff at the specialty clinic at our hospital. The consensus was that an amputation of the poorly functioning and malformed foot and ankle would allow Danielle the flexibility to use a prosthesis for school and activities, giving her a more normally functioning foot. She wanted it done before high school so she could start with a functional and aesthetically superior leg.

I met with Danielle and her mother numerous times during the preoperative period. We talked about the pros and cons of the procedure. She met with the physical therapists, the prosthetics staff, and the surgical team. She was determined and well prepared. Amputation patients are often placed in casts after surgery to protect the incision from accidental bumping or injury and keep the swelling under control to ease later prosthetic fitting. Patients got to choose the color of these casts; determining Danielle's choice was part of my pre-op checklist.

She was admitted, per protocol, the night before surgery. I met at her bedside to go over the plan, answering all the questions she and her mother had. At the end, I asked her about the cast.

"Pink and green striped," Danielle answered me immediately.

"Pink and green striped it is. I'll make it work." We only stocked solid cast colors, but I was pretty sure that if I made the base cast green, I could use a smaller roll of pink and candy-stripe it over the green. I'd find a way to do it for her.

The surgery went well. Uneventfully, which is how I like surgeries to go.

When it came time to place the cast, I went to the casting cart and grabbed four-inch-wide green and two-inch-wide pink casting material.

"Which color is it?" the attending surgeon asked me.

"Both."

"What do you mean, both? It's got to be one or the other."

"No, she wants both. She asked for pink-and-green striped."

"You're not wasting all that fiberglass to do pink-and-green striped," he said to me.

"I'm not wasting it. It's just one extra roll. This is what she asked for and that's what I'm going to give her." I was a third-year resident, and talking back to attending staff was not something I did. Ever. But I couldn't understand why he was questioning this. Danielle had made the difficult decision to proceed with such a significant surgery. The least I could do is give her the cast she wanted.

"Just do the green. I'm not going to have you wasting time doing a striped cast. We've got more cases to do today."

"It will literally take me no more than a few minutes to do it. I don't mind."

"I'm telling you to just pick one color and be done. This is frivolous, having a two-color striped cast. It's a waste of material and a waste of time."

This kid had just had an amputation of her foot. If she wanted a pink-and-green striped cast then, damn it, she was getting a pink-and-green striped cast, no matter what he said.

I stopped talking and simply wrapped the cast on. He became distracted with paperwork, and when he turned around again, I was already putting on the pink stripe.

"I told you not to do that."

"And I promised her a pink-and-green cast. I'm her resident, and I'm not going back on my word. She had her foot amputated today, and if she wants a striped cast, that's what she's getting. I'm almost done with it anyway."

"You don't listen well, do you?" he said.

I was irritated. It shouldn't have been such a big deal. That hospital was supposed to be all about the positive patient experience.

"I'm supposed to listen to her. And that's what I'm doing." I finished the pink stripe and added a fiberglass bow because I was feeling belligerent.

We transferred her to the recovery room. I wrote her orders, talked to her mom, and went right back to the operating room to take care of the next patient.

I checked on Danielle a few hours later. She was awake and alert, in pain and understandably emotional over the entire procedure. Even though she had been planning the amputation a long time and understood what it entailed, she hadn't expected the feelings that washed over her when she looked down at her leg and saw that she didn't have a foot anymore.

I sat on her bed and held her in my arms as she cried. She kept saying she knew it was the right decision, but she hadn't really been prepared for the visual reality of it.

I sat with her until she stopped crying and then she asked to look at it again. And she smiled. "You did it! You did the pink-and-green stripes. Just like I wanted."

"I did. That's what you asked for. I couldn't disappoint you."

"You put a bow on it!"

"Thought I'd make it extra fancy for you."

"Thank you. For everything."

I saw Danielle over the following months, and watched her transition to a prosthesis and pursue activities she never would have tried before her surgery.

I thought of her often in the intervening years since then. Some patients make an indelible impression. Then, in 2008, I joined Facebook. It was a great way to reconnect with friends from college and med school and family across the world.

I was surprised to get a Facebook message from an unfamiliar name one evening in 2013.

"Were you a resident at this children's hospital in 1994?"

I didn't recognize the name or the profile picture.

I answered. "Yes, why do you ask?"

"You may not remember me. My name is Danielle, and in 1994 you were my doctor there. I had my right foot amputated and work done on my left knee as well. My encounter and relationship with you had such an impact on my life, and I wanted to thank you for that."

I think I started crying as I tried to type a reply.

"Of course, I remember you! Your diagnosis was fibular hemimelia and I remember making you a two-color pink-and-green cast after surgery. I can't believe you remember me. I am so glad if I helped in any way."

She answered right away. "You were amazing with me. I've never forgotten you. If it had not been for you being who you are and being a doctor with a tender heart and had I not carried that with me, I wouldn't have had the quality of life for the time that I did and I am grateful. What you have is called bedside manner. You're in the people business. You held me and let me cry. I've never forgotten that."

I wrote her back, and we've stayed in touch since then. She's reached out to volunteer to mentor kids with her condition at a hospital near her.

Her words reinforced to me once again how worthwhile our profession is. It's not just a job. People come and go in our line of work, but they leave imprints on us, and in this case the memories go both ways. She was a strong young girl back then, determined to do what needed to be done. I respected her for that, and I didn't anticipate how much of an impact a pink-and-green cast and a bedside hug would have on her.

Finding Humor in Unexpected Places

Halloween Blood

RACHEL KOWALSKY

"She drank this!"

An elderly woman shoved a bottle of bubbles at me. But rather than bubble fluid, it was filled with a sticky red liquid. The woman reached behind her, grabbed a child by the elbow, and pushed her forward. The child was about two years old, with broad cheeks and enormous lashes. She smiled at me and held out a stuffed bear. An entourage of people pressed in around her.

The girl's name was Imalina, and the other people were, by decreasing level of consternation, her mother, her grandmother (the woman with the bubbles that were not bubbles), her aunt, two siblings, and a cousin. A boy named Julian, who didn't seem to belong to anyone, was also definitely part of the group.

I took the bottle. "What is it? What did she drink?"

"That's the problem," said the grandmother. "We don't know."

While we spoke, I ushered the family from the hallway into an examination room. Rosie, the medical student, followed. The child looked comfortable and healthy, but I put her on a cardiac monitor anyway. ER superstition dictates that if you prepare for the worst, it won't happen.

Now another cousin joined us. Her name was Yolanda. She was breathless, throwing off her coat and scarf as she spoke.

"It's the Halloween blood!" Yolanda exclaimed. She had the story: the blood had been used for an older brother's Dracula costume and left beneath the kitchen sink until now—January.

"Who made the blood?" Grandma demanded.

"Ernesto."

"Tio Ernesto?"

"No—you know who!" piped up a sibling, nodding her head in the mother's direction.

"Oh my god. My boyfriend. My ex-boyfriend." That was the mother speaking.

"Can you call him?" I asked.

"He's in El Salvador. I don't have his number."

"Lydia, just call him. It's important," said the grandmother. "You have his number."

"It would be so helpful," I said. "Do you want me to call him?"

"No!" Lydia clutched at her phone. Then she handed it to her sister. "You call. Ask him what the hell he put in the Halloween blood and why he left it under the goddamned sink."

The phone call was made, but Ernesto's voicemail was full.

"Keep trying," I said. "Can you call his family?"

"I'll Google Halloween blood," said Rosie, pulling her phone from her white coat.

The nurse opened the bottle and took a whiff. "Smells like—oh man, what is that smell?"

Another nurse picked it up. "Hershey's!" she said. "Hershey's syrup!"

She was right, it was definitely sweet and chocolatey.

Rosie looked up, worried. "Halloween blood typically contains some combination of corn syrup and food coloring, but it can be made with laundry detergent too," she said. "You add detergent if you want it to look darker and more viscous."

I looked at the nurse. She looked at me. Everyone in the room looked at Imalina. Laundry detergent exposures are usually benign, but some can cause internal burns and even lead to serious difficulty breathing.

Imalina blinked back at us. She smiled. She wasn't drooling, coughing, or vomiting. She had no facial burns, which would portend trouble in the airway or gastrointestinal tract. I examined her mouth and throat carefully. Everything looked normal. But could there be trouble below the vocal cords? Or in the gut?

Meanwhile, Imalina played with her little bear. Flanked by her entire family and Julian (it turned out that the boy lived down the hall from them), she was having a wonderful time.

Cousin Yolanda had a stuffed unicorn in her bag, and the bear and the unicorn cavorted through a make-believe forest over the countertops and medical instruments in the examination room.

The monitor blipped along benignly, each heartbeat solid and reliable.

Lydia, Imalina's mother, pulled me aside. "Doctor, what did she drink?"

"I'm not sure," I said.

"How can you find out?"

I shook my head. The moment felt absurd. Despite all of the gleaming equipment in the room, my years of training, and the presence of the laboratory that whirred and hummed several floors above us, I had no real way to figure out what Imalina had ingested beneath the sink.

"You don't know," said her mother.

I nodded again. "I don't know."

Information sifted in. Lydia found the ex-boyfriend's mother's phone number, and Imalina's sister had been able to reach the old woman. She hadn't seen him in

a few days. Maybe he was with his girlfriend? His *new* girlfriend. Nobody had the new girlfriend's cell phone number, but she lived in a remote area near a tienda with a telephone that everybody used, and whomever picked up might know where they were.

We decided to call the tienda. But to call an international number, we needed a special code. Rosie was dispatched to get it from the hospital operator.

Every time I walked by Imalina's room, she stuck out her tongue at me. *It is the universe,* I thought to myself, *sticking out its tongue at my medical degree, at the idea that all things are knowable.*

You can't know, her little pose said. *Nobody knows what was in the Halloween blood. Well—perhaps Ernesto.* But nobody picked up the phone at the tienda. Ernesto was unreachable.

Then Julian tugged on my sleeve. "Hey Miss," he said. "They also keep rat poison under the sink." This statement took my breath away. Rat poison can be much deadlier than laundry detergent.

"Imalina," I said, "did you drink anything else that was under the sink?"

"No," she responded, barely looking up from her stuffed animals.

But you can't rely on the declarative statements of a toddler. If I were to measure all the words spoken by small children everywhere for one year, "no" would be one of the most frequent, and the least specific.

I turned to Lydia. "What rat poison do you have under the sink?"

The look on my face must have been terrible, because Lydia began to cry. "The green pellets!"

"What are they called? What are the green pellets called?"

"I don't know."

"Julian!" Now I turned on Julian with the full force of my frustration.

"They are green pellets in a bucket!" He burst into tears. *"What if she dies?"*

The grandmother began to pray.

And this brings us to the point: every ER story encompasses many possible truths. It was easy to imagine Ernesto in a rush, with only enough time to mix chocolate syrup and food coloring before he reached to answer his phone, or flipped the burgers, or turned to greet his girlfriend, who would have been so happy that he was helping out with Halloween. Or Ernesto, alone in the kitchen, eyeing the Halloween blood critically because it was nothing like the blood he had seen in his life—thick, dark, the real stuff of life, and feeling compelled by a desire for verisimilitude, or his sense of honor, to add some detergent. Then there was Imalina, unimpressed by the bucket of green pellets (what child likes green food?), or Imalina, her toddler mind designed to wonder and explore, reaching into the bucket and popping a pellet of deadly blood thinner into her mouth. The truth is always out there, but it can't always be known.

Next came charcoal, a blood draw, a call to the poison-control center. Imalina drank the charcoal in a slurry of cherry syrup with tiny sips, in total disdain of the beverage and of the aproned staff around her, who sang songs of encouragement until she was done.

Then, I observed her for six hours. Here is what I saw: Imalina at the fish tank, Imalina wandering the ER and waving at all the patients, Imalina watching *The Little Mermaid,* and Imalina throwing a tantrum when the movie ended. Imalina napping, with stable vital signs.

The girl drank the Halloween blood, plain and simple. And at the end of six hours, the only thing I knew about the Halloween blood was that it hadn't killed her, and it probably wasn't going to.

It's humbling to think that we can't always solve the mystery. On television, and in mystery stories, the case is always cracked. After diligent sleuthing, pondering, and painstaking deductive work, the detectives—or doctors—are rewarded by a glorious moment of knowing. Viewers and readers can breathe a sigh of relief: the world is logical, predictable. All of our questions will be answered.

In a sense, it is liberating to see that we can't always be certain what has happened to our patients or what will happen next. I like knowing that there are bits of story that are never revealed to me; that there is always a loose thread to the story, tucked into the mesh of it, aglow with the thrill of its secret life. The truth is elusive, and what we do most often is approximate it and arrive as closely as possible. We see it as best we can with the tools that we have.

I like that some things are mysteries. The mystery gives me something to reach for: the long-distance code, the name of the tienda where Ernesto can be found. It leaves some space for human nature between the pages of the textbooks and the blinking cursors of our search engines.

I sent Imalina home. Her grandmother hugged me. So did Yolanda, Julian, and the cousins and siblings who hadn't already gone home for dinner. Imalina was fast asleep in Lydia's arms, so Lydia and I nodded at each other. "Take care," I told her. She nodded in a serious way. "Of course."

Every Halloween, as I walk the darkening streets with my own children, I remember Imalina. Ghosts, goblins, and Draculas swish by us with sticky red blood smeared across their faces and robes. I admit that during those times, I feel a tug of regret. *Wouldn't it be good,* I think, *if I could know the answer?* And I wish for just a moment that I knew what was in the Halloween blood that Imalina's mom's ex-boyfriend left beneath the sink.

There's No Laughing in Medicine

JESSI GOLD

I grew up in a household where sarcasm was a language of love and comedy specials were for family television time. I knew every person on *Saturday Night Live* (when I was old enough to watch it) like they were the starting lineup for the Yankees. Laughter was therapeutic and normal, and humor was very much a part of life.

This value originated with my father, a psychiatrist. He once was moving me out of my dorm when someone in the elevator stared at him with judgment. Instead of ignoring it, he said to the onlooker, "This is heavy. Want to help?" and gestured as if he were going to drop my desk into his hands. My friends could not stop laughing at his comment. They quickly pointed out to me that they "now understood where I got it from."

It wasn't really until I started down the path of medical training myself that I realized my dad's outlook didn't exactly go hand in hand with medicine. It turns out that he was the exception and not the rule.

Everywhere I looked in medical school, seriousness was modeled and humor was discouraged. With a stone face, I learned, came success, power, and respect. Even a hint of sarcasm could be perceived as lack of respect for an engrained hierarchical structure. Or, at least that is what my evaluations said. The words "too cordial with the nursing staff" and "not serious enough" come to mind.

Don't get me wrong. I know that our jobs are important and there's a time and place for laughter. But by focusing so much on the gravity of what we do, we forget that medicine can be funny. We don't allow ourselves the chance to let go.

The truth is our jobs are weird and unique. We experience things that no one else does (or maybe should). That alone is funny.

There's the awkwardness of learning how to take a social history. I remember sitting next to the bed of a sixty-something veteran as he watched me stumble through the words, "Do you have sex with men, women, or both." Halfway through, he stopped me and said, "Just spit it out, honey, I have nothing to hide."

There are the objects patients bring with them to show you and catch you off guard—like the pizza box full of stool for a parasite sample. One tiny bag would have sufficed.

There's also the unexpected answer from a patient—like when an eighty-year-old woman told you her favorite song was by Nicki Minaj and then proceeded to sing it. You listened intently with a mix of shock and awe.

And, then there's the time you managed to somehow screw up your first test for blood in a patient's stool—also known as a guaiac. The favorite test of patient and providers alike, it involves the doctor sticking her finger into the patient's rectum to obtain a stool sample.

Okay, fine. Maybe that one was just me.

I was a third-year medical student spending the day in the urgent care clinic. The attending was in and out, and we mostly saw patients alone and then presented afterward. Around my fifth patient, I walked into the room to see an older gentleman sitting on the table in what seemed like work clothes. His chief complaint was blood in his stool.

I asked him questions about constipation, diarrhea, and the frequency of his bowel movements. He sat there quietly answering, essentially expressionless. Sometimes patients squirm or look uncomfortable discussing this topic. He just looked serious.

I tried to match his attitude by being as stern and knowledgeable as possible. Medicine had already taught me that much.

I knew I had to do a guaiac test to check for the presence of blood in his stool, but I had never done one before. Turns out knowing what test is needed is a lot different than performing it.

I looked around for an attending to help me, but there was no one. A few nurses asked me what I was doing and pointed me in the direction of the supplies. In the closet next to the Band-Aids and splints, I found gloves that fit and the folded card that we use to put the sample on—as if it was an everyday item.

You know, just a little Band-Aid for your cut . . . and a stool sample.

Despite my stalling, I remained alone. I knew, in theory, what to do and wondered if I could just go back alone.

I decided the test was easy enough. For some reason, it didn't feel like a time I needed to "see one" before I "did one."

I was so incredibly wrong.

I went into the patient's room and put on a glove. I explained to him what I was going to do, and his expression stayed the same. I positioned him—bent over and backside exposed—and then positioned myself. I am short, so I had to get on a stool to be at just the right angle to get my short fingers in far enough for the sample. That part was awkward in itself, but I did it correctly.

I then put the sample on the card and exited the room. Proud of myself, I asked the nurse where the indicator drops were located (they help determine if there is blood in the sample). She pointed me back to the supply closet and in there, I put a few drops on the sample. Nothing happened.

I put a few more drops and again, nothing.

Was I doing it right?

Was this the right "indicator"?

Did I use enough?

Was it a negative test?

I had no idea.

Incredibly confused, I went to find the nurse again. I asked her if she could come see the test and let me know what it meant. She came into the closet with me and then looked down at the card. She looked back at me, fighting a smile, and then just started to laugh.

Confused yet again, I looked at her and asked, "What did I do?"

She said, "Is THAT where you put the sample?"

I replied, "Yeah? That's what the card is for . . . right?"

She looked down at the card again and began to smirk. She shook her head trying to find the right (and polite) reply.

She turned back to me, unable to look me in the eyes, and said, "That's what the *inside* of the card is for."

I turned bright red. I looked down at the card and realized I hadn't opened it. I didn't even know that it could open. Instead, I put the sample on the useless protective covering and tested it. Twice.

Way to go, Jessi, I thought to myself. *That is why you are supposed to be supervised.*

I also thought, *So . . . procedures. Not exactly your strong suit. Psychiatry it is.*

As I slowly regained my composure and what was left of my pride, I asked the nurse what to do next.

Still laughing, she looked back at me and replied, "You are going to have to go tell the patient what happened, and you are going to need to do the test again."

Again.

I have to go back and do THAT to him again.

I thought that phrase over and over and wondered how anyone could happily spin that to a patient, even the nicest of patients.

The nurse saw the discomfort in my face. It was a look that said, "Hi, sir, remember me? I have to stick my fingers in your backside again . . . Yes. I know it is uncomfortable, it is not exactly fun for me either."

Maybe it was out of pity, but she offered to come with me to ease the pain.

My heart was beating fast, and I was a bit nauseated as we walked back into the room. We began to talk to the patient, and I struggled to find the, well any, words.

In my silence, the nurse took over. She said, "Hi, Mr. Jones. I am so very sorry, but our medical student has to take another sample, as she did it wrong the first time."

The patient's face did not distort. He also, unexpectedly, did not look angry in any way.

I began to apologize profusely and say how uncomfortable this must be for him. I am sorry.

I am sorry. I am truly sorry . . .

He looked slightly entertained by my profuse apologies.

As I began to put on gloves to repeat the procedure and asked him politely to get back into the same position as before, he stopped me.

This is it, I thought.

He is going to yell at me now. It just needed to be tangible—like finger-coming-at-your-backside-again tangible.

He then smirked for the first time and curled his eyebrows up ever so slightly.

"Well, can we at least get to know each other first this time?"

With those words, my anxiety plummeted, and I started to laugh.

Then, he started to laugh.

Then, the nurse started laughing too.

Walking by his room at that moment, you would've never guessed what was actually going on.

Still laughing, I stuck out my non-gloved hand, shook his, and said, "Hi, nice to meet you, I'm Jessi."

"I'm James."

He laughed again.

Then, we all laughed again.

I was just about to do one of the most uncomfortable things to him for the second time, and he didn't care.

He found the joke in it, and he made me find it too. It was like he gave me permission to laugh.

I couldn't see it alone. I was so focused on my faults and the seriousness of having to redo the test that I missed how, in its complete awkwardness, it was also hilarious.

It was funny. Even with years, it still is funny.

And, frankly, so is medicine.

In a field with a lot of darkness, humor is something we should always value.

It shouldn't take a second guaiac to remind us: laughter is an essential part of medicine.

Attempted Murder

JENNIFER CAPUTO-SEIDLER

I entered the emergency department with Rob, waiting in line to make our way through the metal detectors, wondering how it could possibly take so long to get to triage. I wasn't used to that entrance. I usually entered through the main hospital with my short white coat and hospital ID badge. But I wasn't there for a shift. I was there with Rob—my ever-smiling, talks-to-everyone, easygoing boyfriend—who was looking at me with glazed eyes and sweat on his brow, and was barely saying a word.

Just two hours earlier, we had been home celebrating. It was May of my third year of medical school and his final year of graduate school. After months of long hours and conflicting schedules, the scheduling gods had been on our side. I was somehow not only home for his birthday but off the entire day and able to cook our first real dinner all week. I made his favorite, and my specialty, penne alla vodka. I'd even had time to make the birthday cake!

About thirty minutes after dinner, we were having cake and opening presents. Rob seemed irritable and dismissive of my gift. I was annoyed by his attitude, having spent my one day off preparing dinner and baking a cake. Then he said he didn't feel well; he was lightheaded. Having been diabetic since the age of fourteen, Rob knew this feeling was often a sign that his blood sugar was dangerously low. He checked his blood sugar and it was 60, well below the range of 80–140 it should be right after a carbohydrate-heavy meal. He drank a cup of orange juice and laid down on the couch. By that time, he was tremulous and sweaty which is how he looked when he was delirious with the flu. Fifteen minutes later, his glucose hadn't budged. He drank more juice and ate a fruit snack, but he still wasn't feeling better. We couldn't figure out what was going on; he had eaten way more carbs than he had calculated his insulin dose for. He picked up his insulin pen from the table and realized that instead of taking the slow-release insulin that would gradually control his blood sugar for the next twelve hours, he had taken a large dose of rapid-acting insulin that lowers the blood sugar immediately.

It was an easy mistake to make. The pens look identical, except one insulin is clear and the other is cloudy. It's actually remarkable that had never happened

before, but to our horror we realized he'd given himself an overdose of his rapid-acting insulin. Worried, I drove him to the emergency department.

After what seemed like an unreasonably long amount of time to get through security—but was in reality less than ten minutes—we made it to triage. I relayed what happened to the triage nurse as though I were presenting the case to one of my attendings. Intellectualization is my default defense mechanism whenever a loved one has a medical emergency. Rob, in an effort I'm sure was intended for my benefit, joked that he was just trying to keep his birthday interesting. The triage nurse promptly rechecked his blood sugar, and when the result was normal, at 113, I finally exhaled and realized I'd been holding my breath. I thanked God I had chosen to make pasta.

We were led back to an exam room. I was giving Rob a hard time for making me come to the hospital on my day off, when the attending came into the room.

Upon entering, he stood between the stretcher where Rob sat and the chair in which I was seated, his back to me, his arms crossed over his chest. An uneasy tension settled over the room.

From where he entered, there was no way he could have missed me sitting in the chair, so it seemed incredibly rude that he stood in such a way as to exclude me.

"Who gave you the injection?" he asked Rob in a stern voice. It seemed like an odd place to start taking the history.

"I gave my own shot. I just wasn't paying attention," Rob replied with an uneasy laugh. It sounded like he was being chastised for his mistake.

"Are you sure? Are you sure she didn't give you the injection?" the physician asked, nodding his head backward in my direction.

Rob paused for a beat, chuckled again. He looked at me, then back at the attending. I sat in the corner, wondering where the conversation was going.

"Are you sure she didn't try to give you too much insulin?" the attending pressed.

"Definitely not," Rob answered, this time with no hesitation. My mouth gaped open, but I was too stunned to speak.

There were a few moments of silence. Rob sat on the stretcher with his head tilted to the side, the same gesture our dog now makes when she hears an unfamiliar noise. I was too afraid to say anything, still feeling like the medical student in this situation and scared of confronting this attending. Suddenly, the attending laughed, an inappropriately loud laugh, as though we'd been joking around this whole time and he hadn't just accused me of trying to give my boyfriend an overdose of insulin. His laughing stopped as abruptly as it had begun. He told Rob he should be more careful but that his glucose had stabilized and he would be discharged shortly. With that, he walked out of the room.

He didn't look at me directly even once.

I stared at the curtain after he left, then back at Rob, then at my lap until the nurse returned with the discharge papers. As we walked back to the car I was overwhelmed with a combination of shock, anger, and immense gratitude for the power of pasta to overcome an insulin overdose.

On the drive home, all I could think about was how lucky it was that I'd already completed my emergency medicine rotation and would not have to later face that attending in my white coat.

But I did see him again. When I was a fourth-year medical student doing my active internship in internal medicine, we crossed paths while I was in the emergency department seeing an admission. I was at the admission workstation reviewing the chart for my new patient when I looked up and that same attending stood across the hallway. I froze like a deer in headlights. We made eye contact, and his face revealed no sign of recognition. After a moment, he turned and entered an exam room and I continued on with my admission, beyond relieved that suspicions of my insulin intentions had apparently been forgotten.

I've celebrated eight birthdays with Rob since that night, all without medical emergencies. Or attempted murder.

TMB Disease

JILL GRIMES

"TMB"? My brain raced frantically through its archives, searching for a file that matched. *Tuberculosis? Nope. Trans Mural Something? Nope. Perhaps infectious, like T-something Myco-Bacteria?? Did he mean TMJ? No, that's treatable and not fatal. Cardiac? Neuro?* I panicked. But let me set the stage.

I threw open the doors to my family medicine private practice at the perky age of twenty-nine, tipping the scales at approximately 105 pounds soaking wet, and soaring to a height of five-feet, two-inches on a Texas big-hair day . . . not exactly a doppelganger for Marcus Welby, MD. Let's just say I had plenty of opportunities to try out a plethora of answers to the new patient inquiry, "So, are you really old enough to be a doctor?" I had finished my residency one year prior, and my clinical experience clearly could not measure up against more seasoned doctors. However, I was bursting with youthful enthusiasm, the most current medical training, shiny new state-of-the-art office equipment, and perhaps best of all: seasonally themed, hand-sewn poncho-style patient gowns (thank you, Mom).

The moment I opened the exam room door, a comforting waft of Old Spice transported me back to my childhood. My dad's morning routine was never complete without a splash from the white bottle with "the ship that sailed the ocean," so that incredibly distinctive scent never fails to wrap me in a warm hug. I glanced down at the chart in my hands, verifying my new patient's name, and noting he was a PhD.

"Good morning, Dr. McCarthy. I'm Dr. Jill Grimes, so nice to meet you," I chirped as I offered my hand.

"Good afternoon," he corrected, returning a hearty handshake, "It's officially past morning, although I bet you've worked straight through your lunch. And although I appreciate the title, you're the only doctor in this room who can prescribe a pill, so feel free to call me Mr. McCarthy. Or George. Or anything but late for dinner," he chuckled. I instinctively smiled back, appreciating his twinkling blue eyes, faded red hair dusted with silver, and vaguely Irish accent.

"You've earned that title, Dr. McCarthy. Trust me; my professor father would never let me get away with calling you George." I smiled, sitting and adjusting my rolling stool.

"Your dad was a prof too? Fancy that. Well, I've got one for you. Do you know what they say about old professors? They never die, they just—" "Lose their class," I finished, sharing a laugh.

"Clearly, you were brought up well," he said. "And guess what? Your dad and I have something else in common. My oldest daughter is also a physician—but she's an obstetrician. Since she lives all the way up in Wisconsin, and since I'm not pregnant, we agreed I should have my own doctor down here in Texas. To be honest, I've never had a female doctor before, but when I saw your name on the list, I thought why not?"

"I will certainly do my best on behalf of my gender," I offered.

"I do have one question for you before we get started though," he said.

"Fair enough."

"What grade did you earn in biochemistry in med school?"

I laughed out loud. "I passed! My med school had pass/fail grading for basic science classes. But I did tutor my classmates, if that counts," I grinned. "But may I ask why?"

"Biochemistry was my daughter's toughest class in med school. I kept telling her that no one would ever ask her what she made in that course, as long as she ended up with an MD after her name. But now I always think about that when I meet a new physician."

We laughed together and then reviewed his medications, allergies, surgical history, and family history, all of which were delightfully peppered with commentary. And then, during my review of systems, after detailing his multiple "bionic" joint replacements, Dr. McCarthy dropped the bomb.

"So, Dr. Grimes, I actually do have one very serious medical condition that I need to tell you about. And even though you trained in a great medical center, I'm willing to bet you may not have heard of my illness, although frankly, from my perspective, it is not particularly rare."

I threw back my shoulders, raised my chin, and looked him square in the eyes, steeling myself for the challenge. "Fire away! If I am not familiar with it yet, I give you my word that I will be by the end of the day." Mind you, the year was 1995, and although we had computers, instead of "Dr. Google" or WebMD, I was referring to a search through my trusty medical school bible, the *Washington Manual,* or one of the massive two-handed textbooks weighing down our bookshelf.

"I'm warning you, I've seen innumerable specialists for this condition, and so far, not a single one has been able to help me. My own daughter had no idea what this was. They say there are no surgeries, therapies, or prescriptions that can reverse the damage. In fact, this condition is relentlessly progressive, and ultimately fatal."

I encouraged him with a nod. "Well, together we will deal with it the best we can, and science is always moving forward," I offered, with as much optimism as possible, though my stomach tightened in a knot. "What exactly is it?"

"T—M—B," he slowly spelled out, heaving a dramatic sigh for full effect.

And there I sat transfixed, anxious to prove this baby-faced doctor was capable of caring for him. Wanting to show him that choosing a fresh-out-of-training doctor was not a mistake, and oddly yearning to make his daughter proud, linked in solidarity with another female doctor across the country. I genuinely liked this man and passionately did not want to let him down. And yet—TMB?? The seconds ticked on as my brain raced, but honesty (and the knowledge more patients were waiting in the exam rooms next door) won out over pride.

Brow furrowed and shaking my head in the negative, I confessed, "Sir, you are correct. As I'm sure that you know from your daughter, we have a zillion acronyms in medicine, but TMB? I'm afraid that's not a disease that I am familiar with either, at least nothing I can call up on the spot. Could you tell me what TMB stands for?"

With a sly tilt of his head and now releasing a bottled-up chuckle, he replied, "Absolutely! TMB is . . . Too Many Birthdays!"

The irrepressible Dr. McCarthy remained an office favorite for nearly a decade before he moved back to Wisconsin to spend his last birthdays with his daughter and her family. His office visits brought friendly quizzes, laughter, and fragrant Old Spice hugs to brighten our days, bestowing a poignant gift that I especially cherished after my own father passed away.

Although the science of medicine has indeed made great advances, I find myself more frequently diagnosing TMB in myself, my friends and occasionally in my patients, because sometimes the best prescription is laughter.

Up North

KATIE WISKAR

Let me tell you about the time I spent forty-five minutes trying to get out of an IGA parking lot.

How did I get stuck in my own paved purgatory, you might ask? Well, my grocery store escapade was just a small part of a monthlong general internal medicine fellowship placement in Terrace, British Columbia. Terrace, for the unfamiliar, is a community of just over 11,000 people in northern British Columbia, about halfway to Alaska. I was there in January, which is a quintessentially Canadian experience. Temperatures drop to −30°C (−22°F), the days are depressingly short, and snowstorms are a weekly occurrence. For a Vancouverite whose winter essentials were rainboots and an umbrella, it was a bit of a shock to the system. To say that the month I spent in Terrace has stayed with me is an understatement. In fact, I've never been more appreciative of a learning experience—and never been happier to make it home to Vancouver in one piece.

I should perhaps have anticipated that my time up north would be a departure from the usual, when my travel plans were thwarted from the get-go. I was flying up to Terrace. The sixteen-hour drive is treacherous at the best of times, and January is not the best of times. But I was faced with the realities of air travel in the rural Canadian winter when, on arriving at the departure gate, I was informed that my flight had been canceled due to blizzard conditions. When I finally made it to town on my rescheduled flight the next day, I was greeted at the tiny Terrace airport by a grizzled, khaki-clad, highly respected physician, Dr. M. As we drove to the hospital, Dr. M pointed out all the best ice-fishing and mushroom-gathering spots around town. I had heard legends of his diagnostic genius, crazy trauma cases, and MacGyvered equipment. The stories did not disappoint, and he ended up being one of my favorite people to work with in all of my training. It was clear to me from that first meeting that he loved the people and the city of Terrace just as much as he loved practicing medicine there.

We pulled up to the hospital that first morning, and Dr. M handed me a set of keys. "We have six MIBI scans to do this morning," he said in his gentle South African drawl. (A MIBI scan—a myocardial perfusion imaging scan—is a form

of nuclear imaging used in cardiac stress testing to evaluate patients with chest pain.) "The treadmill room is upstairs next to the office."

My face must have registered my apprehension as I took the keys. "I've never administered a MIBI," I told him truthfully. "At home, the techs do everything. We just confirm their reports."

Dr. M smiled, a twinkle in his eye. "Well, you're not in Kansas anymore, are you? Don't worry, you'll figure it out."

The city girl in me wasn't so sure. I was used to the luxury of large centers where the cardiac imaging department is run like a well-oiled machine. Typically, multiple patients are tested simultaneously in adjacent rooms, with the imaging technicians and nurses shouldering almost all the work. The physician, like me, simply needed to "supervise" and look over the reports.

In Terrace, I discovered, Alex, the imaging tech, and I were it. Really, with Alex bouncing between several other commitments in the department, I was it. I fetched the patients from the waiting room, recorded their vitals, and took their histories. I then attached electrodes to their chests in the correct position and ensured the electrodes wouldn't fall off when the patients started running on the treadmill. This was by far the most daunting part of the whole ordeal. I hadn't given it a second thought when the nurses or techs back home did it effortlessly (and efficiently). Now, I couldn't decide which was more challenging—men, where body hair often made the adhesive backing totally useless; or women, where navigating breast tissue and sports bras made the whole thing an exercise in awkward frustration.

The patients, to their enormous credit, didn't complain when I clearly didn't know what I was doing. Many of them laughed along with me as the electrodes fell off mid-test, and we had to start all over again. Alex was endlessly patient and helpful, making very welcome "suggestions" as to what protocol I might want to pursue in each case. We had six MIBIs scheduled for that morning, starting at 9:00 A.M., with each one allotted thirty minutes. We should have been finished by noon. When I finally reappeared on the wards to join Dr. M at 3:30 P.M., he simply grinned.

"Welcome to rural medicine. I see you figured it out."

I laughed. "Yup," I said with a tired smile and new respect for the nurses and techs at home. "I figured it out."

For the next week, I continued to figure things out and slowly adjust to the rhythm of small-town medicine. Dr. M and I were inseparable. We traveled to and from the hospital together, we ate our meals together, and we worked together to see an incredible variety of patients. In a town without subspecialists, we were neurology, cardiology, intensive care, rheumatology, and everything in between. We worked long hours—often leaving the hospital close to midnight—only to return the next morning and start all over. We went for lunch at his favorite café,

where they knew him by name and had his order ready minutes after he walked through the door. We saw patients from all over the area, some of whom had driven up to six hours on the slippery winter roads to make it to their appointment. No one complained when we ran late or when we saw them in a makeshift clinic room at the back of the trauma bay. They were grateful to be there and for the care we were able to provide. It was a welcome break from the cynicism I sometimes encountered in my urban patients.

When Dr. M left town a few days after my arrival, he left me his truck as my means of transport for the rest of the month. This was a large, rugged, four-wheel-drive truck, and it was a big change for a girl used to city driving in a Honda Fit. On top of that, the roads were icy and snow-covered, despite the city snowplows' best efforts. Oh, and the truck was a standard.

I had never driven a stick in my life.

My "lesson" consisted of about five minutes en route to the airport. "Just go gentle on the clutch. You'll figure it out," he said with a wink.

Needless to say, I was not terribly gentle on the clutch.

For the next three weeks, the most stressful part of my day was the drive to and from the hospital. I tried to do all my driving in second gear to minimize gear-shifting, which didn't always go so well. More than once, I barely made it up the steep hill to my apartment, more nervous than I've ever been during a code or an intubation.

I should perhaps mention that figuring out how to drive stick in a loaned pick-up truck wasn't my first transportation-related mishap while on rotation. At the end of my second year of medical school, I had spent a month learning family medicine on Saltspring Island, an idyllic island off the coast of British Columbia. Saltspring is two parts raw food–eating, hemp-wearing, Reiki-practicing hippies and one part rich urbanites with multimillion dollar vacation properties. (I'll leave you to imagine the conversations I had about vaccinations in that month.) During my time on the island, I borrowed a vehicle from a friend of a friend's grandmother who lived there. It was exceptionally kind of her to loan me the car, as we had never actually met. The first time I ever spoke to her was when I had to call to tell her that I had crashed her car. Totaled it, in fact. On an island with no traffic lights.

I maintain that I was the victim in the situation. I was happily driving along when a huge spider fell into my lap. Huge. Enormous. In my memories it's at least three inches across, though I admit that may be a slight posttraumatic exaggeration. On realizing that a gargantuan spider had just pounced on me and was clearly making a play for control of the vehicle, I did what any normal person would do—completely panicked, let go of the steering while trying to brush the spider off me, and crashed the car into a concrete barrier. Thankfully, no one was hurt in the accident. I think in the end even the spider scuttled out unscathed.

There wasn't even a tiny spider in the truck to blame the day I almost didn't make it out of the IGA parking lot. I had seized a rare free Saturday afternoon to pick up some much-needed groceries. Unfortunately, so had half the town, which led to a heavily congested lot. I made it there easily, bought out its entire stock of kale, and was ready to head home. That's when the trouble started. It took me a few tries to successfully back out of the parking stall, but that was par for the course. Lurching along in first gear, I made to exit the lot but then came up to a four-way stop. I cringed as the truck halted. When it was my turn to go, I gave myself the usual pep talk.

"Come on Katie, you've got this," I muttered to myself. "You are a smart, capable woman. You are a doctor. You put in chest tubes and central lines and run codes and manage complex cases. This isn't rocket science; this is a normal thing that millions of normal people do every day. You can do this."

I took a deep breath. Foot on the break. Turned on the ignition. Shifted into gear. Slowly eased off the clutch, with gentle—gentle!—pressure on the gas. The truck began to slowly lurch forward, and then, with a shudder, it came to an abrupt halt. I had stalled out. Not only that, but I had rolled right up to the small speed bump that was inconveniently placed at the stop sign. To most people, this would be nothing but the most minor annoyance. At that moment, however, I might as well have been trying to start the truck on the slopes of Everest.

The next three quarters of an hour was an endless loop of false starts. I can laugh about it now, but at the time I was close to tears. Twice, people behind me in line—since I had created a veritable parking lot traffic jam—got out of their cars to see what was wrong. I had to explain, shamefully, that there was no major mechanical problem; I was simply a city girl completely incapable of driving under these conditions. For a while, I actually got out of the truck and helped marshal traffic around me, only to hop in for yet another attempt when the cars cleared. When I finally—finally!—managed to get over the speed bump, equal parts elated, embarrassed, and exasperated, I drove home without ever coming to a complete stop. It was totally unsafe, in retrospect, but I just couldn't face repeating the whole ordeal. Very little in life is more humbling than spending forty-five minutes in heated battle against a four-inch semicylinder of concrete. And almost losing.

My daily commute aside, my month in Terrace continued to be an eventful one as I kept figuring out rural life. I ditched my sleek knee-high boots and tailored dresses for snow boots and jeans, which were infinitely more practical for snowy weather. My back and shoulders protested loudly as I discovered that shoveling snow was a killer workout. I encountered native wildlife, including a near-collision with a moose on the highway—which my colleague's deft driving prevented. I embraced local recreation but had the unfortunate experience of being thrown from a

snowmobile during a winter outing, much to my well-intentioned host's horror (I was fine, though I probably won't be getting back on a snowmobile anytime soon).

By the end of the month, I was proud of myself for having navigated the challenges of medicine in the rural Canadian winter but was eager to get back home to Vancouver. I wasn't quite ready to trade yoga classes and Nikes for ice fishing and snowshoes. And after all of my transportation-related mishaps, I was also very anxious about the actual journey home. It was still the dead of winter; storms popped up frequently in the forecast, and it seemed more common than not for planes to be grounded due to weather. All I wanted was to get back to my family, my own bed, and the numerous takeout options within easy, snow-free, walking distance of my apartment.

On the day of my scheduled departure, I didn't take any chances. The entire city had only a handful of taxis, and these were notoriously unreliable, particularly in winter. So I asked a huge favor of a coresident, who graciously agreed to drive me to the airport early on a Saturday morning. I ignored his laughter when I told him how early I'd like to arrive. I knew Terrace was a far cry from the busy international travel hub that is the Vancouver airport, but still, I told him, better safe than sorry.

The airline employee who checked me in obviously shared his amusement and directed me, with a smile, through the tiny deserted airport to the single departure gate. I parked myself in the corner of the waiting room and glanced out the window. Overcast skies, but no signs of a storm. I breathed a sigh of relief. I had made it. I had survived the month, I was at the airport, and the weather seemed to be cooperating. I was going to make it home. Content, I dove into my book and waited.

Gradually, the waiting room began to fill. I didn't really keep track of time. I wasn't wearing headphones, so I was confident I'd hear any overhead boarding announcements. At one point, my morning coffee sent me to find the lone airport bathroom, which back close to the check-in counters. When I returned from the washroom, I probably should have noticed the airline employee circulating in the center of the waiting area or the thinned out crowd in the departure lounge. And I definitely should have checked the time. But I was relaxed; my travel anxiety had dissipated after my successful, if early, check-in. I settled back into my book.

What finally did get my attention were the two women next to me in the corner of the lounge, chatting as they prepared to board the plane. They had pulled out their tickets and were comparing seats, lamenting that neither had scored the emergency exit row. I briefly glanced over and noticed their printed tickets. Their flight was with WestJet. I was flying Air Canada.

I began to have a sinking feeling in my stomach. I reached into my bag for my phone to check the time, and my boarding pass. It was 10:10 A.M., ten minutes *after*

my flight was scheduled to depart. I rushed up to the gate clutching my boarding pass, now realizing that the waiting room was half as full as it had been. "The Air Canada flight has finished boarding," the woman at the gate informed me sternly. "We'll be completing boarding for the WestJet flight shortly."

It had never occurred to me that there would be two flights to Vancouver departing from the single gate in short succession. It had never occurred to me that in such a tiny airport, rather than any overhead boarding announcements, there would be a lone employee circulating in the waiting room. And it had certainly never occurred to me that, unlike the forty-minute ordeal on large international flights, boarding on a tiny plane like this would take place so quickly that in one trip to the washroom, I would miss it.

I begged the gate attendant to let me run on the tarmac to catch the plane. My luggage, I tried to reason, was already on board. She very reasonably refused and also refused to allow me to stow away on the overbooked WestJet flight. I would have to take the next flight out, she told me, which was late that evening. I burst into tears on the spot, mostly at my own stupidity. I couldn't believe that after having arrived at the airport over two hours before my flight, I had somehow still missed boarding.

I spent the next ten hours in the Terrace airport waiting for my flight back home. There was no food other than a poorly stocked vending machine; apparently in Terrace, the airport café closes on weekends. There was, thank goodness, Wi-Fi. When the winds began howling and the storm clouds gathered in the early afternoon, my heart sank. *This cannot be happening,* I thought, desperately. *Please, please don't let me be stuck overnight in this tiny airport thanks to my own stupidity.* I restlessly paced the length of the departure lounge, feeling increasingly nauseated with every fat snowflake and gust of wind.

It came right down to the wire. The winds raged on and off; the snow appeared to abate, only to fall harder ten minutes later. About thirty minutes prior to boarding time, the building plunged into complete darkness when the power went out. The backup generators kicked in a few seconds later, but though the lights came back on, the Wi-Fi did not. There was a tense period with airline employees buzzing back and forth as they tried to figure out how to proceed with the flight in the absence of an internet connection. More than once, in my self-induced misery, I thought all was lost and descended into despair, trying to figure out how I was going get through the night with little more than my laptop and wallet in my carry-on (since then, I always pack a change of clothes, just in case!).

Finally, the gate attendant called us to board. This time, I was paying full attention, and I was incredibly happy to get on the plane. Boarding was comically low-tech due to the Wi-Fi outage: the attendants had us write our names on a yellow legal pad before we proceeded aboard. Takeoff was more like a bumpy

amusement park ride than a smooth commercial flight and was certainly not for the faint of heart. As the plane ascended and then finally leveled out, I breathed a huge sigh of relief.

As challenging as the month was, I am profoundly grateful that my training afforded me the opportunity to practice in Terrace and in a variety of other rural communities throughout the province. I learned an incredible amount of medicine from physicians like Dr. M—some of the absolute best I've encountered. I witnessed the pervasive sense of community and support for one's neighbors that forms the backdrop of many small towns. I learned to be a more resourceful physician when practicing without some of the advanced imaging or interventional modalities that are so readily available in tertiary centers. I was humbled by the grit and resilience of the patients, many of whom faced significant obstacles just to access care yet were continually gracious and patient.

And hey, I figured out how to drive a stick. Sort of.

Bravery: Facing Our Fears

Filing Cabinet

S.P.

Monday morning. Coffee. Handover. Reviews. There's always so much of so much. The day blurs into a frenzied haze, and before you know it, it's time to get the 176 bus home. I had been given the referral letter for the first patient of the day the previous week. Mid-sixties, seen by surgeons for cancer. Low mood, not sleeping. I had a quick look over the notes and fired up my computer, ready to go.

She was in the waiting room, immaculately dressed in a velvet coat and shiny black boots. Her jet-black hair fell into a soft bob that framed her face. She followed me into the clinic room and perched on the brown leather chair closest to the door.

In medical school, we learn the patter: "Hello, my name is Dr. So-and-So, can I confirm your name and date of birth? What's brought you in today?" Bonus points for added enthusiasm.

I rattled through my introductions. We covered the bases: mood, sleep, family history. She didn't say much, but it all seemed to fit—recent diagnosis, low mood, hopelessness. She had spent her life helping others and now found herself quite helpless. With my diagnosis nearly certain, I thought I would tick off a few routine questions before wrapping up.

"So, can you tell me what it was like growing up?"

Silence.

What do you hear when it is silent? Everything. The incessant tick-tock of the plastic clock, babies wailing in prams, taxi drivers swearing. The harsh gusts of wind careering through London and the pigeons squawking as they dive behind the parapet of the old hospital block. Your own thoughts.

She was looking out into the grey middle distance, fully absorbed in another world. "Mrs. D'Silva, can you tell me what it was like growing up?"

Mrs. D'Silva looked away from the window and down at her lap. She knotted her fingers, crossed her legs, and sank deeper into the old leather armchair.

In medicine, there are many ways you can tell that something is not right. Some are obvious: a deranged blood test, the man in cubicle 13 clutching his chest

in pain. But sometimes it's a feeling, an insidious knot forming in your stomach, calling you to attention. And I could feel that knot tightening.

"Something happened, didn't it?"

She carefully raised her eyes to meet mine, and in that moment, I saw fear.

"I said that I would never tell anyone. I was never meant to tell anyone. I promised. He made me promise. When we were young, we were so poor, and there were so many of us kids. Our parents couldn't feed us, so they split us up. The boys went to the uncle in the East and I went to my aunt in the South. I was three so I don't remember much. We lived on a farm, and we ate what we grew. I used to enjoy playing with the pigs, and my aunt would tell me off for getting so dirty."

Her hands were trembling as she spoke. I leaned forward, the knot growing tighter and tighter.

"He had been married for a while to my aunt. He worked in the fields, and most of the time I didn't see him. At first, I didn't know what was happening. I was so young; I didn't know what a man does to a woman. I didn't know what it meant. But I knew it was wrong, because he told me that if I ever told anyone he would tell everyone I was a filthy pig who lied. And what happens to filthy runts? They starve. They die. As I got older, I realized what was happening. I thought about running away—I had even packed a bag. Then one day when he was doing things to me, my aunt walked into the room. She didn't even look at me. She turned away and went into the kitchen. Started making dinner. That's when I knew he was right. I was filthy. And I was alone.

"I left, eventually. Got a job, moved to England. I got married, I had my kids. I pushed it all away. You make yourself busy, one errand after another. The years go by. But recently he has started coming back to me. I see him in my sleep. In fact, I see him all the time. The smell of soil and sweat. The filth. I hear him, I hear the farm. And I just want it to be over. I just want these days to be over. If I could finish it all now, I would. But he knew me so well. He knew I was a filthy coward. And now I am waiting for the cancer to finish me off, but it might be slow. All these doctors, these nurses. They keep telling me to be hopeful, telling me that things are going to get better. No. I don't want them to get better. I want them to end."

She let out a deep exhalation and closed her eyes.

Fifty-eight years. She had been silent for fifty-eight years. Through all those birthdays, jobs, class assemblies, hospital appointments, breakfasts. Fifty-eight years of life, and she had never uttered a word.

I felt sick. Questions and thoughts darted frenetically through my mind. *How could this have happened? How has she survived? What am I going to say?* And then the big one: *What if she never comes back?* I couldn't let her walk out that door without knowing I had tried everything to make sure she got help.

My consulting physician was a brilliant supervisor and someone I greatly respected. Razor-sharp, experienced, and kind—she was exactly the person you wanted on the other end of the phone. Much to my relief, after hearing my gabbled history, she came to speak with my patient.

"I understand that you have spoken at some length with my colleague today. I am not going to go over all the details, but it sounds as though you spoke about some difficult things. I think it is important for me to say that although I appreciate it was not easy to talk about, we are very grateful that you did. We really want to help you."

My patient barely looked up.

"I have worked with several people over the years who have had therapy, and it has changed their lives. It has changed how they see themselves. And you need to be able to do this. You deserve this chance."

I waited, my heart in my throat, for her response. The clock ticked. The wind outside whistled against the old windowpanes.

"No," she whimpered eventually. "I just can't go through this again. I didn't mean to waste anyone's time. I am so sorry. I will be fine."

Suddenly the consultant rose to her feet. She walked over to the dusty filing cabinet in the corner of the room. She opened its second drawer, paused, and turned to my patient.

"This is your mind, with all the things that are in it. All the things you feel, all the emotions you have." Some old papers were lying on the top, and she scrunched them into a tight ball, jamming them into the already packed filing cabinet.

"And this is the resulting trauma from what happened to you." She went to close the cabinet, but despite her best efforts, there was no way the drawer would close.

"Until this is sorted," she said, lifting out the scrunched ball of paper, "this problem is not going to go away. Do you see?"

She took the ball of papers out of the filing cabinet and placed it in the bin under the desk before closing the drawer and returning to her chair.

"Please, let us help you."

A week later, I was due to see her. I didn't think she would show, but as I turned the corner to go to the waiting room, she was there. Velvet coat, shiny black boots. She followed me into the clinic room and we sat down.

"I don't think I am ready for this," she said, half-meeting my eye.

"You're here," I said. "And that's a start."

Chrysalis

REBECCA ANDREWS

Today, my daughter is leaving me.

I knew her before she came into this world. She slept when I slept, moved when I moved, and she possessed complete control over my ability to eat. We grew together; I measured my daughter's life by our joint milestones. Her refusal to allow anything except pink grapefruit and ketchup to pass my lips during both my medicine and OB months. The butterfly sensation of her first kick came during my ICU rotation. Her hiccups made me giggle throughout my USMLE (US Medical Licensing Exam) Step 2; so much that I thought they'd accuse me of cheating. The angst of dehydration and Braxton Hicks contractions during residency interview season. Labor and delivery during my radiology rotation. When she was born, I half expected her to arrive with a stethoscope in hand, but, as always, she surprised me.

She was my medical school baby. She grew in my belly for a glorious nine months. And she was so loved. She was not my first baby, but she was the first I brought home. She began a full year after the unexpected loss. Loss can focus our vision—float our hidden dreams to the surface. My religion had always brought me peace, but now I bargained with God for every one of those nine months. *If I do not have even a sip of coffee . . . If I pass this test . . . If I love the baby more than life . . . Just please let me have her.*

I knew with such deep conviction that she was a girl that I stopped lobbying for the boy's name I wanted: Matthew. The doctor smiled when he asked for the final push. He was excited for the surprise reveal, but I knew who was coming: Isabel. She was born without a sound, her big wide eyes open, looking around calmly. The serene moment sharpened as she went longer and longer without making a sound. My medical training became negligible, taken over by the hundreds of TV and movie births I had seen. I begged her to cry. She consented to my request with only a conciliatory "wah." That sound, suspended in the silence of the room, broke apart the fear and opened my heart.

I had worried about being a mother in medical school with the long hours and overnight calls of residency. I combated those who said it was a selfish decision to have a child with my career. Truthfully? I thought having a child was better than

being a doctor. Dresses, headbands, and tiny shoes came in pink adorned bags and boxes. Watching the spark in her eye when the letters on the page became actual words her mind could read; watching her approach the world with wonder and curiosity. As she grew, I tucked away memories to share when she had her own children. The stolen afternoons for "white tablecloth lunches"; the weight of interlocked hands as her reminder of my presence when she was unsure. Her pure trust married with my unconditional love. Divine intervention saw fit to give me a spunky, "older-than-her-years," precocious and pragmatic daughter.

Or did it?

My daughter is no longer my daughter. He is actually my son. This, this is what held me on the edge of the precipice since he first uttered the word *gender-fluid* two years ago. He knew, but I had to catch up.

My brain was on overdrive right after he told me. *Why? How did this happen? But you like to bake? But you knit me a headband? Are you sure? Sometimes people change their minds? Have you thought of how hard life might be? What if people don't accept you? Have you seen the inside of a boys' bathroom?* Gently, I got my answers and they were so "Isabel" in nature: *Baking is not just for girls . . . knitting is soothing . . . I am okay if it is hard . . . Yes, Mom, I know, and I am certain this will not change.*

My role as a parent is to sometimes push, sometimes pull, to set the bar, but always to love and always to accept. Raising my children has been an expected glorious rollercoaster of emotions. I have known a love like no other. In exchange, I trade my hopes entwined with their growth with the reality that appearances can deceive, and they are the only ones who can own the visions of their futures. The loss of a name that had meant so much to me for sixteen years shattered my facade of calm. And my son held my hand through all of it. This was not about me.

How lonely the world must be for him—a child who cannot harmonize the image in the mirror with the image in his mind. How isolating to have none of his loved ones accurately know him. Suddenly, his longstanding refusal to have his picture taking had new meaning: Isabel hadn't just been a sullen teenager (well, maybe she was), but unwilling to document an unacceptable form of herself. Other things started to make sense too. This was why she refused to go bra shopping. Why she cried when selecting clothes. Why she would no longer put on a bathing suit to join us in the pool. Why she hugged us but kept her body distanced.

He walked me down the path of gender identity. Slowly, he educated me. A wise, old soul, he walked me right into the conversation of his true identity.

Now, I notice a new easy smile. I get hugs throughout the day, just because. Anxious habits have disappeared. Friends fill the house.

I loved her. I love him.

So, today, I say goodbye to my daughter forever.

Today, I say hello to my son: Matthew.

My Doctor-Patient Conflict

SHARON BEN-OR

"Because I don't trust any of the surgeons."

There. I said it.

When my husband asked why I hadn't called my physician's answering service, it was both cathartic and horrifying to utter those words. It had taken three and a half months—during which I had bilateral mastectomies with reconstruction and two surgeries for postoperative complications—for me to say them.

It had been simmering for at least a month. Both my surgeon and I ignored the symptoms. Irritability and discouragement replaced my patience. He responded by trying to see the silver lining and letting me know that we were close to the finish line. Instead of cheering me up, his platitudes further enraged and frustrated me.

I was depressed and crying several times a day. I felt deceived because the "finish line" never seemed to get any closer. Instead, it was pushed further and further away and was constantly being changed. I was tired of being told by everyone how lucky I was that my breast cancer was stage I, an incidental finding on my first mammogram. If I was lucky, then I wouldn't have fallen down this rabbit hole called "my cancer journey."

So I chose anger and animosity to hide my fear, my despair, and the depressive thoughts that were hard to ignore. I was in flight-or-fight mode, and I didn't have the strength to fight any more.

I didn't need my surgeon to cheer me up. I needed him to acknowledge my feelings. I needed to be heard by my doctor, but I didn't know how to express that to him. He did the best he could and tried to help me see the glass as half full, but no matter how he tried, I could only see it as half empty.

I just wanted him to say, "I know that this whole situation sucks, and I'm sorry that you have to go through this." When he finally did so, it was too late. I had lost trust in him and all surgeons.

The ironic thing about this is that I am a surgeon, and my surgeon was a friend and colleague. Perhaps I was a hypocrite for saying that I didn't trust surgeons. How did I act toward my patients who had complications? As a surgeon, I knew

that these complications were out of his hands and that he was doing everything by the book, but as a patient, I blamed him.

The next day, I spoke on a panel of breast cancer survivors at the medical school. I felt like an imposter; I wasn't a survivor yet. I was still struggling through my ordeal.

Except for me, all of the speakers were ten to fifteen years out from their diagnoses. I was only fifteen weeks out. As I listened to each of them share their stories, I noticed a pattern: there was one person on each of their treatment teams who just didn't get it. They might have been fifteen years after the incident, but I could still hear the anger in their voices. I didn't want to harbor these feelings for the rest of my life.

How do you forgive someone who doesn't know they've wronged you? I knew that to achieve closure, I had to let go of my anger and resentment.

I had to do the thing that terrified me the most: I had to shed my armor of anger and show my vulnerability to my surgeon. I had to reveal to him the frightened person inside.

One week later, I was readmitted to the hospital for a possible wound infection. My surgeon was out of town, but he visited me in my room when he returned. He sat on my bed as I sat in the chair, with my patient table serving as my shield. I saw the uncertainty in his eyes as our mutual discomfort filled the room.

"I need to tell you about my existential crisis," I said. My heart was pounding, and I was shaking inside as I told him about not wanting to call the answering service, the survivor's panel, my persistent resentment, and my need for closure.

Now came the scary part. I stared at my patient bracelet and played with it as I inhaled deeply. I hugged my knees to my chest and tried to make myself as small as possible. I couldn't look at him; I was afraid I would lose my nerve if I did. I turned all of my attention to inside myself struggling to find the words to express how I felt.

"I guess the person I resent most is you, and the only way I can think of to move on is to explain to you how I feel. Every time you have to reoperate on me, every time there's a complication, I feel like my life is put on pause. And I see everything else moving forward in the distance: my practice, life in general, my end goal, chemotherapy, everyone else. When you tell me that I can resume regular activities, I run as quickly as I can to catch up to those things, but I never catch up, because I have to stop again."

I took another deep breath in, petrified of what I was about say, as these were thoughts that I had never verbalized.

"My fear is that when I can finally start back with life, I will never be able to find those things and I will never be able to catch up with my end goal, which is having a baby. So, when I get angry with you, I'm scared that I will never be able

to get pregnant; I mourn that dream. I'm like a porcupine: I roll myself in a little ball to protect myself and let my quills hurt whomever tries to come near me."

I finally looked up from my bracelet while my body was contorted into a porcupine's ball. I was scared of my surgeon's reaction. This was going to be a turning point for our relationship.

But instead of condemnation or discomfort, I saw relief in his eyes. The stifling discomfort between us dissipated as he smiled wearily at me.

He said exactly what I needed to hear: "Thank you." Then he continued, "I'm a people pleaser, and you are too."

I did my best to stifle a sigh of exasperation . . . *Why was he telling me this?* I struggled with the urge to interrupt him. I could feel my armor of anger creeping up around me but made myself listen to his feelings.

He explained how difficult it was to take care of a friend who'd had complications. He knew this was keeping me from having a child. My surgeon looked at his hands and told me that, as a people pleaser, the only way he could cope with my resentment and anger was to ignore it. I didn't understand the emotional toll my situation had taken on him and how hard it had been for him. I realized that he had protected himself with a cloak of optimism.

We smiled at each other. I had my closure and he had his. We'd just needed to make ourselves a little vulnerable.

But I never made it to that finish line of what is called "survivorship." I shall always consider myself a cancer patient, as it has insinuated myself in every aspect of my life. The physical and emotional scars are a constant reminder to me that the life that I had—the life that I planned for—died on the day of my diagnosis and that I will never get it back. I am still learning how to reconstruct my life from the rubble of what it was.

How I Found My Voice

KAREN YETER

"All right, guys, let's huddle."

I looked up from the white piece of paper I was scribbling on to see Deepali, my senior resident, clapping her hands to get our attention. My hospital-issued scrubs felt unfamiliar and scratchy as I rushed to join. I was the last.

Deepali was flanked by John and Charlie, the interns. John was tall, with dirty blond hair, chiseled features, tanned skin. Charlie was his opposite in every way but height: a mad scientist with short black hair that stuck out from his pale, pasty face in all directions and glasses that slid to the end of his nose. Dustin and Nancy, my classmates, stood next to John. They were both over six feet tall and at the top of our class academically and vertically. The stiff scrubs that bunched at my ankles and ballooned at my waist fell neatly from their hips to the tops of their shoes, and whether because of the tidy fit of their scrubs or their academic excellence, they exuded confidence and ease. At five-foot-two, I was dwarfed by them all.

"How are you doing after your first call?" Deepali asked.

"Great. Really exciting and fun," Nancy said.

"Yeah," Dustin echoed, "it wasn't that hard."

"Yup," I squeaked out, my voice an octave higher than its usual soprano pitch. "I mean, yes, it was good. Easy peasy." I attempted to deepen my voice to sound more confident and authoritative. I was afraid that at any moment they would burst out laughing at my childish voice. I could never forget walking into the bunkroom at camp to find my so-called friend Emily dressed in my clothes, impersonating me in a babyish voice as the other twelve-year-old girls squealed with laughter. And I could still hear Fred Maxwell imitating my voice, taunting me every day during recess in fourth grade. "He just has a crush on you," my mom said. Yeah, right. People were mean.

"Karen, Dustin, and Nancy," Deepali broke into my reverie, "you'll be presenting to Dr. Freeman this morning. Dr. Freeman likes to hear very complete histories and physicals. Very complete ones . . ." Deepali paused and met our eyes, "with a very, very smooth delivery."

My heart pounded. Great. I thought yesterday, my first day of third-year clerk-ships and medicine wards, was the hardest day of my life. Looks like I had been wrong. I clutched the history and physical I'd written for Mrs. Dell and began to review it. I wondered if Dustin and Nancy felt as anxious as I. Maybe they were just really good at faking it.

"Hello, everyone!" A man with curly brown hair and glasses approached us. His long white coat hung to his knees and the fluorescent lights reflected off his shiny patent leather shoes. He was my height but carried himself like he was six feet tall. Uh-oh, short man complex.

"Deepali, introduce me to the medical students."

Deepali gestured to us. "This is Dustin, Nancy, and Karen, Dr. Freeman."

"Wonderful," he said. "I understand you're post-call and there are new patients."

"We have three to present," Deepali said. "Dustin will go first, then Nancy, and then Karen."

As Dustin recited Mr. Whitman's history and physical, I scanned my paper. Although I knew the history and physical backward and forward, I was nervous. I hated public speaking, and Dr. Freeman intimidated me. My childish voice certainly didn't help.

Dustin stumbled to the end of his presentation. "Great job," Dr. Freeman said.

Nancy went next. She also stumbled through her words and received a "great job" from Dr. Freeman.

Then it was my turn.

"Karen?" Dr. Freeman asked. I blushed, feeling everyone's eyes on me. "Dustin and Nancy delivered excellent history and physicals. Time to see what you can do."

Composing myself, I began. "Mrs. Dell is a seventy-six-year-old female with a history of coronary artery disease. She came to the emergency room with short-ness of breath." I continued to rattle off her current symptoms then went on to her medical history, medications, allergies, family history, social history, examination, labs, and imaging and a complete assessment and plan. My heart was pounding, but I knew I'd delivered a comprehensive report. Better than Dustin and Nancy. Deepali was nodding her head and giving me a smile.

Dr. Freeman was doing the opposite. He was shaking his head in disappointment.

"That was awful, Karen," he barked. "Awful! Dustin and Nancy did excellent work. But not you. That was the worst H and P I have ever heard. Ever. You'll need to rewrite it, memorize it, and recite it to me in an hour. If it isn't fully memorized and you perform it poorly the first time, then we'll continue to work on it until you have it down pat. Understood?" he asked.

I nodded, confused. Hadn't I presented better than Dustin and Nancy? I must not have been the only one confused because Deepali said, "Are you sure you meant Karen, Dr. Freeman?"

Dr. Freeman turned to Deepali. "Yes. I meant Karen. It was awful." He turned back to me. "I'll see you in an hour in conference room B." He pivoted on his heel and darted down the hall, his dress shoes clicking loudly on the slick linoleum.

Sympathetic, Deepali excused me to prepare, and I rushed to find an empty family room to practice.

The hour passed quickly. Soon enough, I found myself alone with Dr. Freeman. He looked at his watch. "Go on, Karen. Hurry up."

I began to recite Mrs. Dell's H and P from memory. I finished with no mistakes.

"That was awful. Again," Dr. Freeman snapped. I recited again.

"Awful," Dr. Freeman repeated, "again."

I did it three more times. Each time after, Dr. Freeman said "awful" and "again." Were there any other words in this man's vocabulary? I was becoming frustrated. With the sixth time, tears welled up in my eyes. My breathing became shallow, and I began to hyperventilate. Then the dam broke, and tears poured out.

"What . . . do . . . you . . . want from . . . me?" I cried. I continued to hyperventilate.

Dr. Freeman looked at me with disdain. "You need to calm down, Karen. Medical students don't cry. Doctors don't cry. I have my doubts that you'll graduate from medical school, let alone make it through clerkships," he said evenly.

Whoa! Who did this guy think he was? I did a mental pulling-up of my big girl panties and got mad. Mad at the people who had underestimated me my whole life. Mad at the Dr. Freemans of the world who always got away with their hypercritical, discouraging comments. The mad inside of me dried up the tears. I wasn't going to let this shrimpie tell me what I could or could not do, who I would become.

"Dr. Freeman, with all due respect, you don't know me well enough to judge my abilities. You heard me present one patient to you. That's it. And honestly, I did a better job than Dustin and Nancy. I did. But because of my voice and my stature, you decided to pick on me. Well, I'm an outstanding student, and I'm going to be an outstanding doctor," I finished, flushed, feeling my heart pound in my chest. It felt good to speak up, but I was terrified. *What would he say?*

There was silence. Then Dr. Freeman spoke.

"We'll see. Thanks for your time. We're done for today." Dr. Freeman pulled himself up from his chair and strode out the door.

My heart slowed to its normal rhythm. I clasped my hands together, shocked at what had just come out of my mouth. To my attending. On my second day. My words were totally out of character for timid, high-pitched Karen, and yet they felt so *right*. I might have jeopardized my grade and my reputation, but it didn't matter. Sometimes you just have to stand up for yourself, no matter the cost.

As it turned out, Dr. Freeman left me alone for the rest of my monthlong clerkship under him. I don't know if it had anything to do with his hasty assessment of me, but it didn't matter. Though its pitch was as high as it had always been, I had found my voice.

Serendipity

TORIE COMEAUX PLOWDEN

I watched while she ripped the wrapper off the scrub brush and ran her arms under the water.

"Now, first you wet your arms like this."

I mimicked her every move. My heart was beating so hard, I wouldn't have been surprised if she could hear it.

"Good. Make sure to give attention to every surface of each finger: front, back, and in between." We progressed slowly through this careful choreography, her sharp eyes focused on me, ensuring the use of proper technique.

I followed her into the operating room, where everyone was standing and waiting. Blinking hard, my eyes adjusted to the bright lights. I could hear various monitors beeping. Suddenly, my nose itched. I wiggled it briefly but didn't dare move my hands.

Everything was done in an exacting fashion. No room for error. Dry, step into the gown, then glove, now spin just so, tie the belt around my waist. I breathed a small sigh of relief when I was finished because I had not contaminated myself or anything else. I was enthralled with this room, its smells and sounds. I saw the light bouncing off of the instruments, which was somehow reassuring. There was a palpable sense of calm there.

The scrub nurse looked over at me. "What year?" she asked.

"Second," I replied.

I couldn't see her mouth, but her eyes were smiling at me. "First time?"

"Yes, ma'am."

She said, "Don't worry. Pay attention, follow directions, and you'll do fine."

My attending asked me to stand directly across from her. She and her surgical assistant finished setting up, and I placed my hands on the patient's abdomen as instructed. And then we began.

"Knife," she said. No doubt she had called for this instrument thousands of times before.

"Skin," she said a moment later, and adeptly incised the patient's lower abdomen.

The anatomy book I had spent hours gazing at came to life in front of my eyes. Two perfect ovaries, delicate fallopian tubes. And a huge uterus, containing multiple fibroids. These tumors were making our patient's life difficult, causing pressure, pain, and profuse bleeding. We were here to remove them and hopefully heal her.

Thus began the first surgical case I'd ever witnessed. We didn't typically go into the operating room until we were third-year medical students. Since my first year, I had been shadowing a pediatrician. Her practice was unique in that she had three partners: a family medicine doctor, an internal medicine doctor, and an obstetrician/gynecologist. Their practice was thriving, and among the four of them, there wasn't a child, man, or woman that they couldn't evaluate and treat. On that day, I was supposed to shadow my pediatrician preceptor as usual, but she had an emergency. Instead, she sent me with her partner, who had a full OR day.

"But, I've . . . I've never scrubbed," I stammered and bit my lip.

"No worries. She's an excellent teacher! She'll show you how."

Dr. M was a fantastic physician. She was obviously smart and skilled, but she also had a beautiful smile, a kind bedside manner, and an easy rapport with her patients and coworkers. She was energetic, powerful, and poised. When I met her, she had already been in practice over twenty years. In that single day, we did four surgical cases and delivered two babies.

I became enamored with women's health. Obstetrics and gynecology is the perfect marriage of primary and tertiary care and, in my opinion, blends the best parts of medicine. I can build long-term relationships with patients, provide them with life-changing counseling, empower them to take charge of their health and sexuality, and help them make informed decisions. I can help women decide when to expand their families and offer them options once their families are completed. I can perform simple or complicated surgical procedures, definitively treating various conditions and improving my patients' quality of life. I can advocate for patients and teach them to advocate for themselves. I have cared for women during very low points, as in cases of sexual assault, miscarriages, and stillbirths. I have cared for women during their most joyful circumstances, working to usher healthy babies into the arms of many. I can help couples navigate the treacherous journey through infertility and achieve their ultimate dream of becoming parents. This incredible field challenges me intellectually and emotionally.

Almost twenty years after I walked into that operating room, I am still so grateful that I did. I'd spent my entire life wanting to be a physician. Not just any physician, but a pediatrician. I had wanted to heal children and make a difference in their lives . . . until the day I walked into the OR with an OB/GYN.

That day changed the course of my life. I was always destined to be an OB/GYN, but until then, I didn't know it.

Pandemic

KATHARINE MIAO

My computer screen glows in the darkness of my living room. It is January 2020, and things look very bad in Wuhan, China. I scour the internet, watching in horror as officials lock down the city with breathtaking speed. Overnight, all trains in and out have been stopped and the roads barricaded. Illicit videos smuggled out of China show bodies piled on top of bodies. The hospitals are overwhelmed.

My parents are on vacation in Shanghai, and my brother and I urge them to change their flights to come back to the United States as quickly as possible.

"It's fine," they protest. "Shanghai is safe. They're checking everyone's temperature."

"Nothing is safe," I say. "Watch what they are doing. They're locking Wuhan down for a reason."

Finally, they agree to move their departure flight up to late January. "We're being very careful," they insist. Only takeout, no more restaurants. They stay in their hotel room and wear masks when they go out, but cancelations grow by the hour, and their escape route shrinks along with it. The remaining airfares are now exorbitant. They manage to leave China via Hong Kong on one of the last flights before all flights are suspended. I breathe a sigh of relief as I monitor the plane's departure. It's better to be lucky than smart.

I am nervous—nervous with elderly parents who live six hundred miles away. And nervous for myself.

We now know that the virus has escaped containment. It rears its ugly head in Italy, and it has a new name: COVID-19. It is breathtaking in its ferocity as it lays waste to Bergamo and doctor after doctor dies fighting this gruesome disease. Not enough ventilators, not enough masks, and they fight barehanded without even gloves to protect themselves. "Have you traveled to Italy?" is added to our patient questionnaire at work. I am glad my husband and I finally made a will last year.

The television shows priests praying over row after row of coffins in Italy. Maybe these are the *camici bianchi*—the white coats—the doctors who have died from coronavirus. I stop wearing my white coat at work and start wearing a yellow protective gown instead. A surgical mask. I am torn between worry and complacency.

I order twenty-four cans of tuna and a large package of oatmeal to be delivered to my parents. It's the only way I can care for them. On my days off, I go to the grocery store more often. Extra packages of spaghetti. Canned tomatoes. Dried beans. Shelf-stable milk. Above all, toilet paper. That's what friends in Asia have told us. For some reason, toilet paper is the first thing to go. Who knows why?

Surely, the virus is here in New York. But where is it hiding? We don't have any tests. Our online physician groups argue about whether it's airborne or droplet spread and wonder if there are any medications that work. We swallow our shared fear, pool our knowledge, and ask for help translating documents sent from Chinese and Italian physicians sharing their experiences on the front lines. Patients begin to ask me if they are safe, but I can only give hollow reassurances that I haven't seen anything yet.

It's February. We've heard about its arrival in Seattle, which means that the enemy is at the gates, but it's not here. Not in New York. Not yet. I do more X-rays, looking for signs of bilateral pneumonia, the hallmark of COVID-19. Perhaps we will be safe. Perhaps our luck will hold. Better to be lucky than smart.

I sit up at night trying to order food online for my parents. They have canned goods, but I want to make sure they are able to get milk and vegetables. Oranges, I think. Oranges keep well. I will make sure they get oranges. "Don't go outside," I warn them over and over. "I'll take care of everything."

"There's a lawyer in New Rochelle who's confirmed positive." My husband rolls over in bed one night and shows me the phone. It is the beginning of March, and the enemy is here. It will not spare us after all. Our luck has run out. I read the news. We are only a few miles away from where this person lives. Surely our lives intersected in some way. The bank, a gas station. My husband's eyes meet mine. We've both watched the procession of trucks carrying out the dead in Bergamo. "You can quit, you know," he says. I pull the blanket to my chest tightly. "You need to be here for the kids. Me. Your parents."

"I can't quit." We physicians have never thought of ourselves as the front line, but in this war, we suddenly are. If we walk away, who will be left to fight?

The N95 is the first thing I put on. These cheap disposable masks have suddenly become gold, and we have to make them last all day. I have a thick plastic face shield I have bought to supplement. Double gloves. Gobs of hand sanitizer smeared over my stethoscope and sanitizing spray between each patient. I sweat profusely under my gown.

The patients are no longer surprised or alarmed to see me in my attire. "Do I have it, Doc?" Their eyes are full of fear and worry. Without any tests, we can only do X-rays. One after the other. None of them has it until one of them does. I know it as soon as I walk into his room. Plump with graying hair, he is sweating profusely and has a dry, hacking cough. He works at the hamburger shop up the street.

"I'm not breathing too good," he says, wheezing audibly. A strange sense of relief overcomes me as he goes into X-ray. And I see it. Feathery branches of white patches. Ground glass opacities in a bilateral pattern. It's here now. The enemy is finally here for us to battle.

"Mom, can't you stay at home too?" My children's schools are shut down, and everyone rushes to lock themselves indoors.

"I'll be fine," I reassure them. Is it safe for me to hold them tight? *Should I lock myself in the basement and stay away from them? What if children are not as unaffected as we think? And if something happens to me, how will they go on?* I sniff their freshly showered hair. *Am I unknowingly spreading the virus to them?* All I want is to be able to protect them.

But if all of the frontline workers stand aside, who will be left to fight this plague?

Like a tsunami, COVID pushes everything aside. It's all COVID, COVID, COVID. No one can breathe, their chests hurt, and everyone has pneumonia now. Dangerously low oxygen levels and deaths. New York has now taken the place of Bergamo and Wuhan. People die alone with no loved ones nearby to ease their passing. There is no one to take the bodies. Hospitals bring in refrigerated trucks. I dare not take off my mask at work except privately, in a corner, so I can drink from a sealed water bottle I've cleaned with alcohol. I have to act like I have COVID and as if all my coworkers do too. We cannot take our masks off in front of one another. We are cogs in a spinning wheel, the little Dutch boy with our fingers in the dike, trying to do our part to keep people alive. March turns into April, and still they are coming. The days are getting longer, and the cold is finally starting to break. We are six weeks into our experience with the pandemic now. One day I am able to get tomatoes and bananas for my parents, and I break down in tears of relief. When will I see them again?

We finally get a handful of tests. Each day, I am allotted three. Pick three people. The ones most likely to have the disease. The old, the vulnerable. I practice saying "I'm sorry" to everyone else. *I'm sorry I can't test you.* They are surprisingly understanding.

One feverishly ill woman pleads with me as I apologize to her. I take measure of her dark hair streaked unevenly with gray. She is about my age or perhaps a few years older. "I'm sorry you don't qualify, but your X-ray is normal." For now. Her oxygen isn't low. Yet. A sack of groceries sits by her feet. Inside are two boxes of chicken broth and a bag of oranges. She pleads with me again. You see, she cares for her elderly parents, and they are sick. Too weak to come and get seen. Too scared to leave the house. "If I have it, then so do they. I've been the one buying groceries." She swallows hard. "I'm the one who has to go outside. I get the food for our family." I see my reflection in her glasses. "I know it's selfish of me to ask."

My breath fogs up the shield. "You don't have to explain. I understand." So far, I have been protected, so far, my family is safe. I open up the cupboard and take out the swab, and push aside my own guilt for a moment. "I'm a daughter too."

Surprise

No Small Feat

AVNI DESAI

I felt happy and accomplished as I walked into the obstetrics ward on a crisp Monday morning. I was on a yearlong internship in a small, rural hospital in India. As part of my obstetrics and gynecology rotation, I was learning how to deliver babies, perform episiotomies, and assist in C-sections. Not just the physicians but the nurses had served as my teachers. My attending often said: "Pay heed to your nurses—they are a wealth of knowledge." A sense of pride surged over me that morning as I realized how much I had learned from them. High from my recent successes, I felt like I could conquer any obstacle. Perhaps it is fitting that was the day life knocked on my door and humbled me, teaching me a lesson.

I was the only intern-doctor that day. My attending had been called to an urgent case at a sister facility and left me in charge of the outpatient ward. If I needed help, I was to page her or another doctor on call and they would respond immediately. In the outpatient clinic, there is usually oversight by senior physicians. Patients do not need to make appointments, nor do they need insurance.

Within an hour of opening, a nurse rushed to me and asked me to assess a girl waiting in line in the outpatient clinic. Not sure what the urgency was, I stepped into the examination room and noticed an angry mob surrounding us, so I asked for privacy.

I realized at once why I had been called. I was looking at what appeared to be a very young pregnant girl wearing a tiny red gown. She was a little less than four feet tall, dark-skinned, and visibly swollen. She was also crying uncontrollably, clutching her pregnant abdomen in obvious pain.

The mob around us was getting angrier by the minute. I worked with security to control the situation, fearful that if we did not, matters would escalate and result in casualties. I drew the curtains for privacy and quickly performed a Doppler. I heard fetal heart sounds through the Doppler and was slightly alarmed because the girl looked like she was less than ten years old. I tried to think through the differential diagnoses, but a scurry of thoughts worried me. Had the young man with her had done something horrendous? Perhaps he had hidden her for the last several months to conceal his wrongdoing? I was taken aback; what kind of a beast would

do that to a little child? I tried to look for other clinical clues. It was very hard to appreciate her facial features due to severe facial edema. Her blood pressure was high, and I could hear a heart murmur with my stethoscope. All signs pointed to preeclampsia, which sometimes occurs with hypertension during pregnancy.

It's strange how bias works. As a statistical concept, it is easy to understand, but it was impossible for me to fathom in advance how confounded I would feel and act when confronted with a situation like that. It did not help that I had seen a few incidents of rape and molestation in the previous month in that same setting, and those had warranted a police investigation.

I did the only thing I could: focused on my patient. I shared with her the results of the Doppler and obtained consent for the imminent Cesarian section. I was still confused about what had happened and how, but when I looked directly into her eyes, I saw a person who had placed her trust in me. She relied on me to be there for her and listen to her, even as we were surrounded by the chaos of the mob in the clinic.

The patient insisted on a physical exam for her baby before we could talk, calm in the face of a threat to her life. I respected her for that. She was clearly in distress: her abdomen was tight, and she was in obvious pain. I paged my attending, who messaged that she would be there within fifteen minutes. I shared with the patient that I heard the baby's heart sounds. It was then that she spoke.

The man with her was her husband, she said. She had "always been little" and made fun of her whole life. She was a dwarf, and her husband was not. He did not belong to the little people and had been ridiculed for choosing someone like her. Even as he brought her to the hospital, villagers had accused him of raping a minor, since they looked like a bizarre couple. He wanted to explain but did not get the chance to prove his innocence. He was occupied in caring for his wife, who was in immense pain, as her uterus could not stretch any farther than it already had. I was overcome with relief, and I felt tears fill my eyes. It turned out that there was more than one side to the story.

In my best attempt to act like a collected and calm physician, I requested the nursing staff to set up the operating room for a C-section, while I transported her there myself. My attending arrived and was followed by anesthesiology. We scrubbed and prepped, and the senior physician operated on our patient's highly stretched uterus, which could have ruptured any moment. Instead, a healthy baby boy was born, and the hospital staff greeted his arrival with laughter and cheer. Later that evening, I saw my patient again in the recovery ward. Still struggling to understand how I could have missed something so obvious, I looked at her and her baby. The answer stared at me. Her face showed typical characteristics of achondroplasia—the frontal bossing and low nasal bridge, evident now that the edema had subsided with proper treatment and care.

When I left the operating room that day, I had not just assisted in a unique surgery but had also learned more in one day than my entire life before had taught me. The lesson: never judge people or circumstances. There are always at least two sides to a story, and the truth is there if you have the patience to seek it.

A Life Saved

ANDREA EISENBERG

In the mid-1990s, I was a young OB/GYN in the Detroit area. Fresh from residency, I felt like I was at the top of my game with my cutting-edge medical and surgical skills.

Then I met Lakshmi.

With spring trying to wake up, I walked into my office to find a young Indian woman sitting with her husband and their two-year-old daughter. As I entered, I saw the young girl grabbing a ceramic bowl from my desk and her mother reaching out to stop her. The girl wiggled out of her mother's grip to run behind her.

"Hi, I'm Dr. Eisenberg," I said as I sat down. "I see you made an appointment because you're pregnant."

"This is Lakshmi," the husband said pointing at his wife. She smiled and nodded her head side to side. Her small body was swimming in her flowery blouse and jeans. "We are hoping she is having a boy," he continued.

I smiled. "Yes, I understand. You want to even things out," I said, intending the comment as a joke. He was the only male in his family. Of course, he would want a son. Little did I know this wasn't just a hope for him. There was a lifetime of cultural pressure to have a son.

Looking back at her, I continued. "I would like to ask you some questions about your health and your last pregnancy." She furtively peered at her husband, then me.

"Her English is not so good," he said. "I will help her answer your questions."

After talking in the office, I performed an exam and confirmed the pregnancy with an ultrasound. Although I couldn't understand what they were saying, they spoke excitedly as I pointed out the tiny baby's heartbeat. Their daughter seemed mesmerized by the screen and sat quietly on her father's lap, his hand absently rubbing her back.

Before leaving, the husband took me aside. "Since we want a boy, what tests do we need to do to make sure?"

I stammered, "Well, we will be doing another ultrasound in about three months. Hopefully, we can tell then, but not always. The only way to know for sure is an

amniocentesis, which is where we take fluid from around the baby and test its chromosomes. But since your wife is only twenty-five, she doesn't really need one."

That night I couldn't stop thinking about this family. "We want a boy" kept floating around my head. In residency, there were rumors of a small group of doctors at my hospital. They would see patients from Canada who wanted an amniocentesis for the sole purpose of determining their babies' genders. Most of these couples were hoping for boys. These doctors wanted no one to question them, so they did not allow residents to observe their interactions with these patients. Most of the women didn't speak English and were brought by their husbands who paid cash for the amniocentesis. They returned to Canada the same day as the procedure and got their results by phone. If the baby was not the gender they wanted, the pregnancy was terminated. I wondered if this couple wanted me to help them with sex selection, and I tossed and turned all night.

The next day, I sat staring at Lakshmi's chart. I took a deep breath and reached for the phone. When the husband answered, I said, "I understand having a boy is of utmost importance to you. I respect your honesty with me. In turn, I believe you would be better cared for by another physician."

I expected they would take the name of the OB I provided to them and move on—after all, they had just met me the day before. It is not like we had a long relationship.

Instead, over the next few days and several phone calls, the husband pleaded with me. "My wife wants you to care for her. We don't want to see anyone else."

Each time I hung up, I felt so uncomfortable. I wondered how I could ask them if they would continue the pregnancy if the baby was a girl. And even if it wasn't a girl—was I still comfortable caring for them?

I was questioning the family's values. And my values. I understood the cultural importance of having a son, but devaluing girls did not sit well with me. As the daughter of a Holocaust survivor, I understood intolerance of those seen as inferior. My blue-eyed, light-skinned mother could pass for Aryan except for the big, yellow Jewish star she had to wear and the gigantic J on her passport. She survived with the aid of those who valued her, even at the risk of their own lives.

With my heart racing and my voice trembling, I finally got out the words I had wanted to say all along. I held the phone in my sweaty hand and began. "I'm not comfortable with the idea you may end the pregnancy if this is a girl."

"No, no, we will not. We have decided no matter what, we will continue this pregnancy," the husband reassured me. Surprised and relieved, I agreed to continue seeing them.

I enjoyed getting to know them—to learn of their big family in India, his work as an engineer that brought them to Michigan, and her recent eagerness to learn

English—each visit she answered more of my questions herself. Their daughter became less shy of me and would show me her doll—who was also having a baby—as soon as I entered the exam room.

Eventually, it was time for her twenty-week ultrasound and a chance to find out if their baby was a boy. In the dark room, the husband peered attentively at the ultrasound screen. The baby was flipping this way and that, enjoying its swimming pool of amniotic fluid. With all that movement, it was tough to do all the measurements. And each time the ultrasound probe passed the baby's legs, they seemed to be tightly pressing together, making it impossible to tell the baby's gender.

As Lakshmi got closer to her due date, I felt the weight of the baby's life on my shoulders. What if it was a girl? Would she be treated as second class or unwanted? Had I influenced them to keep a pregnancy they really did not want?

On a cold wintery day—with the baby's gender still in question—my patient arrived at the hospital in labor. I was glad to be on call so I could deliver their baby. In the labor room, Lakshmi's husband stood over her as she panted through her contractions, offering her ice chips, a cool cloth, caressing her arm. When she began pushing, he supported her leg while the nurse supported the other, and he eagerly shouted "push, push." Sweat was beading up on Lakshmi's forehead as she bore down. With a few more pushes, the baby crowned. And with one last grunt, the baby popped out. Slippery with amniotic fluid and blood, I placed the baby on Lakshmi's belly as it let out a scream. I turned to look at the dad.

"It's a girl!" he shouted, his grin barely contained by his face.

When the nurse took the baby to the warmer, he followed, not wanting his baby to leave his sight. After watching the nurse place the baby on the scale and wrap her in a blanket, he took his new daughter in his arms, his face beaming with pride. Relief showered over me. A beautiful delivery, a beautiful baby, a happy family.

A year later, as I was catching up on my charting, one of my staff came back and said there was a family in the waiting room asking to see me. I looked down the hallway to see Lakshmi and her husband walking toward me, their baby in a stroller and their older daughter running ahead. "We want to thank you for what you did for us a year ago. Today is her first birthday." I peeked into the stroller—their daughter stared back at me with her big black eyes. "Would you like to hold her? We want to take a picture."

Every year on her birthday, they visited me, proudly showing off both their daughters. Each time, they had stories to share their children's latest accomplishments.

I still don't know why this patient stayed with me after that first meeting, but fate gave us this moment and it grew to more than either of us anticipated. We became more than just patient and doctor. We became family.

The Twist of the Patient Apology

DANA CORRIEL

The knife went in.

Sharp, right between the ribs. It then twisted on its axis, and slid right out, glistening in the bright lights of the examination room's overhead lighting.

I didn't want it to end this way, but it had. And there I was, wounded—clutching my stethoscope in one hand, fumbling for the doorknob with the other—searching blindly for my escape route.

Looking for the right words of closure, I made a polite and swift gesture at the door and I left.

Just like that, it ended, and I found myself leaning against the closed exam room door that separated us and letting out air I had been holding inside my punctured lungs. I had been metaphorically stabbed.

Such is the story of many physicians. Like me, they are wounded by the patients they wish to treat.

I was seeing that patient for the first time when she unleashed a barrage of insults at me after only a few minutes during an otherwise ordinary office visit.

Our visit turned contentious when, among other things, I began to tackle chronic habits—ones she clearly wished would remain untouched. Ones that I, too, always despised addressing, and yet knew that I had to, to fulfill the purpose of my profession.

But then—backlash.

I reeled from the force of her reaction. It's never easy to recover from encounters like that, when I walked through that exam room door with completely altruistic intentions.

I left feeling like I did something wrong—a defeat of epic proportions.

They taught me in school, and continued to hammer home through the rigorous years of training, that patients come in all varieties. I learned to arm myself with a thicker skin, but the reality is, I'm still a human being, and human beings break.

In hindsight, her reaction wasn't about me at all but rather about her and the issues she wanted to avoid. My attempt to engage in a difficult discussion had come

across as intrusive. It's a conversation that patients often don't want to have, even when they know they should. I touched a nerve, but my efforts ignited a full-blown attack.

On the walk down the hall to my office, I felt the weight of my unsuccessful intervention on my shoulders, and my head hung low in failure. I had given the topic my best effort because I assumed she wanted to hear what I had to say. But she didn't, and our conversation ended on a sour note. I couldn't help but think of a well-known saying: "Sometimes you have to give up on people. Not because you don't care, but because they don't."

It's never easy grappling with a failed relationship, whether with a romantic partner, a family member, or even a patient. We take them on in hopes that they will work, and it's not an easy feat to let go when they don't, no matter what transpires in between.

Alone in my office, I struggled with my defeat. My patient had spoken to me in anger, treated me disrespectfully, and I needed a bit of time to regain my composure. This was not my first such encounter, but it felt terrible each time it happened. Luckily, it wasn't a common occurrence.

But there was a twist. The patient, who'd had an epiphany of sorts, had followed me to my office. Standing just inside my office, she apologized to me. She asked if she could be given a second chance. In those very words.

I was touched.

I gave it to her without a second thought. Secretly, I also hoped that she'd make good on her promise, rather than commit with only the gesture.

It didn't really matter. Whether she meant to follow through on her promise, the recognition and admission of what she had done, and of how she had contributed to the failed encounter, was more than deserving of a second chance.

Forgiveness was—*is*—empowering. By granting it, we not only give a second chance but also acknowledge that we're human and that we err. It's a crucial affirmation, not only for the forgiven party but often also for ourselves, and it may help build a resilient bond.

This interaction got me thinking about patient apologies. Surprisingly little has been written about them, although I found a plethora of articles on physicians apologizing to patients. It made me wonder if we are held to higher standards because of the nature of our profession.

But why should we be? Doctors are human too!

My contentious patient ended up being a sweetheart. She shed her tough exterior in our subsequent visits, and we developed a tightly knit patient-physician relationship based on mutual respect. However, in a bittersweet twist, I diagnosed her with cancer a short time after her apology.

The irony was that her cancer was likely caused by those issues she hadn't wished to tackle in the first place. And here's the kicker—an even more painful turn of events—she had agreed to turn those habits around, before her diagnosis, and right after that first contentious visit!

So now we move forward together, she and I.

The diagnosis has softened her. As she struggles to find her way into full acceptance of the situation, she turns to me. She cried in my arms at a recent visit, and as she did so, I felt the anger she had held on to for so long melt away and disappear.

She was vulnerable, and I knew at that moment, that I could satisfy her needs. She had changed from a tough, angry woman, who jabbed at those in her way, to a gentle, fearful woman, who embraced reality and was prepared to face it head-on. She had a long road ahead of her and used hugs like mine as fuel.

We move through the journey together—all because of that day when she followed me to my office and delivered a rare and powerful patient apology.

The Secret Keeper

DAWN HARRIS SHERLING

"I have to tell you something," my patient of many years said in a lowered voice, eyes wide, her softly lined face held taut with anticipation. Perched on the examining table, her black hair cascading down her erect back, she could easily have passed as her daughter's sister. She had very few medical problems but appeared in my office two to three times a year for her blood pressure and other minor ailments. She normally carried herself with a lightness of spirit, belonging uniquely to those who manage to reach old age having made a peace with the world that seems to elude the rest of us. Uncharacteristically, no hint of a smile played on her lips today.

"I am sad," she said.

Just a few moments earlier, her daughter had relayed her fear that her mother was depressed. The daughter, seated in the molded plastic chair next to her mother, had told most of the patient's story. The patient herself had said very little. The normally jovial and talkative woman had been rendered unassertive and quiet in the presence of her daughter. Now, her daughter safely dismissed to the waiting room, the patient was free to reclaim her voice.

"But," the older woman now stared at me hard, the familiar twinkle returning to her eyes, "my daughter is wrong. I am not sad because of anything my family knows about." She paused. "I have never told this to anyone."

I met her gaze, trying to convey that I would keep her secret. In studying to become a doctor, I was told that I would become the keeper of a trove of medical knowledge and my job would be to impart some of this medical knowledge to my patients. This role seemed to fit me well. I like to talk, to teach, to explain. Holding my tongue was never one of my strong character traits, but I soon figured out that keeping silent and guarding secrets would become one of my daily tasks—perhaps one of my most important.

"I did not love my husband," my patient began.

I inhaled deeply through my nostrils and tried to relax my facial muscles, to soften, to listen fully. I kept my eyes locked on hers.

"You have to understand, he was a big deal in our community. A leader. A doctor. We were the first family from Pakistan to come to the area. Others soon

followed, but we were the first. He was a hero to everyone, but especially to our children.

"I was so young when we were married. He was older. It was arranged. That is how we do things. Sometimes it is a good match and sometimes not so good, but you make it work. We had to set an example. For our kids and the community, we looked like we had the perfect marriage."

"Many women from your generation tell me stories like this," I said.

She smiled knowingly, looked down, and brushed invisible lint from her lap as if deciding whether or not to go on. I admonished myself to assume less, talk less.

"My husband died many years ago," she began again, pausing as if waiting for a response. I nodded, but this time said nothing.

"The man I truly loved died a few months ago."

Tears began to pool in my patient's eyes. I reached toward the box strategically positioned next to the computer screen and stayed silent. She took the tissue from my extended hand, wiped gently at her eyes so as not to disturb the fine black lines she had drawn around them, and continued.

"He lived in the same neighborhood as we did. He was Jewish," she explained with a raised eyebrow. Whether she declared his Judaism to acknowledge my own heritage or to explain further why their relationship was taboo, I couldn't be certain.

"We had a secret love affair for thirty years," she whispered, perhaps keeping quiet for the benefit of the ghosts in the room. "He died of cancer. His kids did not invite me to the funeral. We had all been friendly in the neighborhood, and they know where I live now, so they should have invited me."

"They should have," I echoed in agreement.

"Maybe they knew," she shrugged. "We thought we had been discreet. I don't know. Maybe they just forgot to invite me."

Tears began to roll down her finely lined cheeks. She quickly wiped them away with the balled-up tissue in her hands.

"Perhaps you should just give me an antidepressant like my daughter wants. I don't think it will do much for me, but it would at least make her happy."

I smiled in spite of myself. A mother's child can be eligible for Social Security, and she will still want to please her, to ease her worry.

"He was a writer, and he was home a lot. His wife was a teacher, and she was gone most of the day. At first it was just a shared pot of tea. Perhaps I had seen him at the mailbox and invited him in. Or maybe it was he who had invited me. Can you believe I cannot remember that important detail?"

"Seems like you remember the important parts," I said.

"Yes, well, we just talked and talked for hours. For years, all we did was talk over tea. He told me his story ideas, and I told him my secret dreams of things I wished I could be doing but could not because of my position. It helped break up

the dullness of the days once my children were gone. It must have been at least three years before we kissed. But I knew I loved him before then even." The kohl was now creating little rivulets down the creases in her cheeks.

"I think he thought I was an exotic beauty," she laughed through her tears and wiped at her nose. "I thought he was the most interesting man I had ever known. Handsome too." She laughed again.

"Do you think you could share this with your daughter?" I asked.

My patient looked into the empty space in the center of the room and shook her head. This would mean the undoing of all she and her husband had spent a lifetime building.

My patient had just told me her greatest secret, and it would have to be enough. Her face, relieved of its pent-up tears, relaxed. We decided to hold off on an anti-depressant. I asked her to seek counseling. She halfheartedly said she would look into it.

It would be months before I saw her again. This time, gray hairs had emerged from her tight bun, her shoulders slumped slightly forward, her posture noticeably less straight-backed. She was changed; a bit of her light had been dimmed. Her daughter noted that she seemed more forgetful. As usual, I requested to examine her alone.

The patient hadn't seen the therapist I had recommended and was curious that I had wanted her to see one. She seemed not to remember her earlier confession. She was trying to cover her memory deficits with pleasantries, and my heart sank as I tested her short-term recall. I expressed my worries about her cognition. We did the usual follow-up tests, but I could find no obvious medical reason for her decline.

Dementia or depression? Sometimes it is both, perhaps precipitated by a mortal wound to the soul. Or maybe she had just contracted the curse of the healthy elderly. Her mind was leaving her before her body would.

Months passed, then years. My patient never mentioned her true love to me again, as if that piece of her memory had been wiped clean for her own protection. Maybe she had forgotten she had told me the story but still had vivid memories of her now-departed love. I was too afraid to ask. The secret now felt like mine alone.

To be a doctor is to be a keeper of secrets. In holding onto our patients' stories, we become the guardians of their truths, desires, and wishes. At times, the collective weight of these secrets may be a heavy burden to bear. Other days, we may find that the honor of bearing the burdens has made us stronger and capable of doing more.

I have chosen to think of my patient's life as having been a happy one. She had love, a great love, and undoubtedly was loved in return.

When the patient could no longer care for herself, she moved out of state to live near another child. Was there a moment of clarity, as some dementia patients

have, in which she confided her life's great secret to her daughter or to her other children? When her story gets too heavy for me to bear alone, I like to imagine that she did, and the children now loved her even more for sharing the complexities of her life and the sacrifices a mother makes.

Sadness and Grief

A Good Death

TEJA DYAMENAHALLI

DAY 1

"My son will be your first miracle," says the mother, with steady conviction, as we stand over her four-year-old son. His face is peaceful, belying the havoc being wreaked under the surface. His breathing tube is taped neatly at the corner of his mouth, and I shiver slightly as I feel the cold radiating from the cooling blanket laying on top of him. It seems wrong to be making him cold instead of offering him the comfort of warmth. He nearly drowned that day, and we hope the cold will slow down the ensuing destruction within his body and brain.* But I know from the sign-out I received from the daytime resident that the damage already done is great and our hopes are low. We stand in silence as I struggle to find the right thing to say.

This is my first night in the pediatric intensive care unit as a newly minted second-year pediatrics resident. This month holds the promise of interesting cases, sicker patients, and good learning. The lights are dim, and all is quiet except for an errant beep here and there. I'm walking room to room introducing myself to the families, giving them my prepared monologue about who I am and that I'd be available all night, should they need anything. So far, everybody has said only "hello" and "thank you." This mother's response, however, catches me off guard. After a moment of silence, I respond with "I hope so too," and briefly meet her warm eyes before bringing them back to her son's face. I want it to be true. I would love to witness a miracle. I know, however, that my sentiment lacks her fervor and confidence. I finish my speech and exit the room quietly after she says, "Thank you."

*In 2002, the World Congress on Drowning defined drowning as "respiratory impairment due to submersion/immersion in liquid," regardless of whether that results in morbidity (harm), no morbidity, or death. "There was also consensus that the terms wet, dry, active, passive, silent, and secondary drowning should no longer be used." Ed F. van Beeck et al., "A New Definition of Drowning: Towards Documentation and Prevention of a Global Public Health Problem: *Bulletin of the World Health Organization* 83, no. 11 (2005): 853–56.

His name is Liam. He's a handsome boy with dirty blond hair. I can't tell you what color his eyes are, but they are bordered by unfairly long, dark, and curly eyelashes. Though now, I think, the only thing unfair is that he is lying, unmoving, in this hospital bed instead of tucked in at home with his favorite stuffed animal. Liam is the second youngest of four, and tonight the bright eyes and faces of his siblings and family stare at me from the many pictures covering every wall. The report I received this evening was that the family is doing well. They smile and converse easily with one another and offer a sincere thank-you to every individual who enters the boy's room. It is humbling to experience their unfaltering gracious-ness for the care our team is providing their son even as he hovers closer to death than to life. I can't help but feel undeserving—even a little uncomfortable. What does one say when thanked by a parent for caring for their dying child? I don't have any words sufficient for this situation. At least I know it isn't "you're welcome." I respond lamely with something to the effect of "no need to thank us, it's our job." I accompany the words with a smile that hides my unease.

Though they are holding strongly onto hope, Liam's family members know they need to prepare for the possibility that he will not wake up. In their world, optimism and pragmatism are not at odds. If he does die, they wish to donate his organs. The complicated and strict process of determining which of Liam's organs are still healthy enough to be donated has been initiated. All imaging, labora-tory, and vitals data has been reviewed. Disappointingly, his kidneys are the only organs healthy enough to be considered, though we won't know for certain until the protocol is completed. We will do what we can to keep them viable.

So now the family hopes for two things: Liam's miraculous recovery, but if not that, the continued viability of his kidneys so they can offer the chance at life to others. His loved ones are desperately searching for meaning.

DAY 2

Liam is being rewarmed, and we will learn tonight what fate has in store for him. A repeat brain scan was done just before I arrived for my shift, and we are waiting im-patiently for the results. My sign-out that evening included reports that Liam's family members were showing signs of fatigue and their outward positivity was starting to crack, though only slightly. Nevertheless, they continue to be exceptionally gracious.

The CT report brings bad news. The brain has lost its elegant architecture; the gray and white matter have blended together, and the brain lacks its characteris-tic folds. It is swollen and mushy, and we can see the cerebellum, the lowermost structure of the brain, starting to protrude beyond the base of the skull. Though

we are not surprised, this CT effectively erases any remaining hope. Now we need to tell Liam's parents the news.

Four of us—Liam's parents, myself, and my attending, Dr. Bradley—find seats in Liam's room. This is not a conversation to be had while standing. I'm glad that my role is not of the messenger but of silent supporter. My attending describes the findings of the head CT and then moves on to the hard part, explaining that the black-and-white pictures on the computer screen mean that Liam will never again open his long-lashed eyes and smile at his parents. He will never again play games with his siblings as he is doing in the photos covering every wall in his room. The CT tells us that Liam is already gone, and machines are the only thing keeping him alive. I can feel my eyes burn as I see utter anguish in his parents' eyes and the final rays of hope extinguish. My eyes well as I see tears start down their cheeks and hear a sob escape his mother's throat. I turn my gaze to the walls as I feel a drop graze my own cheek; colorful photos, drawings, and messages are everywhere, depicting a life full of love, in stark contrast with the grayscale images on the computer that are illustrations of death. We finish our conversation and leave the parents to grieve and to decide what to do next.

DAY 3

Liam will die tonight; the plan was determined earlier in the day. I walk into his room and take a deep breath, letting it out slowly. In place of his hospital gown, Liam is now wearing dress pants and a button-down shirt. His hair is neatly combed, parted to one side. He looks as though he is simply napping and could wake up at any moment. The only tubes that remain are his breathing tube and one IV. There is no one else in the room; his family is attending a piano recital for his older brother. They will record the music and bring it here to share it with Liam tonight. I hold his warm hand and silently tell him that I am sorry that he was not my first miracle. After a moment, I place his hand back at his side and leave the room.

Liam's family arrives not long after, all dressed up. Their collective energy is bright. I can see the CD that his dad holds in his hands.

It is time to say their goodbyes. I watch as one after the other leaves, until only his parents remain. They will travel down to the OR with Liam to spend their last moments with him there before withdrawing support and allowing him to die. If there is a silver lining, it is that they got their second wish: his kidneys are still healthy and will be harvested. I watch soberly as Liam is wheeled out of the PICU. I will not join them in the OR, something I am glad for. I busy myself with my other tasks and patients, waiting for Dr. Bradley to return so that I can hear how it all went.

Later, Dr. Bradley tells me that in the operating room, only one screen was on, to monitor Liam's heart rate. It was silenced and turned away from his parents. Recital music played as his mother sat on the bed cradling him in her arms, stroking his hair, and his father stood close. After the music ended, his breathing tube was removed and his mother read his favorite book to him. Only Dr. Bradley knew his heart rate was starting to slow. As his mother read the final line of the book, Liam gasped twice and then fell silent. The parents were allowed a few more minutes with him before being guided out of the room.

It was a good death.

As Dr. Bradley finishes speaking, I find I can no longer control myself and tears stream down my face.

Sometimes, I Help People Die

KIMBERLY GREENE-LIEBOWITZ

My patient, whom I'll call Martin, had pancreatic cancer, diagnosed only a month or so earlier. He'd come to New York in hopes of inclusion in a clinical trial. The initial screening went well, but his abdominal pain worsened later that day. When it became intolerable, his wife, Chava, brought him to the emergency department.

When I met them, Martin was already in bed. His abdomen was distended, tense against the crisp sheets. Palms loose, fingers unfurled. Faint yellow tinged his red-rimmed eyes and cast a glow over his skin. His wife, wearing a black cloche over a dark wig, sat beside him, fingers knitted together. She had a frantic air.

I had to brace myself before I delivered the news: a scan, perhaps unnecessary, had shown a large, irregular growth in the head of his pancreas, which blocked the hepatic duct. Martin had extensive metabolic derangements and was in hepatorenal failure. In other words, his liver and kidneys were failing.

I pulled a chair up alongside his bed. He seemed to have shrunk beneath the mound of warmed cotton blankets I'd piled on top of him.

"What do we do now?"

It was his wife who asked this question, which is always hard to answer. I'm not an oncologist, so I can't really say. And I'm not a gastroenterologist, or a surgeon, or an intensivist—or any of the physicians who would inherit Martin from me. I spoke to them in generalities—perhaps a stent, or dialysis, or intensive chemotherapy—though I did not think any of these options would buy him meaningful time, and I did not know if the relevant physicians would even be willing to provide these services.

They listened until Martin held up his hand and shook his head. "No. I'm in pain all the time." He looked down, picked at the loose threads of the bedding with his free hand. "Chavi . . . the medicines don't help anymore. They haven't for a while."

Chava lifted her fingers to her lips. "Why didn't you tell me?"

"I didn't want to worry you." His voice was soft. "I think I'm ready now." A pucker formed between Chava's eyebrows. "When we came here, I thought . . . but

maybe I came for you, not me." He looked at me. "I don't want any more treatment if it means more pain. Can you make my pain go away?"

Chava began to cry. I felt my own tears threaten.

This is the conversation for which we are ill prepared after training, no matter how much we are taught. It was abstract until I was the attending physician being asked to help someone die painlessly, without fear, without futile care, in the best way possible, given the circumstances. By the time I took care of Martin, I had come to realize that sometimes the physician's goal should be to help patients die. Curative therapy isn't always possible.

This isn't an advocacy statement for assisted suicide; it is a statement of fact. All of us will die, and we each deserve honesty about which therapies won't work, how to be comfortable, how to make our time useful and meaningful. We deserve people who will help us die without pain and fear and who will recognize the limits of modern medicine and the harbingers of death. We physicians must know when to withdraw additional care and how to speak to patients and families about what to expect. So when Martin told me he was done, I nodded.

"I'm sorry," he said to Chava. "I'm so sorry."

"No." Chava sniffed, and I handed her a tissue. "I knew."

We discussed the Medical Orders for Life-Sustaining Treatment (MOLST) form. Although many patients simply sign a "Do not resuscitate" form when they do not wish CPR to be administered, it is not, in my opinion, an adequate indicator of patient wishes. Most medical situations don't present with a patient in extremis. Most are little decisions that snowball until, one day, people look at their family members and wonder how they got to where they are. No one chooses an intractable coma. First, perhaps, they decide on an intubation. Then a feeding tube. Then antibiotics. Each choice is a step down the pathway toward futile care. The MOLST form breaks these decisions out into individual questions. A healthcare proxy, armed with a MOLST form and a robust discussion, can usually advocate appropriately for his or her loved one.

Martin and his wife completed the MOLST form, signed a hospital DNR, and contacted their family members. I increased Martin's pain medication and contacted the oncology center.

I thought we were done.

Then a young woman arrived. Perhaps thirty, she wore a dark wig and a long skirt and was accompanied by a man with payos and a black hat. She barreled toward me as I came down the hall.

"You stop that DNR!" she screamed. "You stop it! You're killing my father."

I shook my head and her husband grasped her arms. "Stop. Stop." He said more in Yiddish, words I did not understand, and shook her when she began to cry.

"She's killing *Abba.*"

"No." I shook my head. "He asked for this."

"You go in there and change his mind! He doesn't know what he wants. How can you take the word of a sick man? His judgment is clouded by his cancer." She launched into a torrent of Yiddish, directed at the husband.

"Please," he said to me, "this is against our religion, you know?"

I shook my head. As a Jewish woman, I know our religion does not forbid us to refuse medically futile care and does not demand that we die in pain. While we should not hasten death, neither are we to attempt to prevent that which is inevitable.

I got a chaplain, and we sat down with Martin's daughter.

"This is what he wants," I began. As gently as possible, I explained the medical findings: obstruction of the hepatic duct, large volume of ascites, liver and renal failure. Jaundice, itching, abdominal pain, nausea. Fatigue. Terminal illness. Hours, perhaps days, with or without medication. Her shoulders fell as I spoke, and when she left the room to see her father, she was wilted. Her husband helped her down the hall.

Martin was admitted to the hospital that afternoon and died the next day.

I never saw his family again, but I wonder if I helped them let him go. This family, in their private moment of loss, embodied the sacred privilege of medicine: the inclusion by patients and families in their most personal, vulnerable times, when we offer a hand to those in their hours of greatest need and comfort them as we help them make their difficult and final choices.

For Better

HEATHER GOODEN

I knocked on the door, wondering if he'd heard me over the TV. He opened up and smiled when he saw me standing there, awkwardly shifting my bag and jacket.

"Oh, it's you, Doctor. Come in, come in. The clinic called, and I got worried something bad was in the bloodwork."

I rushed to reassure him. "Oh no, nothing like that. I just wanted to make sure you knew the results. Mostly everything is fine."

He looked at me seriously. "Nothing about the cancer then?"

I shook my head, giving him a reassuring smile as his eyes flicked to his wife and then back to me, hoping I would say everything was fine.

"No, nothing like that. Your blood is fine—no sign of anemia, or elevated white blood cell count or low platelets. Your kidneys are good too. Everything is completely normal."

He sat at the small table where they shared their meals, and I watched his face relax, the relief traveling down to leave his slightly stooped, softly rounded shoulders.

He looked over at the couch at her while she starred at the TV, oblivious to his regard or my presence, watching a game show with a dull, disinterested affect.

He looked back at me, then confirmed what I already knew.

"I need to live long enough to take care of her. That's all. I'm ready to die any-time, but I can't leave her alone. She's not right anymore, you know that."

He called her name, and she looked over at us, at my big smile, then smiled back blankly.

"Oh, hello," she said politely, with glazed, absent eyes, before turning back to watch the TV again.

"How are you guys doing? Is the home care enough still? Or do you think you need more support in any way?"

With his cancer and her memory—gone at least two years earlier—I always tried to make sure he had enough help looking after her. Things were getting harder for them. Unless they needed something urgently, I stopped by to see them. It saved him the drive to the clinic and the worry if he couldn't bring her with him.

He didn't like leaving her alone, but it was getting difficult to take her places. It was too much work and stress for them both.

"No, no, we're fine, just fine. I have my kids if I need help, although my son has his own medical problems, and home care helps with her baths. I'll ask for more help, I promise."

I looked at him for a while, but he met my gaze with clear, strong eyes that never wavered. He may have been old, but he had his convictions, and he possessed dignity in abundance.

"As long as you ask, then."

I trailed off, knowing that things would have to get much worse before he asked, but he had his pride, after all.

She was his responsibility and had been since the day they said, "for better or worse." He came from a time when that meant forever, not until things got tough. The last time he came to see me in clinic, he told me how they met. How they'd gone on a date and then she'd disappeared for a year before turning up again with a smile. He'd thought she hadn't liked him, but instead she'd moved to help a friend but then returned, looking for him, once that situation sorted itself out. He told me he'd made sure not to lose her again and proposed as soon as he was able.

I had watched them for years. She'd been brighter when we'd first met, able to hold a conversation and ask her own questions. She'd nagged him like the old wife that she was, and they had bickered in the office, the way only couples long married can.

But she had slowly drifted away from him over the last few years, going on ahead of him.

He anchored her down, his love refusing to let her float away completely before her body was ready. He knew it, too, but we rarely spoke of it.

They say dementia is an end-stage disease. It steals the personality in bits, sometimes letting it visit, before taking another chunk. Each chunk takes the afflicted further from the ones who love them.

It causes a family to grieve loss after unimaginable loss of a loved one's unique essence, long before their body dies.

You see, everyone knows.

It's too painful to speak of, the howling grief that leaves them with an imposter, only a shell of the person they love.

We talked a bit, and his eyes got bright when we spoke about planning for the worst. He walked me to the door, and we shook hands.

"We're doing good here, don't worry. We'll be just fine."

I smiled and left, walking down the hall of the complex where they lived and hearing my footsteps echo down the hall.

For better or worse, in sickness and health. I wonder if we can ever understand those words until we live through them.

Choosing to Die

SUZY FEIGOFSKY

I was thirteen years old when I developed a fear of dying. I don't know what triggered it, but I remember sitting in my room, alone, worrying about the fact that I could die. It was the first time I was aware of my own mortality. I felt anxious, knowing that my life could end, and it was out of my control.

I chose a career in medicine because I wanted to preserve and improve the quality of life. Death was never on my radar. Prior to medical school, I had never seen someone die and I had never been to a funeral. I had *zero* experience with death.

My first exposure to human death occurred when I walked into the anatomy lab. I was completely unaware of my naïveté. As I reflect on that day, I realize that I had never dealt with the emotions associated with death—terror, sorrow, and curiosity—and I didn't then, either.

When my primary goal was education, it was easy to distance myself from my emotions. There was a finite period of time to learn an extraordinary amount of information, and it was easy to forget that I was caring for people.

Four years passed, and I entered residency. I remember my first code like it was yesterday.

I was the first one to arrive. I found the patient in the bathroom and dragged her to the floor of her hospital room. She was heavy, and she had brown fluid coming out of her orifices. I was terrified. I felt her ribs break as I did my first compressions, and I was relieved when others ran into the room. There was an awful smell, and the wet knees of my scrub pants stuck to my legs as I knelt beside her in a pool of fluid. I felt intense sorrow when I could not save her. That was how I saw death for the first time.

I believe we should all die with dignity. In our society, we spend a lot of time planning our funerals, picking our caskets or urns, deciding what hymns will be played, who will give our eulogies, and the place we will spend our eternal sleep. What we *don't* do well is determining *how* to make the transition from here to there.

For the entirety of my education and training, I never saw anyone die a natural death. I saw people die under the care of a medical team desperately trying to

do everything in its power to keep them alive, but I had not seen anyone, in the words of Dylan Thomas, "go gentle into that good night."

I had never seen someone choose death.

About a decade into my career, I was asked to "turn off" a pacemaker on a hospice patient. He was unresponsive and completely pacemaker dependent. Our medical guidelines clearly state that a patient has a right to remove or turn off life-sustaining medical devices. I had never done that before.

After work, I packed up the device programmer and made my very first house call. It was dark, and I was in an unfamiliar neighborhood. A hospice nurse greeted me at the door and asked me to wait in the entryway until the family was ready for me.

The nurse brought me back to a small, dimly lit bedroom where a man and woman stood by a bed. In the bed was a thin, elderly man who did not seem aware of my presence. The hospice nurse, who was there to provide medications and keep the man comfortable, sat down at a small table by the foot of the bed. I opened up my programmer and plugged it in and then explained that I was there to turn off their father's pacemaker, which his heart depended on to continue beating.

His bony chest rose and fell as he breathed, and he did not move or open his eyes. My hands trembled as I placed the programmer over the pacemaker on his chest. Slowly, I lowered the pacemaker's rate and reduced its electrical output. My heart was beating as fast as a hummingbird's, and all I could do was take deep, slow breaths.

"Okay," I said, "It's done."

"Is he dead? Is he dead?" his daughter asked.

"No, he's still breathing."

"How long will it be?" his son asked.

"I don't know," I said.

I felt like a fraud. I was a doctor. I was standing in their home, and I had no idea how long it was going to take for their father to die—I *really* had no idea. I had never seen anyone choose to die.

I stood awkwardly at the end of the bed. Thrust into an intimate moment with complete strangers, I did not know what to do. I was not this man's physician, but I was the only one willing to follow his wishes.

My machine was plugged in at the head of the bed but I stood at its foot. To unplug the programmer, I would need to walk between a dying father and his children, and I didn't know what to do. *Could I just take my equipment and walk out the door? Was I supposed to stay? Was I supposed to say anything?*

These questions swirled in my brain. It felt wrong to leave, so I stayed, and when the rhythm of his breathing changed, the family looked at me for guidance.

"Is he dead?" they asked.

"No, he's still breathing."

I fidgeted as I stood there, trying to find somewhere to look, wishing I could escape the room, the moment . . .

After some time, his children stepped out, and I was left alone with my patient, a complete stranger who allowed me to be with him during his final moments.

I sat down next to the head of his bed. I held his hand and watched him breathe. He took quick, shallow breaths then slow, deep ones. Sometimes he paused or gasped. I patted his hand and told him everything would be okay.

I had no idea how long it would go on. I had never seen anyone choose to die.

After a few minutes, his children returned, and then we were in the room together, silent, looking at him, at one another, and waiting.

I have no idea how long we stood there. Perhaps it was thirty minutes, but it felt like hours.

Suddenly, his face changed. He squinted and then his eyes relaxed. Then he squinted again, as if he were looking at something.

Eyes squinting, relaxing, squinting, relaxing.

Then there was a tear, and a smile, and a deep sigh. His children looked at me, and I nodded. No words needed to be exchanged. After a moment, I went to the head of the bed, unplugged my device, packed up my belongings, and left.

I went to my car and sobbed.

I had never seen anyone choose to die. It was not traumatic. It was not exhausting. It was not inhumane.

I remember the terror, sorrow, and curiosity I experienced in the anatomy lab when I first faced death, but after this experience, I add another emotion: gratitude. I am forever grateful to that family for allowing me to be present for one of life's most intimate moments. I faced my biggest fear.

I do not need to be afraid. I do not know what happens after we die, but I do know that what that man saw was beautiful.

"What Do You Do, Mommy?"

An Oncologist Answers

SHIKHA JAIN

I wish I could be one of those working moms who comes home from work and talks to my kids about the details of my day over dinner. While I listen to my daughter share who she sat next to at lunch and I listen to her dad tell explain how he helped fix someone's tummy ache (the best way to describe to a five-year-old and two two-year-olds how a patient can feel better after medical management of a partial small bowel obstruction), I wonder when, if ever, will she be old enough for me to share with her what I really do. She knows that Mommy is a doctor and that I go to work to take care of sick people. Will she ever be old enough for me to come talk to her class about what I do for a living? How would I ever explain to these tiny faces that sometimes I have to have heartbreaking conversations. That my patient had to tell his daughter that his cancer might not let him live until her September wedding, and he asked her through tears if she could move the wedding up to June so he could walk her down the aisle. And how could I tell her about the end-of-life conversations I have with my young patients who still have so much left to live for. And the powerful conversations on the difficulties that accompany not only existing with a cancer diagnosis but living with it and trying to continue life with as much normalcy as possible in between chemotherapy visits and CT scans that elicit anxiety every few months.

Even adults don't want to hear about my day. During my internal medicine residency, my friends would love to hear stories of the outlandish things that would happen at work. These stories made great conversation starters when I was out to dinner because they gave my nonmedical friends a peek into the intriguing world of medicine. Now even other physicians don't want to hear my stories. No one wants to know about the young woman with metastatic lung cancer who no longer has any therapeutic options, or the young man with metastatic colon cancer and three young children. This can be the isolating world of an oncologist.

"But there are other stories too!" I want to shout. Yes, it is sad that my patient with metastatic lung cancer passed away on hospice last week, but his is actually an inspiring story. While he was on hospice, he was able to reconcile with his brother, and they spent his last days catching up and reminiscing. He enjoyed time with

his family in the comfort of his own home, surrounded by his memories and the people he loved. When he passed, he went peacefully and comfortably, which is what he wanted, and his family thanked me for helping them with the transition from active treatment to hospice and comfort care.

Can I tell you about my patient who thought she only had months to live and set out to complete her bucket list? Her husband planned a prom for her, she has traveled all over the world with friends and family, reconnected with numerous people, and now two years later she is still alive because of a new immunotherapy agent. Her clinic visits consist of discussions of what adventures she can add to her bucket list because she finished the last one. One of my truly inspiring patients has metastatic kidney cancer, and has run a dozen marathons. He even ran the ten miles home from the clinic after one of his infusion visits.

These stories, and these lives, are so remarkable; and the ways families, friends, and communities come together to support their loved ones going through challenging times is inspirational. Through my patients, their stories, and their families, I have found beauty in unexpected places. A father with three children makes sure he times his anticipated chemo side effects around the dates of his children's swim meets and college move-in weekend. A woman choosing hospice moves to California so that in her last few months she can spend quality time with her daughter and special-needs grandson. The decisions my patients make, and the glimpses I have into their lives, is extraordinary. I chose oncology because I saw the strength these patients showed, and I wanted to help them through their journeys however I could. While cancer can be a scary diagnosis, there are so many different ways one can approach it. How we as oncologists face these conversations and encounters with our patients will often determine the shapes of their journeys.

There will come a time in each physician's career when she will have to deliver bad news to a patient. From that day onward, those patients and their families will forever remember her face. She will be a permanent part of their story. This holds true in all fields of medicine. The person who tells the ICU patient's family that nothing more can be done or the oncologist who goes over scans indicating the cancer is not responding to treatment will never be forgotten. That is an enormous responsibility.

In medicine, we are trained to compartmentalize our feelings and try to stay professional—not only for the sake of objectivity but also for self-preservation. But it is also important while compartmentalizing not to lose the human element—especially the compassion and empathy—necessary to help patients through difficult times. I have seen those who become detached and start to lose their ability to deliver the news empathically. I have also seen those who cannot compartmentalize and have a very difficult time being honest with patients and their families. It can be difficult to find a middle ground.

I work in a field where we discuss various aspects of life and death every day. We talk about end of life, quality of life, goals of care, longevity, progression-free survival, overall survival, statistics on the number of months a person may or may not have left, and percentages or odds of how long one may live. These are emotionally charged and often difficult discussions for both patient and physician. But maintaining one's humanity and empathy are what makes an outstanding physician. These are the types of things I would talk about if people wanted to hear about my workday. I can see the beauty when other people see sadness and hope when others see despair.

As oncologists, our day-to-day lives are full of emotional ups and downs, and no one wants to hear many of the stories because they force us to think about and accept our own mortality, which doesn't really make for good dinner conversation. In spite of my career, I have never really sat down and thought about, or discussed, my own mortality or that of my family members. As I grow older, I see myself and my family in my patients' stories. With that introspection comes a deeper understanding of and appreciation for what my patients and their families are going through. Having children has made me face the fragility of life, which has made me a better physician and a more empathic oncologist.

I cared for a young man with metastatic cholangiocarcinoma, a very aggressive cancer. But his diagnosis isn't what sticks out in my mind. He had a twin brother. Three years after my patient's initial diagnosis, I stood with his brother and wife, and we discussed end of life and palliative care. I cried with them as he made the decision to enroll in hospice. His twin shared that he felt a part of him was also dying. His father later told me that although I had only been in their lives a short time, our conversations had helped them make the transition to the next part of his care in a way that made it easier for all of them, and words could not express how much they appreciated it.

My patient and his family did not need statistics on cancer survival rates or side effects of other potential therapeutic options; they needed guidance to make the transition to a different phase of care that focused on aggressively managing symptoms and ensuring their brother/son/husband was without pain and at peace in his final days. I hugged my children closer that night and felt a profound sadness for my patient and his family and a life lost too soon. I read *Goodnight Moon* to my twin sons and tucked in my daughter, and reminded each of them how much they were loved. That is how I could share my day with my family.

Until my children are old enough to understand, I will continue to tell them that Mommy takes care of sick people. As far as their young minds know, Mommy is magic and can take away everyone's pain and make everyone feel better. I tell them about the successes, the hugs I get from patients, the cards, the weddings and the graduations, the celebrations, and the conversations we have, and, most importantly,

the love I see on a daily basis in my clinic visits. But I will protect them from the heartache, and the struggles, because that's what a mom does, and that's what a physician does. We take our work home with us, but then we put it away until the next morning, when we walk back into the office. And maybe one day, when they are older, I can share with my children what the art of medicine is, and why I love what I do.

Balancing Act: Physician Parents

The Transition from Doctor to Mom

SASHA K. SHILLCUTT

It's early morning, and I'm driving against commuter traffic. I leave the hospital as fast as I can so I can get home in time. I need to see my crew, my four kids, before they leave for school. I'm exhausted and teetering between numb and jittery, the effects of coffee stimulating my fatigued nerves. I want to see my children's faces and smell their freshly showered skin when I kiss them goodbye. I need to be their mom, even if only for a few minutes before they rush out the door.

I need it.

I left for work yesterday, over twenty-four hours ago. What day is it? Is today Wednesday? I'm not sure. My mind starts to calculate, as my oldest has a doctor appointment this week and I'm on deck as his ride. Is that today?

I can't remember.

I walk in the door to the morning hustle and bustle and make a beeline to start the coffeemaker.

"Mom, I need you to register me for this weekend's dance performance," my daughter tells me as she walks down the stairs. My brain tries to take note, but it's as if I'm struggling to reach for a pen I can't grasp.

"Do we have pipe cleaners?" my youngest son asks from the pantry. "I need them today, Mom! Did you see the paper from school? Pipe cleaners!"

My second oldest is sitting at the island eating breakfast and wearing earphones. He's laughing at something on his phone. I wave at him and he nods. I go to hug him, interrupting his scrolling. His body stiffens, and I ignore it. I hug him harder; he softens. I think he hugs me back. He's thirteen. He doesn't realize how many hugs he needs.

I hear my oldest barreling down the steps. He's late, and his face is all business. He strides to the fridge, and then he sees me. He smiles and comes in for a bear hug. He's an expert at recognizing what I need in my post-call zombie state. I had him my first week of medical residency, and he's only known me as hybrid mom-doctor. His hug energizes me. "Is your math test today?" I ask. "No, it was yesterday," he says.

What day is it again?

My phone dings. It's the hospital with a question about a patient I took care of overnight. I need to respond. I notice sixteen emails came in on my drive home. My brain starts to make a list. Where is the pen? I need a pen. I need to write things down.

"Have a good day! I love you!" I yell as they load into the car with our nanny.

"Love you, Mom!"

I'm not sure who said it. It doesn't matter. I saw them. I hugged them. They are okay. They are alive, and they are mine. I am blessed.

I think back to the three surgical patients I cared for in the last twenty-four hours. I think of how they are someone's blessing. They are hug-givers and pipe-cleaner-finders. They are moms, dads, brothers, and sisters. Grandparents.

I think of how much we worked to keep them alive, and my mind goes to my last patient. I reflect on how tenuous it was, how each heartbeat was hanging in the balance. I wonder how he is doing now in the critical care unit, and I am instantly thankful for my partners who are watching over him now.

Medicine, like parenthood, is simultaneously the most rewarding and the most exhausting job in the world. It is a mix of highs and lows, unknown trials and assured wins, heartache and joy.

I can still hear the beep, beep, beep of the pulse oximeters echoing in my ear as I shower. I climb into my bed and shut my eyes. I have a few hours to rest until I am "Mom" again. Until I am "Doctor" again.

"I don't know how you do it—being a mom and doctor," people say.

This is how, I think.

Just like this.

Forty Is Greater Than Twelve

ROHINI HARVEY

The text from home came as I left the room of a confused older man. He couldn't tell me if he'd had any more chest pain since I last saw him, and he didn't know the year or the president, but he'd happily chattered on, allowing us to have a lovely conversation about nothing at all, my hand on his for reassurance. His family wasn't there that Sunday morning. Presumably, his loved ones were off doing normal weekend things like attending church (they're quite religious) or maybe having a leisurely breakfast with coffee, doughnuts (glazed are his favorite), and the Sunday paper. For me, a Sunday at work meant no meetings, no frantic calls about billing issues, no administrators, colored jeans disguised as work pants, and maybe, depending on how the week went, a hoodie sticking out of the back of my white coat. It meant I had the time and mental space to sit with my patients.

I relished that contact because the day was otherwise lonely. I left in the morning before our house woke up. The roads on my way in were quiet and dark, and even the hospital, normally a bustling city with its own characters and neighborhoods, felt like a small town on a forgotten highway.

In the artificially bright hallway outside of my patient's room, the text reminded me that my husband, Andy, was home with our twin girls that weekend. My mind played and replayed our girls protesting when I tucked them in the night before: "Mama, I don't want you to go to work! Why do you have to go to work, Mama?!" Even with a few deep breaths, it was hard to reframe my guilt.

It was basic math: If there are fifty-two weekends per year and a hospitalist works twelve weekends each year, how many weekends per year does she not work? Forty! Hey, forty is greater than twelve! Forty is greater than twelve—a lot greater—I told myself, but the mantra wouldn't stick in my brain.

I slowly walked to the next patient, staring at my cell phone. The text was a photo of Andy and the girls at a birthday party. It was slightly blurry, but I could see it clearly enough. Andy was balancing with the girls on roller skates, all three bathed in red neon light. My daughters looked like wide-eyed foals with knobby legs and huge, wheeled feet. Both had their torsos leaning forward, inner arms bent, one hand clasping their father's, and outer arms held out straight like tightrope walkers.

Andy showed none of that symmetry. One of his pant legs fell over his skate while the other was tucked into the boot and, inexplicably, the opposite shirt sleeve was rolled up. Staring off, perhaps at some danger like a fast kid on roller blades careening toward them, he wore a crooked half smile and one raised eyebrow. A friend sent the photo, with the caption: "Working on your Father of the Year award!!"

"Father of the Year." Obviously, I was not "Mother of the Year," because instead of supporting my girls on roller skates I was enjoying my day at work talking about doughnuts with an old man who didn't even know if he had chest pain. I paused, stared at the speckled linoleum floor tiles, and grasped the varnished wooden handrail that wound around the unit. If it had been me alone at the party, I wouldn't have been able to hold up my wobbly daughters. And then I heard it again: "Mama, why do you have to go to work?"

I knew I should be proud of my husband, who determinedly towed ninety pounds of kids on wheels. I knew I should be proud of myself, a physician who spent time with her patients. *Forty weekends are greater than twelve,* I told myself. *Forty is greater than twelve.* The words thrummed through my sour thoughts like a drum, pushing me through the corridors for the rest of my workday.

I finally released the tight grip on my emotions that night, as the girls and I relaxed into each other on the couch and read out loud. I marveled at how even as wise first graders they felt comfortable draping their pajama-clad bodies over me like infants. We were there, together. The three of us snuggled deeper into each other, getting lost in our book, one of my childhood favorites, each chapter still familiar after so many years. As we read, one of the girls pulled a blanket up over our heads. The light shining through the pink fleece unexpectedly shimmered with flecks of rose gold. We looked at each other and all said it together: "We're in a fairy cave!" Two heads were on my chest, four legs no longer knobby without the skates and twenty soft, bare toes were tucked up over me. It was pure warmth.

"Mama?" asked the younger twin.

"What, sweet pea?"

"Did you see grown-ups or kids today?" Ah. Our routine.

"I saw grown-ups."

"What kind of sick were they?"

"Well, a lot of people were breathing sick, some heart sick . . ."

"But how heart sick?" Her forehead wrinkled.

"That's a good question. You know how you need oxygen to breathe and to keep your body healthy?" Both girls nodded in the shadowy, sparkly light, their eyes wide open. "Sometimes part of the heart gets all blocked up and so the oxygen can't get to it. And it makes their heart hurt."

"Are those people going to be okay, Mama?" the older one asked.

"Are they going to die?" from the younger. The girls had a sense that hearts are important for living.

"It's okay, they're going to be okay. They're lucky that they have a lot of doctors and nurses helping them get better."

"I'm glad that they have you to help them, Mama. You're really good at helping us when we don't feel good." Now it was our turn to clasp hands.

"Thank you, my loves."

We sat in silence for the last moments before sleep, enveloped in fleece, fairy dust, and each other.

Sometimes Doctor Mom Is Just Mom

JASMINE R. MARCELIN

When I was a third-year internal medicine resident, just a few months from graduation, I still considered myself Supermom. If someone told me I was like Wonder Woman, I'd nod, shake my head, but then nod again. After all, I worked eighteen-hour days, took care of daycare pickups and drop-offs, prepared meals, and still managed to publish my research.

One Saturday in early May that year, my two-year-old son and I were out with some friends. The snow was finally gone, the sun was warm on our shoulders, the birds were chirping, and the parks were bursting with a rainbow of colorful flower blooms. The park welcomed us with smells of barbeque and smoke and hot dogs. We had prepared warm chicken wings dripping in barbeque sauce, grilled corn on the cob, potato salad, and ice-cold lemonade. The kids had just finished playing, and we settled down to eat. My friend had found a nice bench under a tree in the shade, and my son sat next to me. The wooden bench was low to the ground, and my son was excited about being outside, with friends, in the park. I kept reminding him to keep still while he was eating so he would not choke.

Even though I was Supermom, it took a moment for me to realize he'd fallen silent.

I turned toward him, and found him lying on the ground next to me. I picked him up and he seemed to all right; a little subdued, perhaps, but no tears. But then I looked closer and found his right arm was contorted into the shape of an S. Heart pounding, I looked for signs of bleeding or other injuries.

Remarkably, he just stared at me. I tried not to draw attention to his snake-arm but I could feel the blood rush to my head, replacing every iota of medical knowledge with irrational panic.

I turned to my friend's husband, who was a radiology resident, and asked, "Do you think it's broken?"

He looked at my son's arm, gave me an odd look, and looked at his wife, who was my coresident in internal medicine.

I knew that look. It was the "Is she serious? Like, really serious?" look.

With a kind smile—and probably suppressing his laughter—he said, "I'm not a radiologist *yet,* but yes, it appears to be *quite* broken."

I looked at the snake arm again and asked, without an ounce of sarcasm, and perfectly straight-faced, "Do you think I can put it back together?"

His eyes widened. By then, he couldn't suppress a huge grin.

In that moment—after four years of medical school, almost three years of internal medicine residency, and an entire lifetime of learning common sense—I was not a doctor. I was a very anxious, panic-stricken mother, and all I knew was a drowning sensation of helplessness.

It doesn't end there.

"What should I do?" I asked.

"Take him to the emergency department."

I stared at them blankly. "Where is it?"

Torn between pity and laughter, my friend offered to accompany me. My question would have been perfectly legitimate if we were in a strange town, but we were in Rochester, where I was in training. And I knew that emergency room quite well. But in that moment, there were no maps in my head, no functioning logic. I could only think about the snake arm.

Given my state of mind, I can't imagine why my friend let me drive, but despite not consciously knowing where I was going, I drove us there safely. En route, we called my husband, at an urgent care shift about an hour away. Once I got into the hospital and my son was receiving care, I started to relax a little, and bits of medical knowledge returned. He got ketamine for sedation, and I knew what that was. I remembered his medical history and that he had no allergies. I reviewed the X-ray with the medical team and recognized a displaced fracture of his radius and ulna. By the time my husband arrived, I was a physician again—asking medical questions and thinking about my son's future medical needs. I was my old self.

But that other self—the irrational, panic-stricken, and probably entertaining mother—was me too.

I've been the physician providing care in the setting of a "family accident" and can appreciate how harried I looked, how frazzled I sounded. I know how other mothers look. Now, when I look at that moment when I wasn't "Doctor Marcelin," I realize no one truly expected me to be. In a moment when my child was hurting, all I could ever be was "Mom." And that's okay.

Doctor Mothers

MONICA KALRA

The harsh sound of the alarm shook me from a half-wakened state. My mother lay beside me, breathing heavily. For a moment, I was confused, wondering where my husband was. Then I remembered: Vik's father was in a hospital in Houston, and he had gone to be with his family. And today I was returning to my residency. My mother was beside me because she had left her comfortable teaching job to help us out until we found a nanny.

Exhausted, I stumbled out of bed. Everything was cold and dark as I pulled half-wrinkled scrubs over my healing body, including an almost flat belly that had carried life just five weeks ago. On my way out the door, I paused by Bella's crib to touch her warm skin. She was my baby, and I was leaving her in someone else's arms while I left to care for children who weren't my own.

As I entered the main pediatric hospital in the heart of one of the busiest medical centers in the nation, I was struck with the realization that maternity leave was over. It was my first day of inpatient pediatrics, and an onslaught of door codes, stretchers, and frantic parents reminded me I was a foreigner in the small town of severely ill children. Giving birth had happened five weeks earlier, and it seemed irrelevant now.

Two weeks later, we'd settled into a new routine. Vik's father, who had suffered a massive heart attack, remained in the ICU. Plastic tubes invaded his every orifice while artificial ventilation kept him alive. The most important organ in his body was pumping at 10 percent of its normal power. Until that point, his primary medication had been the turmeric in his food. At sixty-eight, he was a normal weight, never smoked, rarely drank alcohol, and consumed a healthy diet—his health was relatively unscathed by his years on earth. But heart attacks were common in his family, and genetics won the last hand.

Vik flew back and forth every few days to see his dad. My mother left after we found a nanny who understood she was on twenty-four-hour call, seven days a week because of our erratic schedules. Bella was quickly weaned off breast milk because my body couldn't sustain her demands. It was an inadvertent blessing.

At work, I had good days and bad. Days when we effectively oxygenated an asthmatic child's lungs. And days when we watched a teenager fail chest compressions after a motor vehicle accident.

Most days were in-between—cases of gastroenteritis, appendicitis, broken bones. Sometimes, under the stale blanket of the call room, I lay awake, thinking about the children writhing in the beds nearby.

Intern year is a time of growth and reflection. Medical residents learn from the sickest patients and fight for the ones wrangling with their own mortality. Interns bring life into the world and withdraw care on the same day. Most importantly, they serve some of our most vulnerable populations as a voice for those who can't speak for themselves.

Morning rounds were a daily ritual, medical staff huddling around a table, discussing overnight admissions and divvying up patients. The descriptions were concise and objectifying: ten-year-old in diabetic ketoacidosis, infant with dehydration, seven-week-old with blistering rash, left alone in car with soiled diaper.

As a new mother, I found all the babies intriguing. But that one, even more so. He was left *alone.*

Noah was born two days before Bella but under starkly different circumstances. Noah's parents were teenagers, smoking marijuana a few yards away, while he was left in a car for hours—crying, hungry, neglected. His skin was a battlefield of craters, exuding fluid from each pore.

Shortly after birth, Noah was diagnosed with epidermolysis bullosa, a rare genetic disorder. His skin sloughed with any hint of pressure or touch, to the point where he couldn't be touched at all. I imagined his young mother's face, contorted with fear as she first witnessed his skin fall off. Inevitably, this evolved into detachment as she realized he would never be "normal."

Three weeks after his diagnosis, Noah was left alone in a car.

The next two weeks, I spent every free moment in Noah's room, checking on him, waving stuffed animals in his line of sight, reading him a story as he fell asleep. The deep contrast between his life and Bella's lingered in the back of my mind. I seldom saw our daughter, but she had redefined my ability to love. Bella had a library of books waiting for pages to be turned, while Noah's room was sterile, void of Caldecott Medal books, love, and, most importantly, touch. He had nothing embracing his frail little body except the bandages.

Noah lay alone most of the time. No family members came. No arrays of hydrangeas wilted on his windowsill. His only disruptions were bottles placed in his mouth or IVs infiltrating his veins. His limbs were covered in gauze dressings, protecting his skin from any hint of friction. And as his wounds slowly healed, we needed to find Noah a new home.

Caring for a child with lifelong disabilities is challenging. Noah would need weekly dermatology, physical therapy, and nutrition appointments. He would need costly dressings and ointments for his evolving wounds. Changing Noah's diaper, feeding him with a bottle, or soaking him in a tub required extensive planning and time. I worried we would never find a family who fully understood or accepted the complexities of Noah's condition.

A few days before the end of my inpatient pediatric rotation, Vik's father died, and on the day we cremated him, we also found Noah a place to live. As the embers lit the pyre, a fellow intern called me with the news. A loving couple would take Noah home. I would never know if Noah would become a healthy, sassy preteen like my daughter is now, but I would always wonder. His diagnosis had changed the trajectory of his life, possibly for the better.

When I left the pediatric hospital for the last time, the large metallic doors clanged behind me. I left Noah in his barren room, waiting for his new family, to go home to a husband who had lost his father and a daughter who had forgotten her mother.

As I walked away, I watched the golden sun disappear behind a concrete canvas. It was my last glimpse of light before night fell. Similar to each patient's story, it's this glimpse of hope through the aperture of disease that allows physicians to keep working and fighting for our patients—and for doctor-mothers to care for *your* children as they would care for their own.

Inspirational Stories

Pink Panties

ELISABETH PRESTON-HSU

"Go see new joint consult and page me to go over list."

I was a resident on the physical medicine and rehabilitation consult service when the attending physician paged me. That was the usual shorthand.

The patient I was to see—I'll call her Ms. Smith—was an elderly woman who needed to be evaluated for potential acute inpatient rehabilitation after her hip replacement, and like many other orthopedic patients, she was stable and motivated, and ready to get back to her daily routine after surgery.

When I arrived, she looked at me with wise, sparkly eyes and a smirk. She had an air of Katherine Hepburn: even in a hospital gown with mussed-up hair, she looked regal.

I introduced myself and proceeded with the interview and exam.

"Do you live with anyone who can help you at home?"

"Oh, no," she said in a sing-song timbre with a wave of her hand. "I never did, and I'm not married. Being single has kept me alive! Married women are so unhappy." She paused and looked at me without a change in her facial expression. "Are you married?"

"Yes," I said. It felt awkward. "We have a baby," I added.

In my mind, this softened my affirmative reply. *Yes, I'm married. There's a child. It's all good, lady.*

But was it? My husband and I, both resident physicians, had an infant. In my eyes, I was a tolerable resident. A cog in the wheel who invariably had been mucking up the schedule ever since I had the audacity to go into early labor on one of the busiest inpatient rehab rotations. How dare I?

My daughter glued my husband and me together in a way that nothing else could in our dual-physician family. She forced us to communicate with constant updates on our work status.

We worried about who was going to pick her up from daycare, praying we both didn't get a late afternoon hospital admission or consult so one of us could get her on time. We pored over newly released on-call schedules every month to identify days we were simultaneously scheduled and contact colleagues to negotiate switching work dates.

Sleep deprivation from our daughter's nightly cluster feeds and overnight call took its toll. Despite our constant communication, there were times when I didn't see my husband for three consecutive days. His existence was evidenced only by the signature in the daycare's logbook where he signed in our daughter.

As a result of our focus on our baby, we fell behind on domestic duties. We cleaned our cat's litterbox infrequently. One night, the cat finally retaliated by urinating all over our daughter's car seat, sending us into a frenzied panic when we discovered it the next morning. My husband and I both had to get to work on time. We couldn't launder the seat pad—no time. Stores weren't open to buy another seat—too early. So, our daughter and a strategically placed towel were strapped into the seat, and we went along our day, wondering if the daycare noticed our daughter smelled faintly of cat piss.

What we needed was a vacation from these consuming schedules. I wanted to while away the hours poking my baby's cheek or sniffing her sweet, baby scent, but I had no vacation days my first year because I had used them for maternity leave. Some childless colleagues joked that maternity leave was an extended vacation. Maybe—if vacation featured baggy clothing and no bra, sore breasts, pain and itching from a healing C-section, lack of sleep, hormone fluctuations, postpartum depression, and taking care of a new human.

Though words failed me then, I knew this entry into motherhood wasn't right. Did childfree people think a baby wasn't a big deal? And did people with older children enter a fugue state, unable to remember the joyous yet lonely upheaval a baby brought to their lives?

Anyone welcoming a new baby is challenged and humbled. It's all-consuming. Yet it was the medical field's interrogation of new parenthood that wounded me. We were supposed to value health and humanity, and many of my physician peers and mentors failed to validate my very human parts. It seemed my motives for being in medicine were questioned. I could almost hear them asking: *Do you really want to be here? Or be a mother?*

I wanted to do both, and I hated that their behavior made me doubt myself. Sometimes I wondered if we should have started a family at all.

Expectations were high in residency for all of us, no matter our family status. I worked to keep up with journal articles, procedure numbers, and the arduous plod of studying for boards, but I also wanted nothing more than to be a good and present mother. It saddened me that my daughter was often the first kid dropped off at daycare and the last picked up. Did I touch her enough that day? We didn't throw her a fancy first birthday party. Our condo was too small, there was no easy parking for visitors, and I was too tired to care. I often doubted my abilities at home and at work.

Though hard to find, there were pockets of support.

"Align yourself with people who support you," a colleague and friend told me. She was also a young mother. "You're doing great at being a mom," she added. I didn't know if I should believe her.

I navigated my career carefully, not knowing who to trust with my feelings of insignificance. I was sure no one wanted to hear how I doubted myself. It would make me look weak. There was already a perception in my program that some residents worked harder than others. Gossips said that the young mothers were not working hard enough and were "distracted."

In reality, we were on call every night for either our patients or our child. We silently fretted about bonding with our baby while addressing anxious patients or medical crises. We called consultants and coordinated care. Everyone's care except our own. Still, we weren't working hard enough, they said.

"Oh, that's lovely!" Ms. Smith exclaimed, pulling me back to my consult. She wore the same plastered-on smile. "Babies!"

I smiled back at her politely.

That day we first met, she was recently postoperative and not ready to start acute inpatient rehab. I did my examination and went over the expectations of acute inpatient rehab with the goal of getting home.

"When can I wear my pink panties?" she asked.

"What?" I thought I hadn't heard her correctly.

"When can I wear my pink panties?" Ms. Smith emphasized the words "pink panties" when she repeated the question. "I bought them special for my hip surgery. I know when I wear my panties, I'll be on my way home soon. Move forward!"

I'd never heard a request like that before. "As long as the leg elastic doesn't overlap your incision too tightly, you can start wearing them once the evaluating therapists can help you get them on. They'll teach you how to pull them on and off without hurting your hip."

"Great!" Ms. Smith said with a genuine smile.

I was glad my answer satisfied her.

A day later, I admired her incision before she was transferred to acute inpatient rehab. She proudly lifted her gown to show me. There were the pink panties. She punctuated the moment by slapping herself on the bottom and giggling.

That night after, folding laundry at home, I opened my underwear drawer. It was stuffed full of the ratty maternity underwear I still wore although I had not been pregnant for almost a year. As I dug through the drawer, I saw a crumpled pair in the back corner. Plain, cotton, and pink. I couldn't help but smile as I held them up. Faded letters on the front read "ommv-tc-be."

"Mommy-to-be" no more, I thought. *I AM. I can do this. All of it.*

I put on those scruffy pink panties the next day, the same day Ms. Smith transferred to the rehab hospital. Although I can't say I'd be happier if I never married or never had children, I do agree with her attitude about underwear. When in doubt, just put on your pink panties and give yourself a slap forward.

Selfless Service

TORIE COMEAUX PLOWDEN

It was midway through my third year of medical school. I had finished my inpatient, outpatient, and surgical rotations, and I was doing new things every day. It was thrilling.

On that particular day, I was rotating on cardiothoracic surgery. It was, perhaps, the most amazing thing I had witnessed to that point. Just hours before, I had been standing in the operating room with my hand inside of someone's chest, touching a man's heart while the surgeon performed a coronary artery bypass. Miraculous.

When we were finished, the surgery resident and I walked over to the cafeteria. I could hear the usual noises of people chattering and saw other harried residents rushing to get something of sustenance while they had a precious few minutes to spare. Delicious smells wafted out as we got closer. I could smell something mouthwatering—maybe it was apple pie. I heard my stomach growling slightly. I hadn't eaten all day.

When we turned the corner and walked into the spacious, noisy, brightly lit cafeteria, I stopped and gasped, eyes wide. I blinked hard a few times but couldn't find my voice. I had never before seen anything like the scene in front of me. The resident noticed my reaction and looked around.

"Blast injuries," he said.

Blast injuries? I wasn't even sure exactly what that meant. I vaguely remember hearing something about blasts on the news.

"Sadly, we see this very frequently."

"But, but . . . they're so young! And there are so many of them!"

I could see at least six young men who were amputees who were simply going about their days and grabbing lunch like we were. Some were eating with their young wives, and one wheeled past me in his wheelchair, laughing, his toddler son on his lap. Several were missing multiple limbs in a variety in combinations—both legs, or an upper and lower extremity. None of them appeared older than twenty-two.

It was 2003, and our country was at war. The year before, I had accepted an Army scholarship to medical school. Even though I understood what that meant

and was well aware that serving my country could take me into the heart of a war zone, I was still shocked as I stood in that cafeteria. It hadn't occurred to me that the aftermath of war would affect me at home or that I would encounter its viciousness while simply heading to dinner—even though I was at a major military hospital. I felt like I had been slapped. At twenty-four, I wasn't much older than these soldiers. Looking into their young faces was like looking into the faces of my younger brothers.

At our hospital, there were exciting breakthroughs in prosthetics development. It was innovation born out of necessity: the severe injuries experienced by many young men and women might have been fatal in the past. The healthcare teams were good at pulling these soldiers back from the brink of death and had created an opportunity for the injured to live full lives.

So many thoughts ran through my head. I couldn't imagine going from healthy and fit one moment to missing a part of oneself the next. These soldiers had to learn to live in a completely new way. The blast injuries exacted a terrible toll.

I had no way of knowing how far those men were from their initial injuries, nor could I comprehend how difficult the remainder of their recoveries would be. But as I gathered my food, I watched them. One laughed at something his wife said, and then she leaned over and kissed him, her affection obvious. There was a sweet moment between a father and son. Another man, a look of determination in his eyes, rolled his wheelchair unassisted while his wife walked next to him. I saw grit and grace in each of their faces. I glimpsed the tenacity of their human spirit.

Throughout medical training, doctors undergo many transformations—from the naive medical student to the talented resident to the insightful and experienced attending physician teaching future generations. These transformations are made through countless hours of work: first reading and learning, then discussing difficult topics, allaying fears and dispelling misconceptions, encouraging patients, and sometimes having our hearts broken and then repaired. And, of course, there is the ever-present sleep deprivation. Training as a military physician added an additional layer to the typical medical training. I had to be constantly aware that the soldiers I treated need to be ready to train and ready to fight and their families needed to receive top-notch care so they could continue to focus on their missions.

Nearly two decades have passed, and I still think of the young men I saw that day. Looking at them and knowing that a team of physicians, nurses, and other healthcare professionals had helped them thwart death and rebuild meaningful and productive lives was humbling and inspiring. That chance encounter in a cafeteria was one of the most profound moments of my medical training.

In my daily life as a military physician, I frequently encounter amputees. They run past me as I walk into the hospital. They work out next to me at the gym,

often pushing their bodies harder than I can push mine. They shop with me at the commissary. They escort their wives to appointments with me. They walk forward, one step at a time, living their lives boldly and unapologetically. They motivate me to do the same.

Game On

ANNETTE K. ANSONG

Daggone it. My pager went off again.

It had been a chorus-filled night of vibrations and relentless buzzing from that outdated, oversized device of evil. In darkness, I reached out of my bed and searched blindly for it on my carpeted floor. With one eye open, I saw the familiar extension number for the pediatric emergency room. I dropped the pager, felt for my plugged-in cell phone charger cord, and followed it to my phone.

I called the ER back, and I could tell by the expeditiousness with which my call was transferred to the attending that he wasn't calling me to review an EKG quickly. His voice was tremulous, and it took me a moment to decipher his words: "I have a tachypneic three-month-old with a big heart on chest X-ray."*

Say no more.

I knew this would occupy the rest of my night. I got the remainder of the clinical history as I stealthily rolled out of bed—trying not to rouse my two small kids, who had made their way into my bed, or my husband, forced to sleep at the foot of our bed. I wondered how they could sleep through all the noise I was making. Must have been nice.

On my drive to the hospital, possible diagnoses were racing through my head: ventricular septal defect in heart failure, Ebstein's anomaly, myocarditis.** These were the sorts of critical cardiac illnesses I'd seen in very young infants as a pediatric cardiology fellow. These were the life-altering occasions for which I had been trained—not so much for chest pain in a sixteen-year-old that's been present since she was five nor for the morbidly obese eight-year-old with inexplicable weight gain. I could not help the growing excitement as I thought about the cardiac mystery I would have to solve.

When I arrived at the hospital, I made my way to our echocardiography lab to grab the ultrasound machine I needed. From there, I went to the pediatric ER,

Tachypenic means fast breathing.
**A ventricular septal defect is a hole in the wall separating the bottom chambers of the heart. Ebstein's anomaly is a malformation of the tricuspid valve, the heart valve on the right side of the heart; and myocarditis is the inflammation of the heart muscle.

where my patient, his parents, the attending, nurse, resident, and respiratory therapist (did I leave anyone out???) awaited me. I introduced myself and explained to the child's parents, who had the frozen look of all terrified parents, that I had been called because the emergency physician was worried about their baby's breathing and heart. I'd be performing an echocardiogram as part of my assessment, which was just a painless ultrasound of the baby's heart.

Before beginning, I examined the patient. As I laid my stethoscope down, I noted the fast breathing and irritability of my tiny friend as he weakly gazed up at me. This, I could tell, was going to be the beginning of a long relationship. Verily, my auscultation revealed an unforgiving systolic regurgitant murmur.*** Under the stares and glares of the many in the room, I began my scan. As soon as I placed the probe on his chest, I saw torrential mitral regurgitation and poor cardiac function.

It took the next several minutes to figure out whether the findings were from congenital or acquired heart disease.**** Meanwhile, the little one fussed at me as I scanned, clearly tired and short of breath. I owed it to this little guy to figure out what was wrong and make it better.

His parents' eyes darted between the images on the echo machine and my face. They looked at the swirling reds and blues on the ultrasound screen and then studied my face, searching anxiously for the answers to their questions. I had on my game face, which revealed nothing. I knew doing so would heighten their anxiety. Only the occasional low whimper of their little one broke this intensity, drawing his parents' attention. They rubbed his little head and wiped the tears streaming from the corners of their eyes. I proceeded routinely from one echo view to another. Everything was structurally normal so far.

It was my parasternal short axis view where finally something did not seem right. The left coronary artery was not coming off the left side of the aortic valve, which is where it should have been.

Crap.

I followed my hunch and looked toward the pulmonary artery. Sure enough, there was the left coronary artery . . . coming off the pulmonary artery.

This patient had anomalous left coronary artery off the pulmonary artery, un affectionately known as ALCAPA. This coronary "steal phenomenon" misdirects blood flow from the heart and dumps it into the pulmonary arteries so that the heart does not get enough oxygen. It was as if my little friend was having mini heart attacks all the time.

Surgery is the only way to repair ALCAPA, and this child's defect had to be repaired or he would likely die. My mind was reeling as I considered what lay ahead

***A systolic regurgitant murmur is a type of extra heart sound heard when the valves inside the heart close.
****A congenital abnormality is present from birth.

for this family, and I struggled to find the words to tell these parents their little one was going to need open-heart surgery . . . right now.

I cleaned off the probe, set it aside, and pulled up a chair, steeling myself for the conversation. Gently but firmly, I explained my findings and the need for emergent surgery.

They were crushed. His mother began sobbing and asking if she was to blame for this travesty. "Was it something I did during my pregnancy?" she asked. I vehemently reassured her that there was nothing she did or could have done to prevent this defect. I left them to call our pediatric heart surgeon. During this time, the staff from our pediatric intensive care unit came to the ER to evaluate the baby. He was quickly taken up to the PICU for intravenous line placement and intubation prior to surgery. A milrinone drip was started to help with cardiac function and mitral regurgitation while we waited to hear from the operating room (OR).

My little friend tolerated his procedures like a champ! Before the sedation took its effect, his facial expression literally screamed, "What's all the fuss?" Soon after, he was taken to the operating room.

As his parents made their way to the PICU waiting room, I made my way to the echo lab to get what little bits of sleep I could. Hours later, my little friend was recovering. The PICU team received the obligatory surgical-anesthesiology sign-out. The surgery had gone well—although it was hard to tell from the numerous tubes, lines, drips, and personnel around his bed. Though the baby had a way to go, I could not help but think what a big save this had been.

His parents were allowed into the room once all the proper postoperative checks had been made. His mother clasped both hands to her mouth as she walked in, and when she leaned down, she was careful not to touch any of the ICU apparatus. His father's hand rested on her right shoulder as tears flowed down both their cheeks and they whispered their love to him.

They laid a small cross, a symbol of their Christian faith, at the head of his bed before they left, and his nurse reassured them that all would be well. They could call anytime during the night.

The following days he was transferred out of the PICU and continued to recover on the pediatric floor. He even managed a little smile for me.

We were standing in the hall, discussing his plan of care, his mother with us. Before we moved onto the next child, his mother stopped us.

"Thank you for saving his life," she said, tears in her eyes.

I placed my hand on her back. "Thank you for entrusting your son's life to us."

What I do is important. It matters, as do I. Lives are saved. Till the next call night, when it's Game On.

The Perfect Birth

KRISEMILY MCCRORY

The adage of labor and delivery warns: the length of the birth plan inversely correlates to the probability of needing a C-section.

My patient, whom I'll call Connie, presented me with a three-ring binder of requests related to her pending birth. After years of infertility, she yearned to deliver this baby, who might be her only one, the "right" way. For her, that meant no interventions: no unnecessary exams, no epidural or pain medication, minimal monitoring during labor. Connie planned to incorporate hypnobirthing and a doula. I imagined the cost of a professional birthing advocate stretched her thin budget. Reviewing the binder, I found detailed instructions on the music and light during delivery, skin to skin after delivery, immediate breast feeding. We went over words forbidden in the delivery room. *Pressure* would substitute for *pain* in an attempt to harness even the subliminal power of language.

As a both a physician and a mother who has delivered three children without an epidural, I support my mothers seeking minimal intervention during pregnancy and delivery. Although I had not previously had a patient use a doula, I understood the benefits this type of support provided. Although her doula, whom I'll call Jane, did not opt to come to any prenatal visits, I would have welcomed her.

Her doula's absence did not faze Connie. She joyfully attended all her appointments, bubbling with anticipation of the baby girl growing inside her. Each kick and hiccup met with an excited belly rub. When he could get time off of work, Connie's husband, "Martin," accompanied her as well. He beamed at the sounds of their baby drumming through the fetal Doppler.

As she approached her due date, Connie experienced typical "I am so ready for this pregnancy to be done" moments, with swollen ankles, back pain, and the endless struggle to find a comfortable sleeping position. Overall, her pregnancy had progressed without complication. She had perhaps gained a few more pounds than recommended, but serious medical concerns such as elevated blood pressure or pregnancy-induced diabetes remained absent. With each prenatal visit, she worried about failing to go into labor on her own. I remained optimistic and encouraged good hydration and walking.

When Connie was at thirty-nine weeks, a little before her due date but still full term, her contractions came forcefully. She tolerated them at home for a few hours, and then Martin drove her to the hospital. Jane had not yet arrived when a resident physician, part of our labor and delivery team, evaluated Connie. He observed her contractions and examined her cervix. Calling me, the resident described Connie as uncomfortable. Her cervix was five centimeters dilated but needed to reach ten centimeters before she could push. It was likely several more hours before delivery. I informed the resident I would be there shortly.

Less than thirty minutes later, one of my labor and delivery nurses called my cell phone. "Your patient wants an epidural," came through the line before I even said hello. In the background, I could hear Connie yelling, even though I knew the call had to have originated at the nurses' station. The doula still absent, the nurse promised to let the patient know that I was en route.

Labor pains would not wait for me. Anesthesia exited Connie's room as the doula and I arrived in tandem. From their station, the nurses gave me the knowing looks only labor and delivery nurses have. They had seen the detailed birth plan. The epidural would be the first domino. I tried to ignore them and went into Connie's room. She lay peacefully in the bed with her post-epidural IV fluids running. I apologized for the time it took me to arrive; she smiled reassuringly. The relief she found from the epidural erased her concerns. The doula joined Connie's husband at the bedside, looking flustered by the epidural. I assumed doulas typically met the mothers at home once the first twinges of labor appeared. Her late appearance was infuriating.

In the next several hours, more dominos toppled. Nursing struggled to consistently keep Connie's baby on the fetal heart monitor, which uses ultrasound to detect a baby's heartbeat through a mother's abdomen and records it as a tracing on a screen. A good tracing, one where all heart activity is visible and appears normal, is reassuring, but poor tracings can be concerning because they might not accurately portray the baby's condition. Knowing that, I hesitated to pursue any unnecessary interventions. A wiggly baby coupled with Connie's larger body size led to a broken-up tracing. When we could see it, the baby's heartbeat would drop to a lower rate, a deceleration, but then come back up to normal. At the same time, Connie's cervix had not dilated any further. Her contractions began to space out.

Sitting at her bedside, her birth plan glaring accusingly from the table in front of me, I broached using a different contraction monitor. An internal pressure catheter would let me observe the contractions from within the uterus. This monitor gives not only the timing of the contractions but also the strength, which cannot be determined with the external monitor. I reviewed the risks and benefits with Connie and Martin. Knowing the strength of the contractions could help determine whether we needed to augment her labor with medication. Placing an internal

monitor would also require artificially breaking her water. They listened intently, and after answering their questions, I stepped out to allow them space to discuss.

Connie opted to move ahead with the internal monitor placement. Jane, who had barely said anything in my presence, stared at the floor. I positioned myself at the foot of the bed, and, using a small plastic device resembling crochet hook, I popped a small opening in the amniotic sac surrounding the baby. Meconium-filled fluid rushed onto the crux pads on the bed.

The look from my nurse reflected my own concerns. Babies form stool in their bowels as they develop in the womb. The first bowel movement, or meconium, typically happens after birth but in babies under strain can occur prior to that. Meconium in the fluid signaled the baby's stress. Removing my gloved hand from within her, I explained to Connie that her baby showed indications of distress and she would need to be closely watched.

Within twenty minutes, I saw Connie's inadequate contractions on the monitor. More than six hours had elapsed since her arrival on labor and delivery, and with her cervix unchanged, I knew I needed to augment her. Pitocin would stimulate her uterus to contract more effectively, hopefully dilating her cervix. Once again sitting with Connie and her husband, I described my plan and recommended an additional internal monitor for the baby's heartbeat. The current monitor, located externally, failed to consistently register the baby's heart rate. I knew this baby already felt stressed, and stronger contractions, while necessary, could exacerbate that stress.

Connie asked for a few moments with her husband. I dutifully stepped out into the hallway. Inside, I mourned the loss of the beautiful birth Connie had carefully scripted. The nurses looked at me sympathetically from their station, where they could see the fetal heart tracings on the computer monitor. Everyone knew my worries for this baby.

Jane, the doula, exited the room and said she did not see much point in staying any longer.

Her seeming abandonment of my patient angered me. Now, when Connie probably needed a doula the most, Jane simply walked away.

I returned to Connie's room to find she and Martin had agreed to the recommended interventions. Her nurse started Pitocin. A moment later, I reached into the cervix, felt the top of the baby's head, and placed an internal heart monitor on her scalp. For the first time all night, I had a steady picture of the baby's heart rate. Initially, all appeared well.

As the night progressed, I watched the monitor, never feeling fully at ease. The initial reassuring heart tracing drifted into intervals marked with decelerations. These drops remained just intermittent enough that I thought I could continue to push for the vaginal delivery Connie so desired. Her dutiful nurse would turn Connie back and forth, trying to find the sweet spot where baby's heart rate remained

appropriate. She applied oxygen and gave fluids in the IV, all interventions geared at supporting baby until birth. Questioning my decisions to defer a Cesarean section, I consulted a colleague on the floor, asking for another set of eyes on the strip. He agreed with me that the strip looked good enough. No OR needed yet.

Just after midnight, the deceleration dipped lower and took longer to recover. I rushed back into the labor room. Connie's ever-present nurse was again trying to reposition her. This time, we turned the Pitocin off, concerned that the contractions might be too much for the baby. I quickly donned a glove to check her cervix because decelerations can occur when the cervix changes suddenly or the baby drops further into the birth canal. Miraculously, I found that her cervix had reached the magical ten centimeters. The baby's head had dropped much lower, likely explaining the sudden changes I observed on the fetal monitor.

Moving out of the waiting to a more active stage, Connie obediently pushed with her contractions. I felt encouraged, knowing we had reached the final point. Like many first-time mothers, Connie needed time to figure out how to push effectively. Her already stressed baby did not like squeezing through the birth canal. Although I could not see the monitor recording her heartbeat, my trained ears could hear the slowing heartbeat, the longer duration to recovering. I could visualize those dips, understood the urgency. So close, yet still not done, Connie's pushes weakened as she tired. Looking up at Connie from my position at the foot of the bed, I could not ignore the inevitable. In my calm-doctor-in-chart-and-not-at-all-terrified voice, I explained that baby could not tolerate labor much longer, and I needed to get her out faster with the assistance of a special vacuum device. I hoped my steady voice did not expose the worry in my head.

Feeling for the landmarks on the baby's scalp for correct placement of the vacuum, I realized I would need to cut an episiotomy to create enough room. Connie simply nodded as I explained. The scissors cut her perineum. The vacuum was correctly placed. Gentle traction on the baby's head as Connie pushed her baby into the world. As her head emerged, I removed the umbilical cord, wound tightly around her neck, a likely source of the stress and meconium. The rest of her body slid out like a wet fish. The floppy, purple baby girl remained limp as I rushed to clamp and cut her umbilical cord. Handing her off to the waiting nurse, I turned my attention to the placenta and episiotomy repair. Then, the most beautiful cries echoed in my ears. We all breathed a collective sigh of relief and cried for joy. I looked up to catch a glimpse of the baby pinking up. By the time I finished stitching, she appeared healthy and vigorous.

The nurse placed the baby on Connie's breast. Hearing her mother's familiar heartbeat, the baby calmed and nuzzled against her skin. I congratulated Connie and Martin on their new addition. More than three hours after stepping into the

room for the delivery, I emerged, heading back to the call room. Changing out of my scrubs, I collapsed on the bed to sleep.

Connie and her daughter, Maeve, left the hospital two days later with no further complications. Despite the positive outcome, I believed I had failed Connie. In the days following the delivery, I second-guessed every decision I had made that led to each additional intervention. I thought back to the binder where she had painstakingly outlined the birth she wanted to have. Her actual birth had little resemblance to her plan. I dreaded facing her during her postpartum visit. She would be disappointed at best, furious at worse.

As her appointment loomed closer, I contemplated the best approach. How could I best debrief her on what had happened, everything that went wrong? I could find no good answers. The day finally arrived, and I steeled myself to knock on the exam room door before entering. Inside, Connie sat with Maeve cuddled in her arms. Her eyes met mine, and a bright smile flashed across her face. "Thank you for the best birth!"

Her words floored me. I had worried for weeks that the many deviations from her birth plan might devastate her. What I saw as my failure—her lost dream—she viewed as a powerful, beautiful experience. She thanked me for openly communicating with her at each step. Connie cradled her long-desired baby girl as she explained that my reasoning and our shared decision-making empowered her throughout the long labor. Even though the birth did not go as either of us had planned, she felt in control and included in every step, which mattered more than any individual detail in her birth plan.

Precious

HEATHER HAMMERSTEDT

Let me tell you my stories.

It's 2007 in rural Uganda. My face is wet, plastered to a thin-sheeted pillow. I'm awakened by a shrill ring. I've just fallen asleep after being awake for twenty-two long hours.

The flip phone beneath my pillow only rings once; cell phone calls are expensive here, and the nurses would rather not have to pay for the call just to tell me to get my behind back to the hospital. When they call, I trust I'm needed there, no matter the time. The only emergency physician on staff in the small nonprofit hospital where I've been volunteering, I've found the last four weeks nothing short of tireless.

I slowly drag my body out of bed, coughing up mucous (because why not get a cold in Africa?). I throw on my scrubs, which feel as though they could stand up without me in them, and remind myself why I'm not at home, crawling out of—or back into—my own bed.

I'm a senior emergency medicine resident, and I'm here because this entire country is without an emergency department or a trained emergency physician.

So, I pick up the pace a little and shuffle across the concrete room, past my nonflushing toilet, and I emerge into the wet night. The rain is coming down so hard that my headlamp is basically useless. My pants are soaked within seconds. I kick my feet off the ground, running faster with every step, ignoring the protest in my lungs as I push through the darkness.

When I arrive several minutes later, I make a small effort to catch my breath and swipe my hair behind my ear as I enter the minor surgery room where three frantic Ugandans are waiting, surrounding an unconscious woman I believe to be one of their family.

The woman is covered in blood, laid out on an unpadded, steel surgical table, rusty with age. My student nurse looks panicked, wearing his pink sweater and a tiny, five-inch nursing hat precariously propped atop his head. I pad across the room to the head of the bed, grab one of few rare gloves, and shine my headlamp onto the woman's face.

Her pupils react, but I have to check them again to make sure because my eyes were immediately drawn to a jagged gash through her scalp, twenty centimeters by five centimeters, down to her skull. She has a palpable depressed skull fracture.*

I've been in the country long enough to recognize this as a machete wound. Machetes are a popular weapon of choice, unfortunately. I glance around, wanting to bark out a stream of requests: "Get the mannitol.** Prep for intubation. Call for a CT scan. Call neurosurgery—she needs a craniotomy."

You see, I know what this woman needs . . . she needs a fully equipped emergency department! Yet I have none. Had she been brought in during daylight hours, I might've had an X-ray. The rest is wishful thinking.

I begin to explore the wound, and she stirs, causing her family to erupt in chatter. They're just as encouraged as I, thinking she might have a chance. I grab a surgical tray and pull back the portion of the skull I can grab, bringing it up, toward me, and off of the brain. And wait. Thirty minutes later, she opens an eye and moves her extremities the slightest bit.

I stare outside the window, silently weighing my options. A US-trained surgeon (who is currently out of town) and a few "just out of med school" Ugandan doctors (who often come to surgical cases with their books out) staff the clinic. I call the hospital supply driver and a senior nurse, arranging for us and one of the family members to be driven three hours away to the referral center, which I was informed had a visiting surgeon on staff.

It's difficult to describe the terror of driving along these roads at night without streetlights: invisible potholes illuminated by the single headlight on our SUV, the smell of the rusty vehicle, the noise of the rain, the devastated sounds of wailing when her heart finally stopped beating, just as we arrived to the referral hospital to hear that there is no visiting surgeon.

After the long, silent, dawn-breaking ride home, I wipe my weary eyes, thank the staff, and apologize. The woman's family member climbs out of the car, and, after paying fuel costs to the driver, walks home, five kilometers down a red mud road I would use later that day for running the cobwebs and fragility out of my soul.

There had to be another way.

Internationally, there is a lack of awareness regarding the global need for emergency medicine, as well as for the possibilities of improving public and primary health outcomes and strengthening healthcare systems and poverty outcomes overall—not to mention the political inertia and lack of financial resources standing in our way.

* In a depressed skull fracture, the broken piece of skull can be pressed down and into the brain.
**Mannitol is a drug used to bring down pressure in the brain and buy the patient some time.

Without an emergency department or trained hospital staff, without an education or resource system to provide what is needed to save a life, we may as well be sitting by while people die because we can't save them if we don't know what to do with what, if anything, we have on hand.

I realize that day I made the wrong call and put many of us at tremendous risk in trying to save the life of somebody who, with our resources, could not be saved.

There had to be another way.

That same trip, I met Precious. Just two years old, she died of diarrhea and malaria—unfathomable in the United States. That year, a thousand children like Precious may have found their ways to our hospital: dehydrated, sick, malnourished, and dying, greeted by a locked front gate. A mother, who carried her precious offspring for many dusty miles, came here desperately, in a final plea for life that she very likely could not afford.

In 2007, all of these children were met at the front gate by a security guard with zero healthcare experience who would likely direct them to wait wherever they could find a place. It may have been twenty-six hours or more before an actual doctor would come to see these children—if they could make it that long.

The nurses at this resource-poor hospital had limited clinical decision-making skills, due to their inadequate medical education. Surely, at least one of them saw Precious or any of the other children, sitting in a dark hallway, waiting for help and solace. Despite their great hunger to care for these children, their training rendered them unable to do so. Instead, the children had to wait for one of the few generalist doctors to become available. Thus waiting, children died, a thousand times over.

There had to be another way.

Fast-forward eight years. Now, it's 2015 in rural Uganda. Dark, and so humid I can taste the day's heat when I breathe. I receive a text message from the hospital's emergency department. I've just eaten dinner and spent a little time reading a book in my creaky, thin-sheeted bed. The text is from J.B., one of our now fully trained Ugandan emergency care practitioners.

"All tuned up ☺"

He's ready for me to evaluate a patient before admittance. I tread slowly down the dark path, my headlamp barely filling the space in front of me. I twist my ankle in the same damned hole I twist it in every night. I enter the hospital and look toward the minor surgical room to my left, then take a right instead, into an eight-year-old emergency department: brightly lit, nice and tidy, books and computers filling the place.

I see another "Precious" lying on a gurney with a brightly patterned blanket over her lap. She is gaunt, with difficulty breathing and dark hollows under her eyes, and a tongue so pale I can almost see through it. This is a severely ill child, likely with malaria or a related tropical disease. Malaria parasites grow inside the red blood cells, destroying them, causing red blood cell counts to drop dangerously low and thus making it hard for the blood to carry oxygen and nutrients to organs.

J. B. is sitting comfortably at the bedside, smiling confidently and consoling the worried family. He breaks into a wide grin when he sees me, proud and serious but with a wryness that makes him a dear friend.

This "Precious" came in unconscious, dehydrated, sick, malnourished, dying and was greeted by warm and knowledgeable staff, then carried into the emergency department and seen in seconds. Within twenty minutes, J. B. had placed an access line into her bone to deliver rehydration fluid and collected samples of her blood to view under the microscope for diagnosis. Unfortunately, she has *P. falciparum* malaria, the most severe form of malaria and also the most common type of the disease to get locally. Precious has a red blood cell count twelve times lower than normal and is receiving a blood transfusion.*** Paracetamol, the European version of Tylenol, is lowering her fever, and she is arousable. A spinal tap is reassuring, showing no sign of infection in her brain or the covering of her brain (the meninges). J. B. is covering her with antibiotics directed against meningitis for now—just in case.

I go to her bed, and she opens her eyes, looking at me apprehensively—my blond hair likely surprising to her. She looks at her mom, then back at me, and she smiles. I smile too.

J. B. and I banter through a few more differential diagnoses on what we might be missing or what we could be doing with the resources at hand.

I approve her admission to pediatrics and rejoice with J. B. over another Precious who survived. You would be reading an entirely different story if she had been brought to nearly any other hospital in the country up until that year, when the proposed model for emergency care capacity development was approved, and cadre building and task-shifting began taking shape within the construct of the Ugandan government, universities, and partners.

And the lethally injured woman I risked my life and my staff's lives for on that rainy night in 2007? I no longer transfer patients like her in futility—in fact, in eight more trips to Uganda over the following ten years, I never tried that again. Some things are difficult to fix in a resource-limited country such as Uganda; however, our emergency care practitioners now have the skills and knowledge to save the lives they can, with the resources the hospital can sustain, teaching the classes of eager

***Her hemoglobin was 1.3 grams per deciliter compared to the normal range of 10.5–14.5 grams per deciliter.

hearts that come in behind them, as we US-trained physicians work ourselves out of a job through train-the-trainer education programs and capacity development.

As Ugandan physician Annet Alenyo Ngabirano has said, "In Africa, we may not have resources—but we are resourceful."

I walk past the shuttered minor surgery room as I hear the heavy clinking of the emergency department doors being locked behind me. I hang back to allow J. B. to catch up with me, and we walk out together into the dark night. I can feel the thick humidity in my nostrils and I smell the fragrant smoke of kitchen fires all around. As we stroll up the red mud path, J. B.'s excited voice echoes as he gushes about his patients, his community, his hospital, and his dreams—and the dreams that thousands of children like Precious can have now too.

Contributors

Jazbeen Ahmad, MD, MBA, is a board-certified internist who has an MBA with an emphasis in health care administration. She lives and works as a hospitalist in Waco, Texas, with her husband and two children. In her free time, she enjoys spending time with her family, writing, and hosting the *Her American Story* podcast.

Rebecca Andrews, MS, MD, is lucky enough to have found her three true callings in life: being a mom, practicing primary care internal medicine, and educating future doctors at the University of Connecticut Health Center in Farmington, Connecticut. Andrews also serves as UConn Health's clinical lead for the Connecticut Comprehensive Pain Center and Patient-Centered Medical Home. She hopes her role as chair of the American College of Physician Board of Governors has led to healthcare improvements for physicians and patients. Her two sons, an unabashed love of coffee and trivia, and half-marathon training rule her world.

Annette K. Ansong, MD, FACC, is a board-certified pediatric cardiologist. The daughter of immigrants from Ghana, she grew up in the suburbs of Washington, DC. She received her bachelor's degree from the University of Virginia. After graduating from medical school at Howard University, Ansong completed her pediatric residency and pediatric cardiology fellowship training at Duke University Medical Center. She enjoys patient care and finding innovative ways of improving that care.

Sharon Ben-Or, MD, is a thoracic surgeon originally from Baltimore. Her hobbies include yoga, traveling, and knitting. She can also say the alphabet backward.

Julia Michie Bruckner, MD, MPH, is a pediatrician, cancer survivor, mother, and writer whose work has appeared in *Narratively,* the *Bellevue Literary Review, Discover, Journal of the American Medical Association, Intima: A Journal of Narrative Medicine, Academic Pediatrics,* and *Academic Medicine.* A native New Yorker, she now lives in Colorado.

JENNIFER CAPUTO-SEIDLER, MD, is assistant professor in the Division of Hospital Medicine at the University of South Florida. Her professional interests include gender equity, narrative medicine, and medical education. You can follow her on Twitter @jennifermcaputo.

DANA CORRIEL is a board-certified internist and a healthcare social media influencer who recently left clinical medicine to focus on the company she founded, SoMeDocs, which amplifies the voices of physicians on social media. She blogs at drcorriel.com about medicine, parenting, and traveling. She is a vaccine advocate and a supporter of female physicians across the spectrum of their careers. Dana has been published in *Self* magazine and on *Medium, KevinMD,* and *Doximity.* In her spare time, she travels and seeks outlets for her creativity. She lives with her husband and three boys in New Jersey.

AVNI DESAI, MD, MPH, is a medical doctor who completed her training in India. She completed her MPH at Columbia University, New York, and a master's degree in biostatistics at Georgetown University, in Washington, DC. She serves in a senior consulting role in a Big Four accounting firm as a federal health subject-matter expert. Her passions include environmental and children's health, alternative medicine, and healing.

TEJA DYAMENAHALLI MD, MPH, is a board-certified pediatrician who completed her training at the University of Washington and University of Rochester. Additionally, she completed a fellowship in integrative medicine at the University of Arizona and currently practices both pediatric hospital medicine and integrative health in Duluth, Minnesota. Their two girls, Lena and Iyla, keep Teja and her husband very busy. She spends her spare time dabbling in a number of creative pursuits and loves cooking and eating good food.

ANDREA EISENBERG, MD, has been a board-certified OB/GYN in the Metro Detroit area since 1993. Through her work in women's health, she has shared in countless intimate moments of her patients and shared in their joys, heartaches, secrets, losses, and victories. In her writing, she captures the human side of medicine and what doctors think and feel in caring for patients. She has several published essays and blogs at www.secretlifeofobgyn.com. In addition, she has developed a narrative medicine program in the OB/GYN residency at William Beaumont Hospital.

SUZY FEIGOFSKY, MD, is a clinical cardiac electrophysiologist at the Iowa Heart Center in Carroll, Iowa, and medical director for Kindred Hospice. Her focus is

on syncope, wellness, and end-of-life care. Outside of work, she is a wife, mother, cyclist, and avid baker.

JESSI GOLD, MD, MS, is assistant professor of psychiatry at Washington University in St. Louis. In addition to traditional research publications, she regularly writes freelance articles about mental health. Her work has been featured in many publications, among them *TIME* magazine, the *New York Times,* the *Washington Post, Self, InStyle,* and she is a contributor to *Forbes.*

HEATHER GOODEN, MD, is a rural family physician who has been scribbling on everything since she first learned how to hold a pencil. Unfortunately, life, work, and family have conspired to make it possible for her to write only in the wee hours or at coffee shops. In October 2017, she published her first book, *Dream of Darkness,* which follows the adventures of a group of girls fighting evil with abilities that H. M. Gooden would love to have; 4:00 A.M. has never been busier, but she wouldn't have it any other way.

KIMBERLY GREENE-LIEBOWITZ is an emergency and urgent care physician with over a decade of clinical experience, and she also holds a master of public health degree in epidemiology. Kim is a writer, editor, and beta reader who lives with her husband and two children in suburban New York. In her spare time, she is a gluten free / kosher chef, celiac advocate, voracious reader, and reluctant supporter of her family's baseball habit.

JILL GRIMES, MD, FAAFP, is a nationally recognized medical media expert, popular speaker, and award-winning author. Her latest book, *The Ultimate College Student Health Handbook: Your Guide for Everything from Hangovers to Homesickness* (2020), reflects her current focus on college health at the University of Texas at Austin.

HEATHER HAMMERSTEDT MD, MPH, FACEP, is an emergency physician in Boise, Idaho. After medical school at Temple, and emergency medicine residency in the Harvard system, she and several emergency physician colleagues started Global Emergency Care in 2007 to help create emergency care education and support emergency care capacity development in Uganda. See the Global Emergency Care website (www.globalemergencycare.org).

ROHINI HARVEY, MD, is a hospitalist practicing internal medicine and pediatrics. In her free time, she is a writer who has been published in *Intima: A Journal of*

Narrative Medicine and *KevinMD;* and she blogs at *Ginger Mouse* (doctorginger mouse.com). She lives in New England with her husband, twin daughters, two cats, and a dog.

SHIKHA JAIN, MD, is a board-certified hematology and oncology physician. She is the chief operating officer and cofounder of the COVID-19 action group IMPACT and the founder and chair of the Women in Medicine Summit. She is a nationally renowned speaker, is a regular contributor to Fox 32 in Chicago, and writes for several national publications, including *Scientific American, The Hill, US News, Physician's Weekly, Doximity, KevinMD,* and *ASCO Connection.*

MONICA KALRA, DO, FAAFP, is a faculty physician at the Memorial Hermann Family Medicine Residency Program in Sugar Land, Texas. She has been published in several national medical journals, including *American Family Physician* and the *New England Journal of Medicine.* Her favorite pastime is spending time with her unusually calm husband, Vik, and her conversely rambunctious children, Bella and Kush.

RACHEL KOWALSKY, MD, MPH, is a pediatric emergency physician and assistant professor at Weill Cornell Medicine in New York City. She believes that words are powerful. Her essays have been published in several anthologies, *Journal of the American Medical Association,* and *Hektoen International,* and she uses poetry and prose with learners at all levels to support discussions about cultural competence, humanism, and physician wellness.

PHOTINE LIAKOS, MD, is a board-certified orthopedic surgeon and certified physician executive. She lives in Illinois with her husband and two children. When she's not reading, writing, or obsessing over Tolkien minutiae, you'll find her indulging in her beloved baking hobby.

MARIA MALDONADO is associate professor of medicine at the Icahn School of Medicine at Mount Sinai and a primary care physician in Yonkers, New York. She is passionate about health equity and patient-centered care and believes in the power of patient advocacy through medical narrative. She has written for *KevinMD,* and her essays have been published in the *Journal of the American Medical Association, Annals of Internal Medicine, Health Affairs,* and the *Washington Post.* She is working on a memoir.

JASMINE R. MARCELIN, MD, is an infectious diseases physician whose mission is to create a more diverse and equitable healthcare workforce. She is mother to

two beautiful sons and wife to Dr. Alberto Marcelin. You can follow her on Twitter, @DrJRMarcelin.

KrisEmily McCrory, MD, MS, Med Ed, FAAFP, is a family physician and physician educator practicing family medicine in upstate New York.

Katharine Miao, MD, is regional medical director at Summit-CityMD, the largest urgent care chain in the Metro New York City area. She lives with her husband and two children and enjoys travel and gardening.

Audrey Nath, MD, PhD, is a pediatric neurologist and physician scientist with research expertise in neuroimaging. She is passionate about storytelling through writing, stand-up comedy, and audiobook narration. She believes that any day can be better by making a cheesecake.

Torie Comeaux Plowden, MD, MPH, FACOG, is a double board-certified OB/GYN and reproductive endocrinologist and infertility subspecialist. She educates medical students, residents, and fellows and is involved in clinical research. She is passionate about eliminating health care disparities, treating infertility, and improving sexual health. She also serves as a lieutenant colonel in the US Army and is the chief, OB/GYN Department at Walter Reed National Military Medical Center. She is a wife and mother and prioritizes community service.

Elisabeth Preston-Hsu is a physical medicine and rehabilitation physician in clinical practice in Atlanta, Georgia. She has had work appear in *Glassworks, Hektoen International,* and *Intima* and received an honorable mention in *Glimmer Train*'s Short Story Awards for New Writers in March–April 2019. Words will carry her, always.

Dawn Harris Sherling, MD, is an internal medicine physician and a writer of both fiction and nonfiction. Her debut novel, *Not Quite Dead,* is a medical mystery. She is currently working on a nonfiction book on how to fix food to eliminate IBS symptoms.

Sasha K. Shillcutt, MD, MS, FASE, is a professor and the vice chair of strategy and innovation in the Department of Anesthesiology at the University of Nebraska Medical Center. Shillcutt is a well-published gender researcher, international speaker, CEO and founder of Brave Enough, physician, wife, and mother. Sasha's greatest passion is empowering and encouraging others to achieve well-being in their professional and personal lives.

S. P. is a psychiatrist in London. She works with both adults and children who have experienced significant trauma.

KATIE WISKAR, MD, from Vancouver, Canada completed her medical training, including internal medicine residency and a general internal medicine fellowship, at the University of British Columbia. She now practices as an academic general internist in Vancouver, and her clinical interest is in point-of-care ultrasound. Outside of medicine, she can be found running, hiking, playing beach volleyball, and hanging out with her husband and toddler.

KAREN YETER, MD, is a rheumatologist in Los Angeles. She blogs at www .resuscitatingyou.com and has been published on *KevinMD, Pulse,* and *Mothers in Medicine.* She is currently working on a novel about a complicated relationship between a father and daughter and developing a middle grade series. She enjoys watching romcoms and tween series.

Index

Abella of Salerno, 20n45
academic journals, 2
adversity, 25–42
advocating: for patients, 3; for self, 95–97
Aetius of Amida, 5
Ahmad, Jazbeen, 7, 45–47
airborne illnesses, 10, 101
Air Canada, 81–82
Akhethetep, 4
amputation, 57–60; war and, 157–59
Andrews, Rebecca, 2, 16, 48–49; "Grandma" patient, 48–49; pregnancy, 90–91; residency interview, 90
anomalous left coronary artery off the pulmonary artery (ALCAPA), 161–62
Ansong, Annette K., 15, 160–62
Aspasia, 5
assisted suicide, 127–29
Awdish, Rana, 3

barriers to success, 1, 2, 25–42
Barry, James, 12, 22n75
Beauty in Breaking, The (Harper), 2
Ben-Or, Sharon, 16, 92–94
bias, 1, 2, 15, 108–9
birth, 11, 21n61, 90, 98–99, 148–49; doulas, 165; fetal sex selection and, 110–11; intervention, 165–67; out-of-wedlock, 22n67; plan, 5–6, 161, 163–67; pregnancy, 90–91, 107–12, 153
Black Death, 22n67
Blackwell, Elizabeth, 12, 13, 14
Blackwell, Emily, 13
Bourgeois, Antoinette, 8
Bourgeois, Louise, 8, 19–20nn37
bravery, 85–103

breastfeeding, 17
British Medical Corps, 12
Bruckner, Julia Michie, 8, 54–56; patient relationships, 54–56; twenty-four-hour calls, 54
Bulkley, Margaret Ann, 12
burnout, 1, 17

Calenda, Costanza, 20n45
cancer, 46–47, 87, 98–99, 130; breast, 3, 92–94; metastatic, 135–36; pancreatic, 127–29; treatment of, 135–38
Cantor tube, 50–51
Caputo-Seidler, Jennifer, 11, 71–73; boyfriend of, 71–73
Causae et Curae (Hildegarde of Bingen), 8
Central Park, 28
chemical cures, 11
chemotherapy, side effects of, 136
Christianity, 6, 8–10, 162
City College, 28, 29; Department of Pharmacology, 30
Clark, Nancy Talbot, 22n79
clinical competence, 16
Cole, Rebecca J., 14
Collectio Salernitana (De Renzi), 7
compassion, 10, 15–16, 43–60, 136
Copho, 6, 20n38
Cornell University, 13
Corriel, Dana, 14, 113–15
Council of Tours, 21n52
countertraction, 34–36
COVID-19, 1, 2, 17, 100–103
Crimean War, 12
Crumpler, Rebecca Lee, 14

Printed in the United States
by Baker & Taylor Publisher Services